ROOM TO BREATHE

ROOM TO BREATHE

The Wild Heart of the San Francisco Peninsula

Edited by Kristi Britt
Foreword by Ken Fisher
Preface by Steve Abbors

Heyday, Berkeley, California
Midpeninsula Regional Open Space District, Los Altos, California

Quotes by Edward Abbey are reprinted by permission of Don Congdon Associates, Inc.: page 33 from *Earth Apples* © 1994 by Clarke Abbey; page 41 from "Shadows from the Big Woods" from *The Journey Home* © 1977 by Edward Abbey, renewed 2005 by Clarke Abbey. Quotes by Baba Dioum, Robert Hass, and Gary Snyder are under copyright and used by permission of the authors. "Prescription of Painful Ends," from *Selected Poetry of Robinson Jeffers* by Robinson Jeffers, copyright 1925, 1929 and renewed 1953, 1957 by Robinson Jeffers. Used by permission of Random House, Inc. Quote by Anaïs Nin is used by permission of Tree L. Wright, author's representative, © The Anaïs Nin Trust. All rights reserved. Quote by George Orwell from *Tribune Magazine,* "Some Thoughts on the Common Toad," April 12, 1946; used by permission of Chris McLaughlin, editor, and Keith Richmond, deputy editor. Quote by Wallace Stegner © 1991 by Wallace Stegner; used by permission of Brandt and Hochman Literary Agents, Inc. All poems are under copyright by their respective authors.

Front Cover: Ian Sims, *Above the Fray,* Long Ridge Open Space Preserve, 2007
Back Cover: Bonnie Welling, *Dawn on Stevens Creek Shoreline,* Stevens Creek
 Shoreline Nature Study Area, 2010
Book Design: Rebecca LeGates

Library of Congress Cataloging-in-Publication Data:
Room to breathe : the wild heart of the San Francisco peninsula / edited by Kristi Britt ; foreword by Ken Fisher ; preface by Steve Abbors.
 p. cm.
 ISBN 978-1-59714-199-4 (pbk. : alk. paper)
1. Midpeninsula Regional Open Space District (Santa Clara County, Calif.)—History.
2. Midpeninsula Regional Open Space District (Santa Clara County, Calif.)—Description and travel. 3. Natural areas—California—Santa Clara County—History. 4. Natural areas—California--Santa Clara County—Description and travel. I. Britt, Kristi.
 QH76.5.C2R66 2012
 333.73'160979473--dc23

 2012019242

Orders, inquiries, and correspondence should be addressed to:
 Heyday
 P.O. Box 9145, Berkeley, CA 94709
 (510) 549-3564, Fax (510) 549-1889
 www.heydaybooks.com

Printed in China by Everbest Printing Co. through Four Colour Imports, Ltd., Louisville, Kentucky

10 9 8 7 6 5 4 3 2

Contents

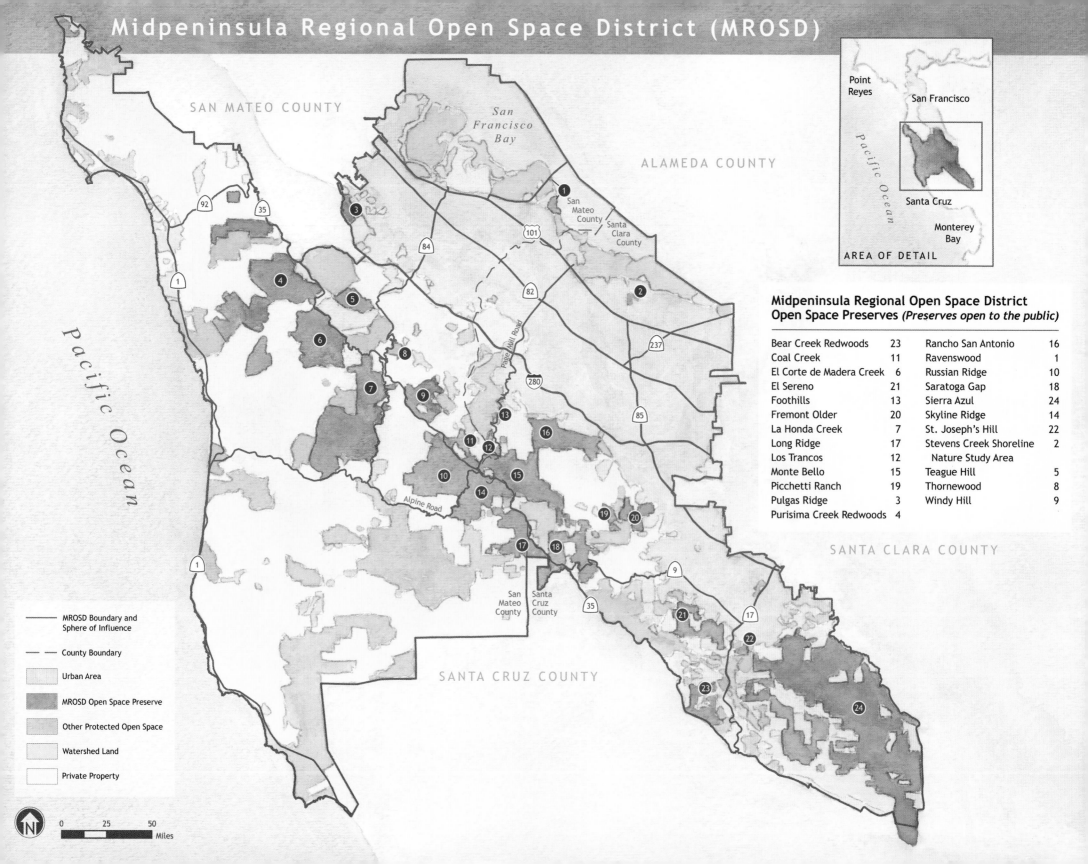

Midpeninsula Regional Open Space District (MROSD)

AREA OF DETAIL

Point Reyes
San Francisco
Pacific Ocean
Santa Cruz
Monterey Bay

Midpeninsula Regional Open Space District
Open Space Preserves *(Preserves open to the public)*

Preserve	No.	Preserve	No.
Bear Creek Redwoods	23	Rancho San Antonio	16
Coal Creek	11	Ravenswood	1
El Corte de Madera Creek	6	Russian Ridge	10
El Sereno	21	Saratoga Gap	18
Foothills	13	Sierra Azul	24
Fremont Older	20	Skyline Ridge	14
La Honda Creek	7	St. Joseph's Hill	22
Long Ridge	17	Stevens Creek Shoreline	2
Los Trancos	12	Nature Study Area	
Monte Bello	15	Teague Hill	5
Picchetti Ranch	19	Thornewood	8
Pulgas Ridge	3	Windy Hill	9
Purisima Creek Redwoods	4		

Legend:

— MROSD Boundary and Sphere of Influence

-- County Boundary

Urban Area

MROSD Open Space Preserve

Other Protected Open Space

Watershed Land

Private Property

SAN MATEO COUNTY
ALAMEDA COUNTY
San Francisco Bay
San Mateo County
Santa Clara County
SANTA CRUZ COUNTY
SANTA CLARA COUNTY
Pacific Ocean
Page Mill Road
Alpine Road
San Mateo County
Santa Cruz County

0 25 50 Miles

The Midpeninsula Regional Open Space District dedicates this book to the people and the communities it serves—to those who appreciate and enjoy the lush acres of grassy meadows, forested hills, and rich baylands that make up this great heritage of the San Francisco Peninsula, and to those who continue to support the mission and vision to permanently protect these open space lands that provide a scenic backdrop to our cities. It is also dedicated to the wild things that inhabit these special places and captivate us each time we are lucky enough to catch even the briefest glimpse of them.

Preface

A Welcome from the Midpeninsula Regional Open Space District

Steve Abbors, General Manager

One of the most recognizable features of the Bay Area landscape is the uninterrupted tree-studded skyline of the Santa Cruz Mountains stretching from San Mateo to the south beyond Los Gatos. The area's unique temperate rainforests, dominated by magnificent coast redwoods and Douglas fir, create a defining panorama against the sky.

Back in 1971, about the same time I began my career in parks and open space, a group of visionaries living on the Peninsula found a way to preserve that magnificent skyline to ensure that any of us, gazing upwards, would forever see forested slopes rather than home-dotted hills. On November 7, 1972, the voters passed Measure R, creating the Midpeninsula Regional Park District, later renamed the Midpeninsula Regional Open Space District. It is a single-purpose, independent, special District with a board of seven elected directors dedicated to preserving land and protecting the natural environment for the public. Forty years after that election, the reality that has grown from the initial vision far surpasses the dreams of its founders.

When I came to the District in 2008, I found a board of directors and staff that are creative, collaborative, and totally dedicated to the District's mission. I found partners in state, regional, county, and city government, and in the private

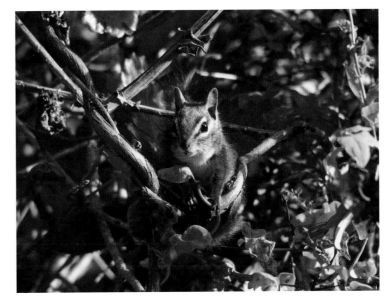

Steve Abbors, *Merriam's Chipmunk,* Rancho San Antonio Open Space Preserve, 2010

sector, particularly the land trusts that are eager to share energy, knowledge, and resources to complete a vision of a whole functioning landscape stretching across three counties and beyond. Most importantly, I found a generous public with deep environmental roots.

We are now more than a generation removed from the District's beginnings, and still it is the public that gives the District meaning and validation. So it is fitting that this fortieth-anniversary book, *Room to Breathe,* is an expression of the deep love and respect that you, the public, have for the land and the wonderful life-forms inseparably bound to it. Turning these pages, we see these more personal visions expressed in the photographs, paintings, and poems that many of you have shared because you treasure some part of this incredible landscape.

Let us consider this volume an invitation to connect with this special part of the planet that sustains us now, as it has over the millennia. And in so doing, let it rekindle the passion in each of us to watch over and protect these special places for the generations that follow.

Foreword

Ken Fisher

When I was a boy, in a world now long gone, it took no more than thirty minutes to walk from my parents' San Mateo home, hitch three rides, and be on top of northern Skyline Boulevard. When I could, I did. It was this child's fantasy land. In the mid-1960s, I could drive my 1942 Willys Jeep on roads like Purisima Creek Road, which was then a through public dirt road, and streak off on tangents, wherever.

Brock's Kings Mountain Inn still existed—great burgers. Today's Mountain House restaurant was then the King's Rendezvous—and redneck. Guns blasted in the distance. Bullets whizzed in the woods nearby. Remains of buildings built long before, but now long gone, offered glimmers of ghost town life. The Hells Angels liked to party at what I would later learn was the former site of the 1870s Borden and Hatch mill. On weekend nights, the west entrance to what is now the Purisima Creek Redwoods Open Space Preserve (Purisima), and a bit east, was chock-a-block with Half Moon Bay High School kids drinking beer and partying in what they called "Hatch's Woods." John Wickett, the son of a wealthy New York life insurance executive, who backed him in buying timberland, owned it, including the original Purisima Preserve land purchase and all of what is today El Corte de Madera Creek Open Space Preserve. At the time, I didn't have a clue who owned it. Logging, long dormant, was newly reborn in the area with John Wickett operating a small mill on his land. Much, I didn't understand—but all was fascinating!

I traversed many other properties and mostly didn't know who owned them. All wild, wide open—and you could just get lost, seemingly forever. I explored, collected (wildflowers, skulls, bones, you name it), camped, and lived a life not accepted today. I could walk down Skyline Boulevard with a .22—no one would think a thing about it. A world long gone! I couldn't fathom—didn't have a clue—that this wonderful world couldn't possibly withstand the forces soon to mount as the Bay Area expanded and modernized.

My life motivated me to forestry school, and then to economics. I returned, married with child, and moved permanently to Skyline. It was 1972, the year the Midpeninsula Regional Open Space District (MROSD) was created, before it expanded to San Mateo County in 1976. The world had changed by then. Hitchhiking? Not safely! When a bullet first whizzed past my wife and son in Purisima, life felt different. The economics, I then fathomed, had changed drastically. These vast wild properties couldn't be maintained in private hands without development unless by the largess of the few and far between uber-rich—who mostly weren't preoccupied with skulls and weird oddities.

Locals feared the District, eminent domain, Big Brotherism, and remote rule. They feared everything would be bought up

and merged into some macro-park, and they would be forced from the woods they loved. While the District used eminent domain a few times, including against me, it evolved its approach to an ever lighter touch and created a good-neighbor policy. It was the land inflation of the 1970s that motivated most old-timers to sell—at, to them, outrageously high prices—and move to cheaper, more remote living out of state.

Times evolved. Soon my sons tagged along as I, with adult capabilities, explored mill sites and much more. Mostly off trail, we used metal detectors and dug. When my middle son, Nathan, uncovered a 260-pound, 60-inch belt-wheel core in Corte Madera Creek at the 1860s Taylor mill site, well, his beaming smile might have made you presume he had discovered Bigfoot's bones. Great times! In the course of my ramblings on today's District land, I found Native American shellmounds and the world's officially twistiest redwood, a 212-foot-tall, 12-foot-diameter giant whose spine does six full twists from ground to crown. In the upper Soda Gulch area of Purisima, I saw the most spectacular ancient trees! I laser-measured all of the District's tallest trees as a baseline for the future.

Eventually I became seen as the scholarly historian of Kings Mountain—an unincorporated community located along Skyline Boulevard—simply by putting its story together for the first time from archival materials and through just rooting around. Much of that involved District lands. Craig Britton, then head of land acquisition and later general manager of the District, came to be a friend and ally after we got off to a rocky start because my first interaction with the District was through the eminent domain issue mentioned above. From that experience we came to know each other. He appreciated and recognized the value of my history. I've explored on District land, and what I've found, I've catalogued, including thousands of artifacts and more than twenty pre-1920 lumber mill sites! Two, I don't believe anyone but me has ever seen in modern times. And cabin sites. It was all a thrill. My role has been to care for them until whenever the District might want them back. Craig knew it was better if I carefully extracted pieces in the right manner than if looky-loos hauled artifacts away pell-mell, losing them and their associated history forever.

In 1988, I bought the only in-holding in the Purisima Preserve. The seller had a long pre-existent, formal recorded option on adjacent District land, which I exercised against dedicated open space—and Craig honored it, to the amazement of locals, a demonstration of the District's lighter touch. In 1990, I bought commercially zoned land next to the northern Purisima parking lot and initiated plans for my now corporate headquarters, which houses 180 employees. Craig was supportive because the District was a good neighbor and he knew having a good neighbor was good too. The District has always been a great neighbor, never unreasonable or irrational, or even cranky.

In my fifty years around District lands, I've seen wonders. You will see many here. Purisima remains my favorite. Its former mill sites still haunt me. I still haunt them. It contains the edges of a ghost town and hears daily coyote cries. This wonderland I loved as a boy, bought by the District, to me is a gift. I get full access, yet it's protected from the development forces that would have destroyed it as I returned from university. Each preserve is special in its own way. But they're for you, me, and those who adore the woods—and those who want to experience them for the first time. Thank the Lord. And thank the District's founders and first general manager, Herb Grench.

Acknowledgments

"It takes many pieces to make one whole." This was certainly true for the production of *Room to Breathe*. We deeply thank all of the photographers, artists, and poets whose vision so brilliantly captures the seasonal beauty, unique features, and symbolism of the natural open space lands. All of them have enabled this artistic collection to come to life as the centerpiece of the District's celebration of its first forty years of preserving open space. Many thanks also go to the authors of the quotations featured in the book, and to Carole Norton for her timeless sentiments expressed in the Measure R campaign materials, which are featured in the Introduction and have provided inspiration for the title of this book.

We are honored to have local resident and Kings Mountain area historian Ken Fisher share in the Foreword for *Room to Breathe* his personal experiences in and connection with the Purisima Creek Redwoods and El Corte de Madera Creek Open Space Preserves. Ken was the ideal person to author the Foreword, in which he tells the story of his association with the District, offers a unique viewpoint as shared through his explorations and discoveries, and includes fascinating cultural and historical information about the area. The piece is a wonderful complement to the book's theme of meaning and importance of open space.

Thanks go to the board of directors' book committee, which helped define and shape the project and aided with content selection. Steve Abbors, Rudy Jurgensen, Renée Fitzsimons, and Kristi Britt also contributed to content selection and editing; Casey Hiatt, Alex Roa, and Deborah Mills produced the featured area map; Veronica Davis obtained permission requests; and Vicky Gou provided photography-related support. Special thanks also go to Kristi Britt, who authored many sections of the book, including the Dedication, Introduction, and Epilogue, as well as managed a significant portion of the project.

Of course, this book would never have been produced had it not been for the determined efforts of local conservationists whose vision, energy, courage, and perseverance cleared the path, with the support of wise Santa Clara and San Mateo County residents, for the creation of the Midpeninsula Regional Open Space District. Our heartfelt thanks are expressed to the board of directors and staff, and to the volunteers, docents, and supporters who've given their time, talents, and donations so that the Midpeninsula Regional Open Space District can realize its mission.

Introduction

Kristi Britt

What is "open space?" In 1972, the Measure R campaign, which founded the Midpeninsula Regional Park District, illustrated it this way: "Open space is our green backdrop of hills. It is rolling grasslands, cool forests in the Coast Range, orchards and vineyards in the sun. It is the patch of grass between communities where children can run. It is uncluttered baylands where water birds wheel and soar, where blowing cordgrass yields its blessings of oxygen, where the din of urban life gives way to the soft sounds of nature. It is the serene, unbuilt, unspoiled earth that awakens all our senses and makes us whole again… it is room to breathe." Even forty years later, these words still remain relevant and true.

Open space, joined together in a hued pattern of gold, yellow, brown, rust, gray, blue, and purple, creates a patchwork quilt—an intricate greenbelt of foothills and baylands. This greenbelt provides a backdrop for the densely urbanized region of Northern California's San Francisco Bay Area, where open space connects with other tracts of undeveloped land to provide unspoiled wilderness, wildlife habitat and migration corridors, native seed banks, watersheds, and magnificent views.

There are plenty of numbers that tell the story of the Midpeninsula Regional Open Space District and its success in land protection, most notably: sixty thousand acres saved within the agency's 550-square-mile boundary, which encompasses northwestern Santa Clara County, southern San Mateo County, and the San Mateo County coastside, as well as a small portion of Santa Cruz County. Taxpayers have invested a small share of the annual total property tax revenues in the purchase and care of twenty-six open space preserves that are filled with redwood and mixed evergreen forests, oak woodlands, grasslands, chaparral, and salt marsh, and offer 220 miles of trails for hiking, biking, and equestrian use, and for walking your dog on leash.

But numbers tell only half of the story because open space is about the connection between people and nature, offering resources for education, recreation, and renewal of spirit, affording a respite from urban living, enhancing our quality of life, and providing opportunities for appreciation of the natural world.

Room to Breathe is about the way open space feels to the people who spend time in it. There is something about our natural environment that awakens the senses and captures the imagination, and you can experience this in the photos, paintings, and poems collected here, all created by local residents based on what they have experienced on open space preserves.

Through this book, we join the public we serve, and their communities, in a celebration of our open space. The meaning and importance of open space is intimately expressed by those whose work appears in these pages. We hope you will be inspired to support future land preservation and management efforts and to enjoy the beauty of open space, as each visit to a preserve—with changing time, locations, weather, and seasons—provides you with a new perspective and a new experience.

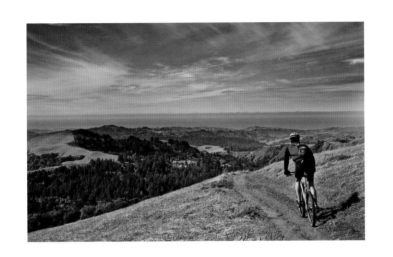

Is There Anything,

that sings
like the wind,
blowing leaf by leaf
down the long road home
as the seasons change
 —Breeze Momar

Karl Gohl, *Open Space Ride,* Russian Ridge Open Space Preserve, 2009

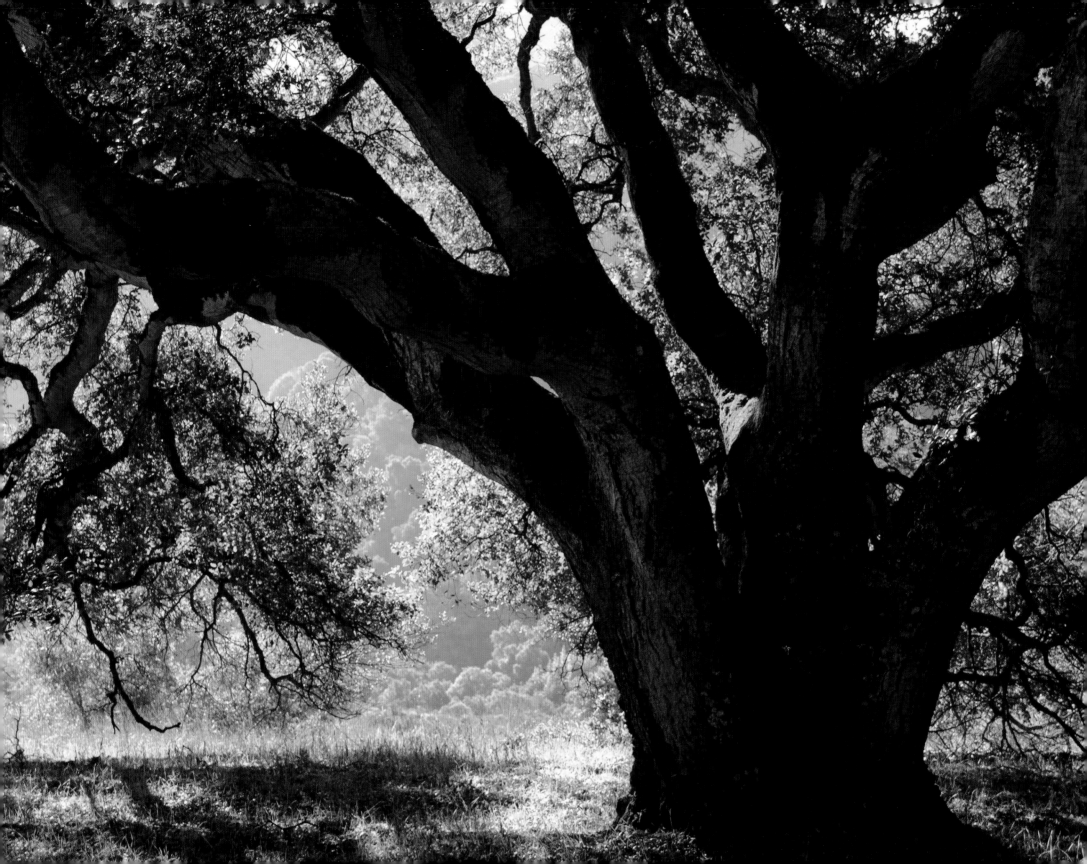

What is such a resource worth? Anything it costs. If we never hike it or step into its shade, if we only drive by occasionally and see the textures of green mountainside change under wind and sun, or the fog move soft feathers down the gulches, or the last sunset on the continent redden the sky beyond the ridge, we have our money's worth. We have been too efficient at destruction; we have left our souls too little space to breathe in. Every green natural place we save saves a fragment of our sanity and gives us a little more hope that we have a future.—Wallace Stegner

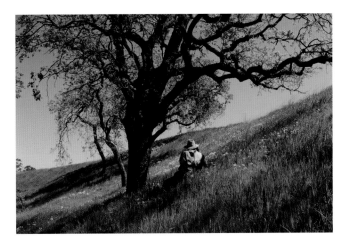

ABOVE: Sue Copeland, *Springtime,* Rancho San Antonio Open Space Preserve, 2009

FAR LEFT: Henri Lamiraux, *Oak Tree,* Pulgas Ridge Open Space Preserve, 2004

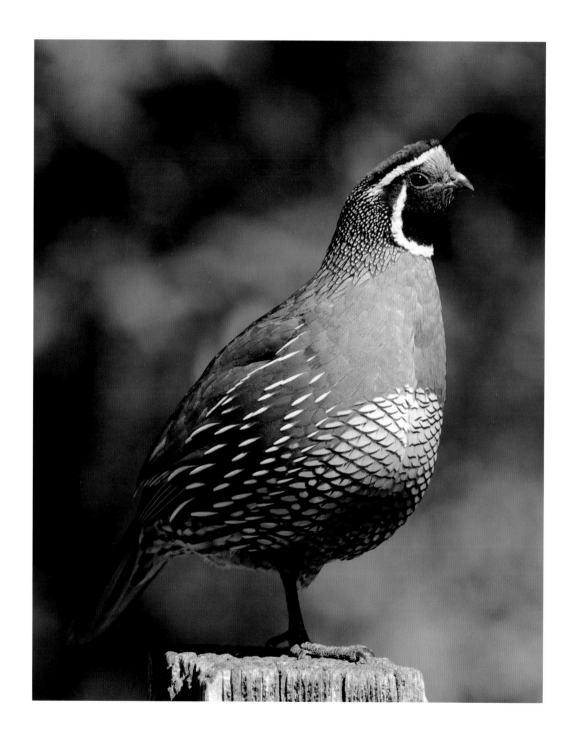

We don't inherit the earth from our ancestors, we borrow it from our children.
—Proverb

LEFT: John Kesselring, *Male California Quail*, Rancho San Antonio Open Space Preserve, 2010

RIGHT: Paul Jossi, *No Path Trail*, Windy Hill Open Space Preserve, date unknown, oil painting

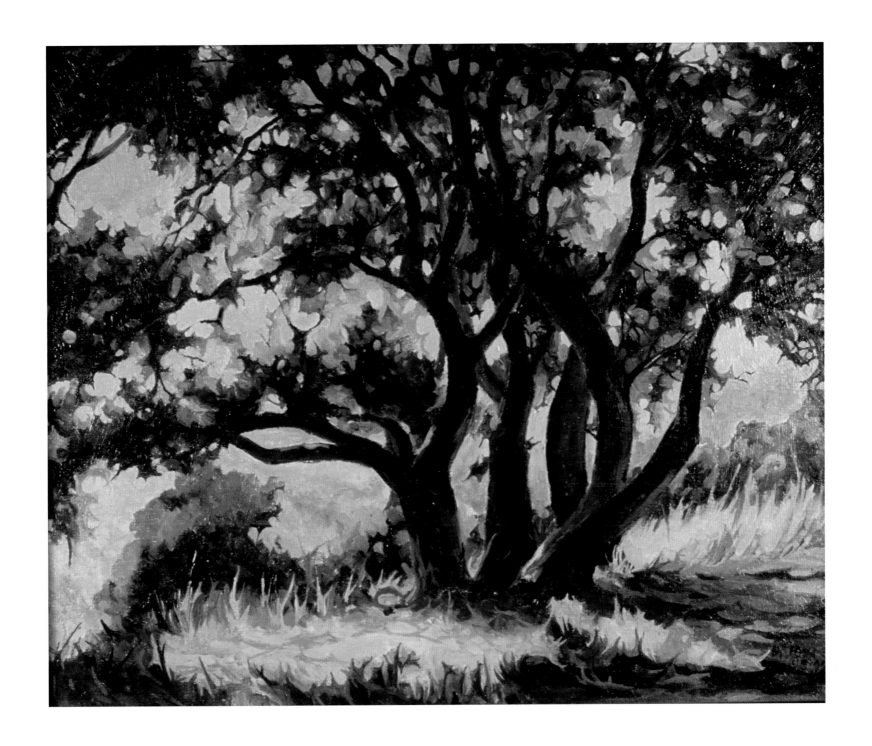

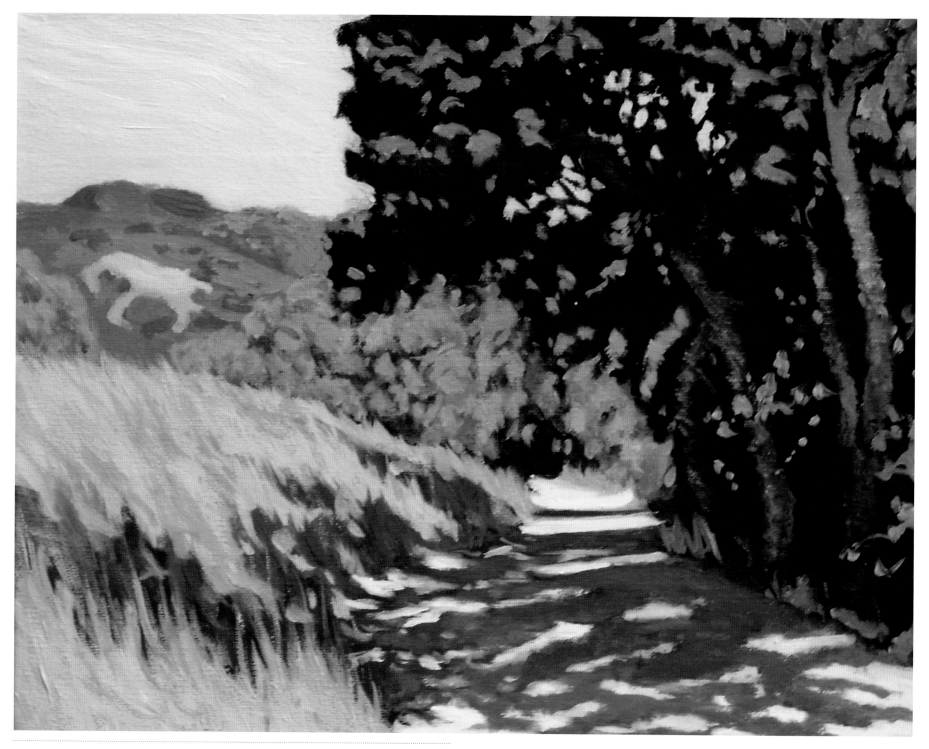

Nina J. Hyatt, *Windy Hill Oak Shadows,* Windy Hill Open Space Preserve, 2010, acrylic painting

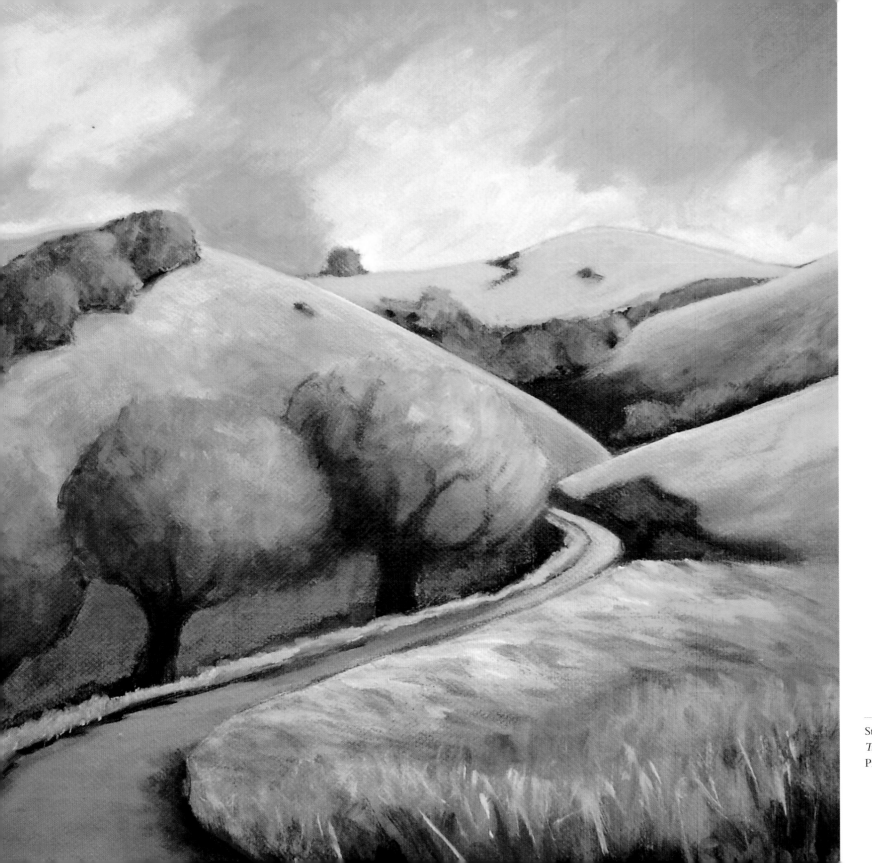

Stephanie Maclean, *Bella Vista Trail,* Monte Bello Open Space Preserve, 2009, acrylic on canvas

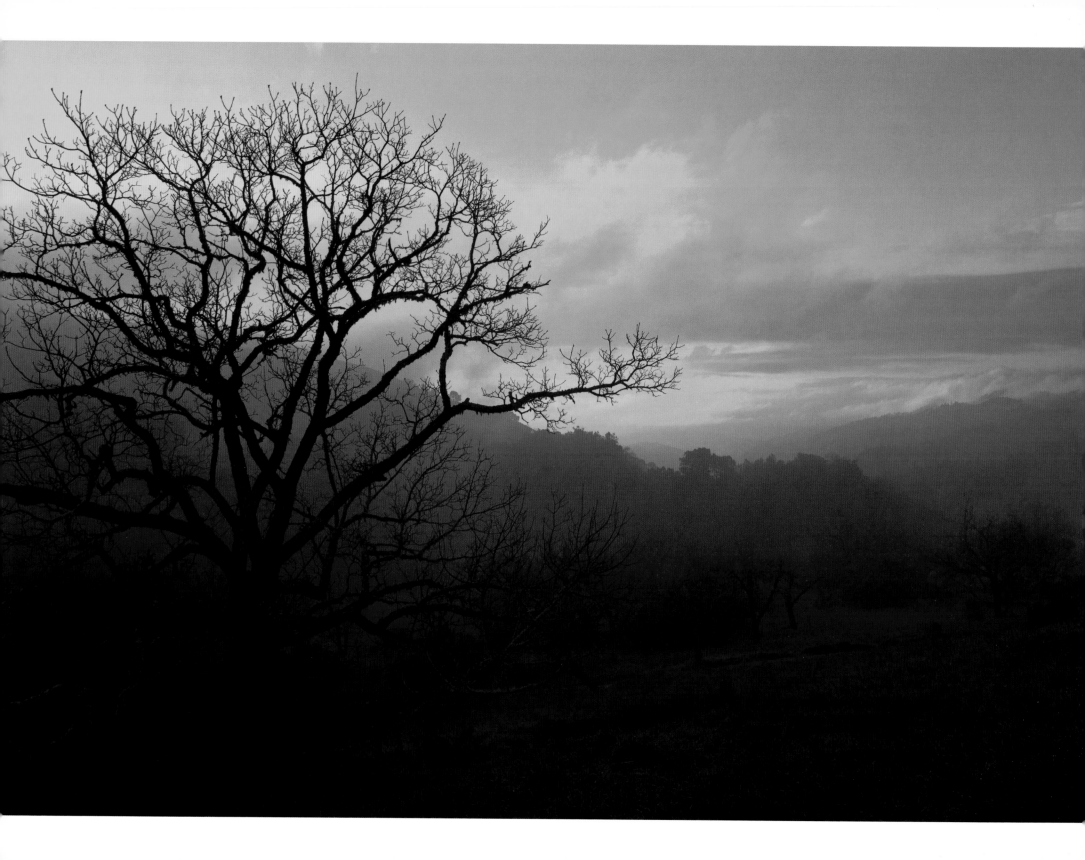

In California in the early spring
there are pale yellow mornings
when the mist burns slowly into day.
The air stings
like autumn, clarifies
like pain.
Well, I have dreamed this coast myself.
—Robert Hass

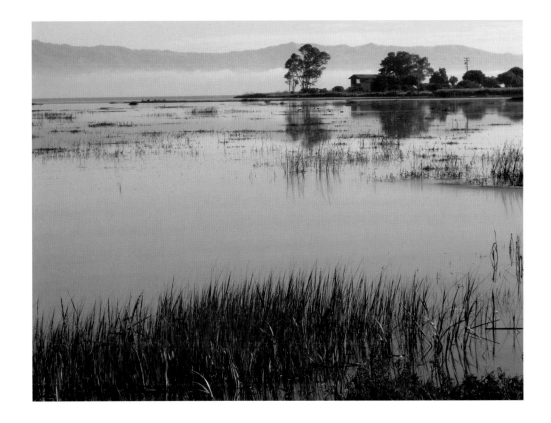

LEFT: Karl Gohl, *Sunrise on Old Orchard,*
Monte Bello Open Space Preserve, 2007

RIGHT: Anna George, *January Morning,*
Ravenswood Open Space Preserve, 2011

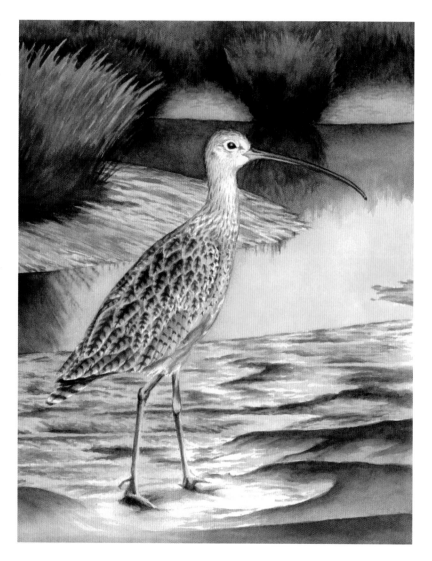

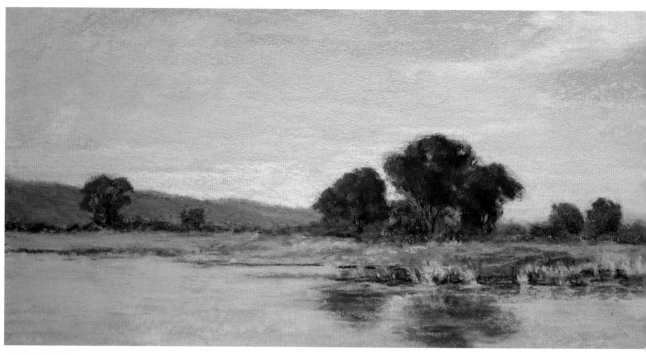

ABOVE: Timon Sloane, *Orange Wetlands,* Stevens
Creek Shoreline Nature Study Area, 2010

LEFT: John Richards, *Curlew,* 2010, watercolor

RIGHT: Susan Migliore, *First Vista,* St. Joseph's
Hill Open Space Preserve, 2010, oil painting

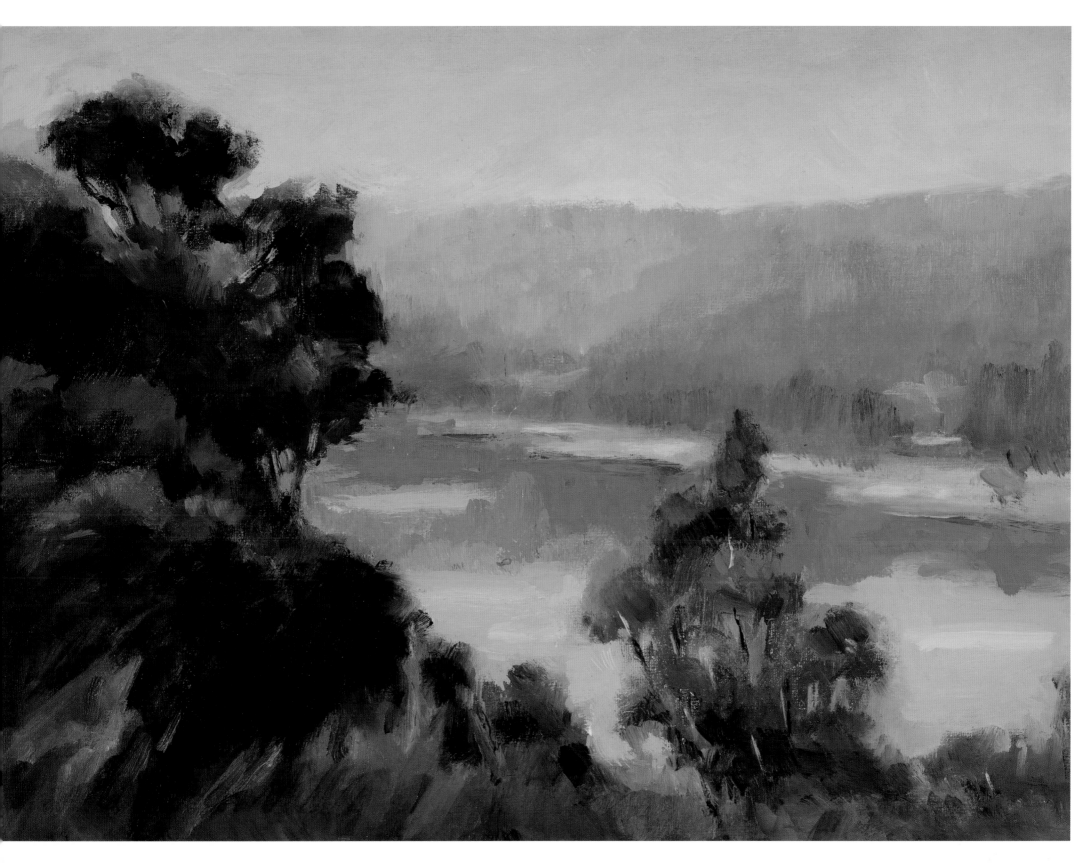

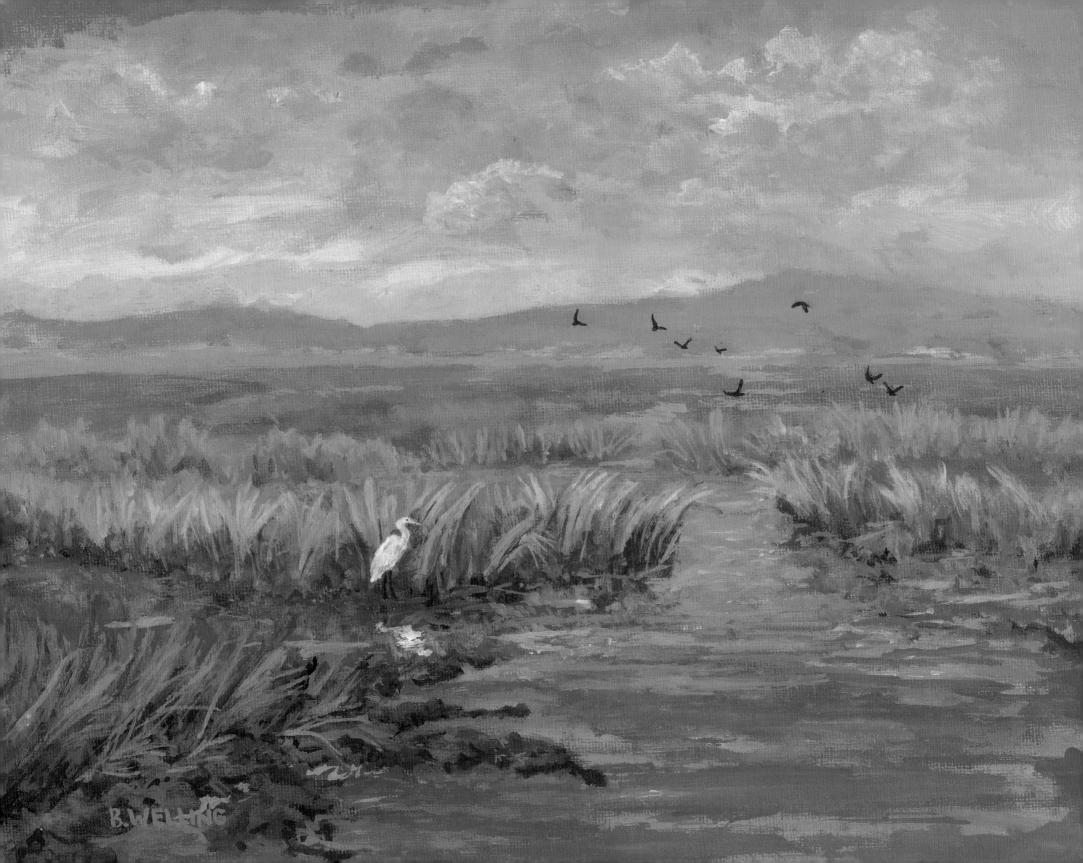

If you truly love nature,
you will find beauty everywhere.
—Vincent van Gogh

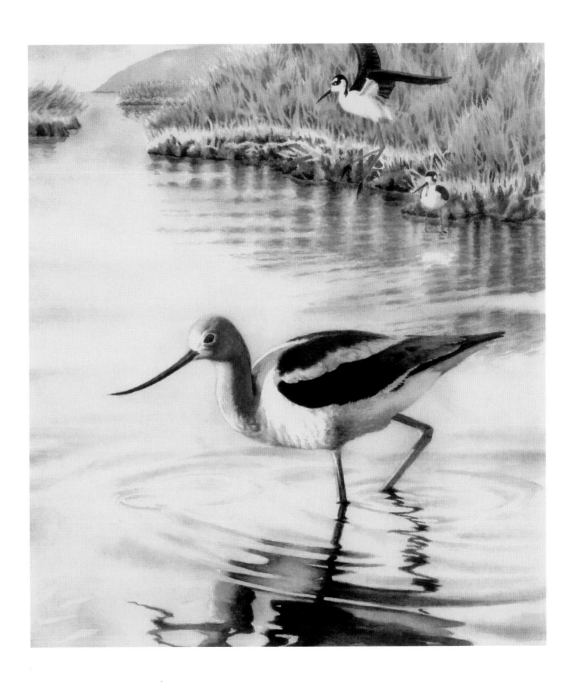

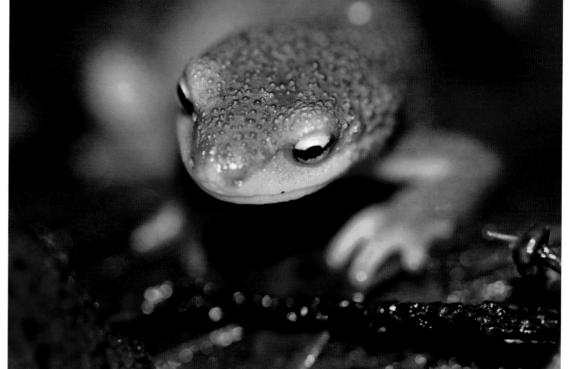

TOP RIGHT: Nikki Weidner, *The Three Amigos,* Stevens Creek Shoreline Nature Study Area, 2010

RIGHT: Brian Bucher, *California Newt,* Rancho San Antonio Open Space Preserve, 2010

FAR RIGHT: Susan Migliore, *Walk in the Marsh,* Ravenswood Open Space Preserve, 2010, oil painting

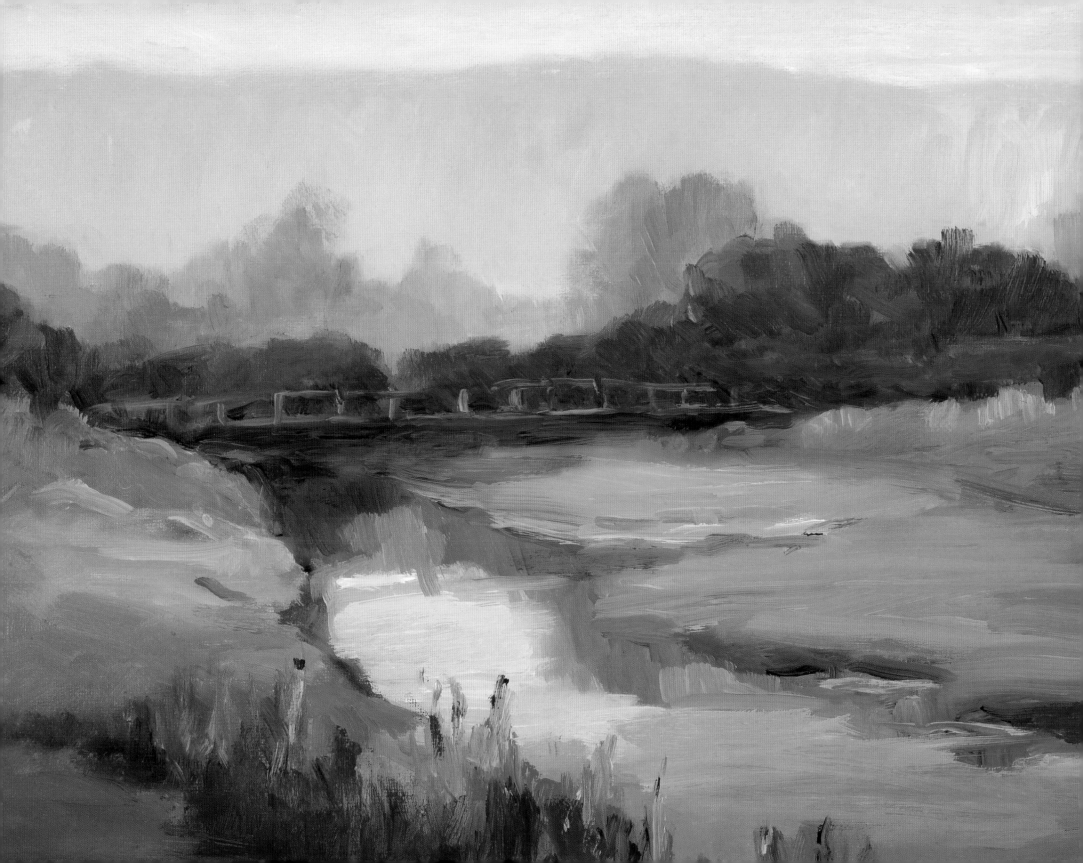

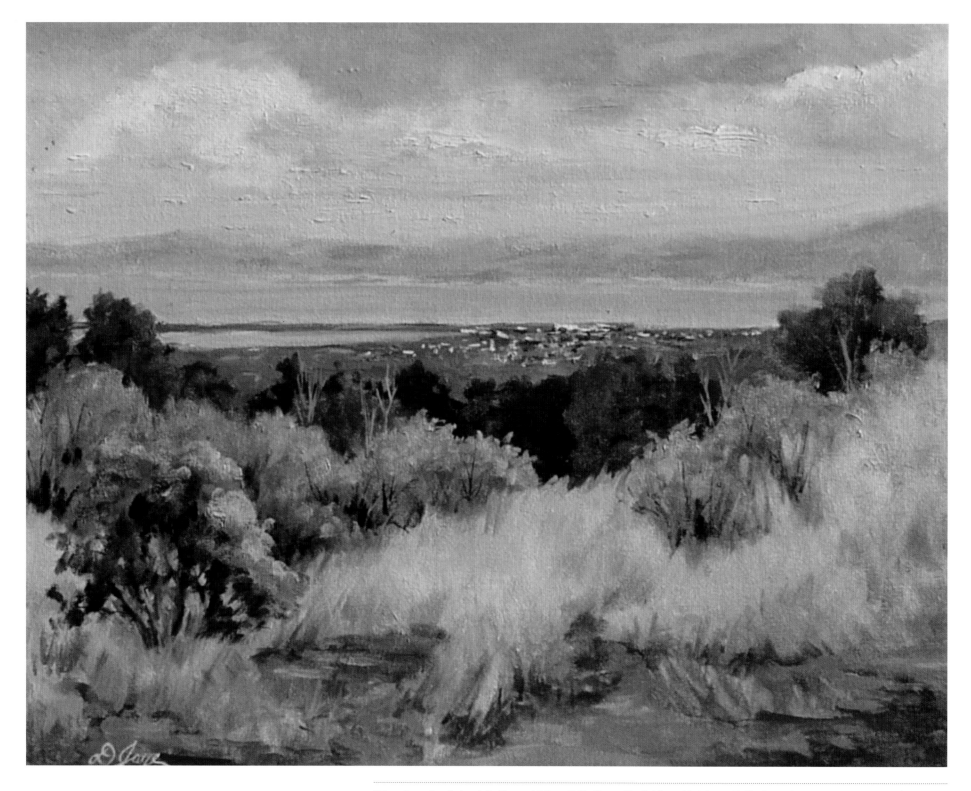

Diana Jaye, *Stanford and the Bay* and *Monte Bello Coyote Brush* (diptych), Monte Bello Open Space Preserve, 2007, oil paintings

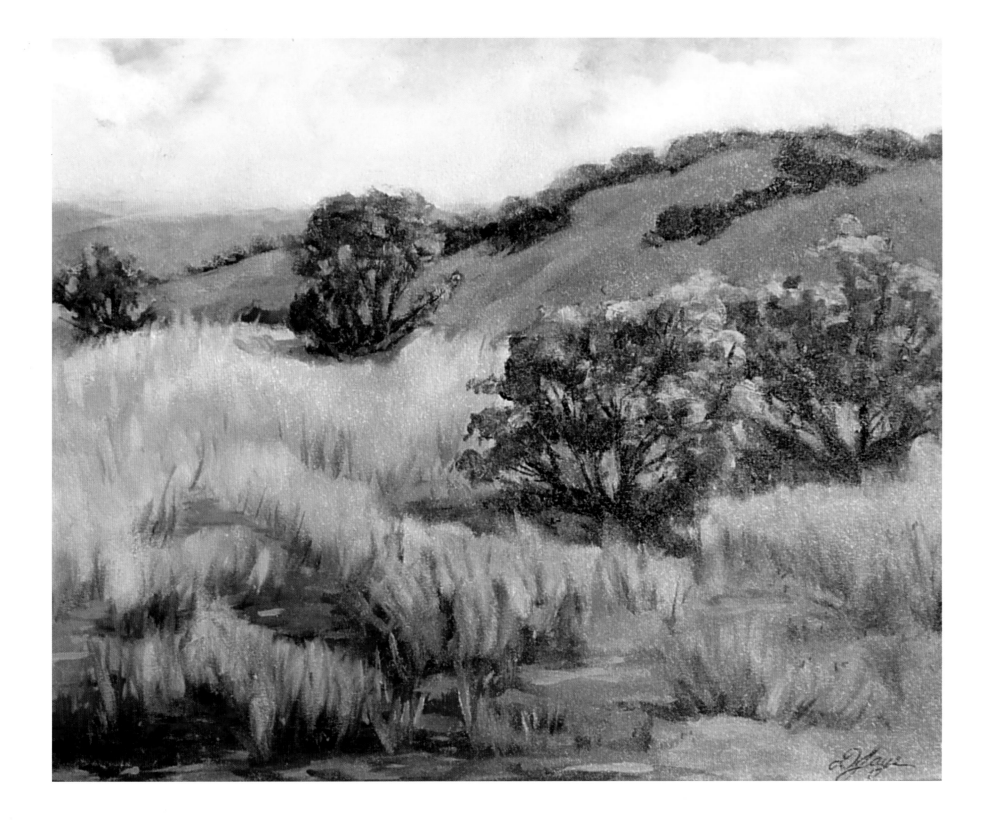

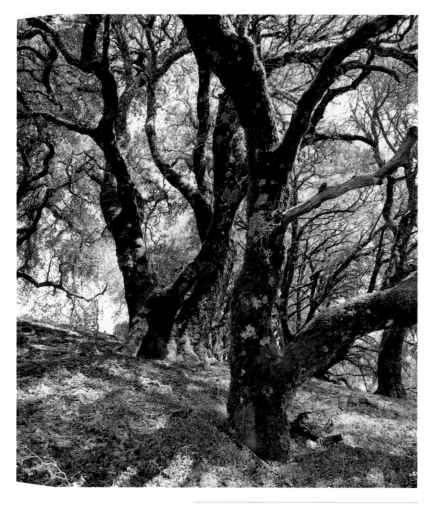

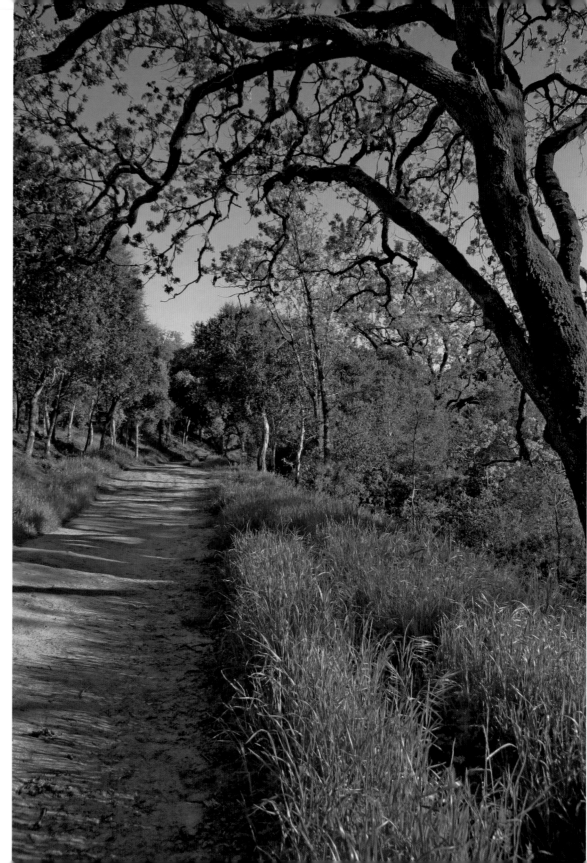

ABOVE: Deane Little, *Oak Knoll, Long Ridge,* Long Ridge Open Space Preserve, 2006

RIGHT: Susan Stienstra, *Trail of Beauty,* Windy Hill Open Space Preserve, 2010

FAR RIGHT: Paul Jossi, *Legacy,* Russian Ridge Open Space Preserve, date unknown, watercolor

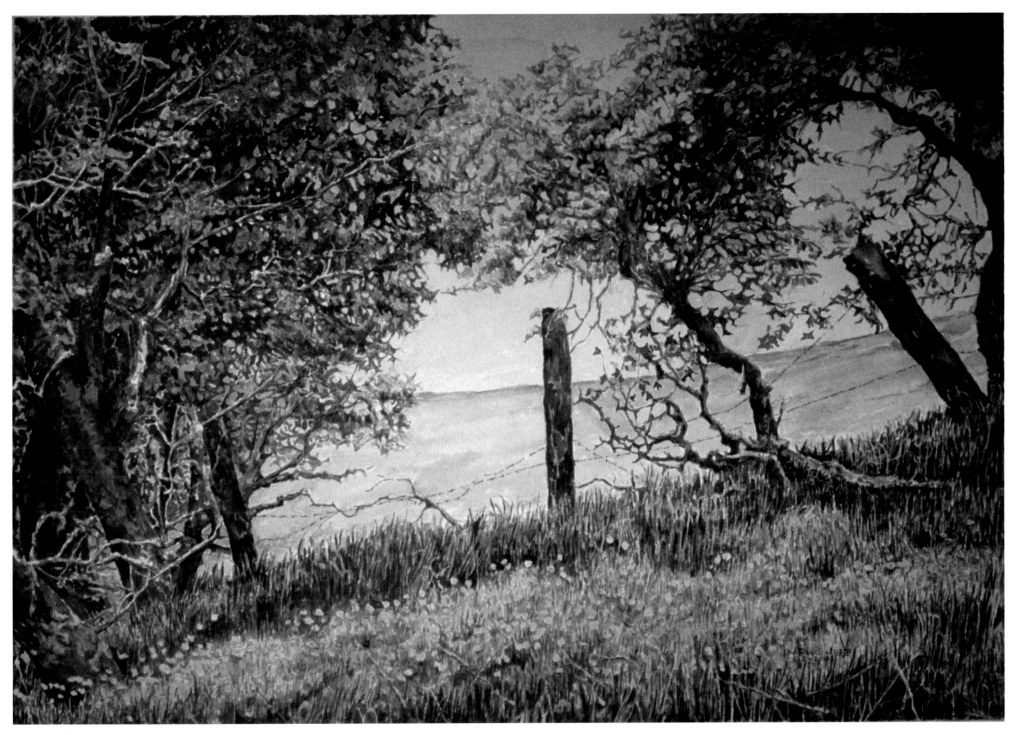

If nothing ever changed there would be no butterflies. —Unknown

TOP LEFT: Strether Smith, *Swallowtail and Checkerspot*, Monte Bello Open Space Preserve, 2007

MIDDLE LEFT: Frances Freyberg Blackburn, *Variable Checkerspot Butterfly*, Purisima Creek Redwoods Open Space Preserve, 2009

BOTTOM LEFT: Judy Kramer, *Mule Ears*, Russian Ridge Open Space Preserve, 2007

RIGHT: Vaibhav Tripathi, *Wildflowers Dance on a Windy Evening at Sunset*, Russian Ridge Open Space Preserve, 2010

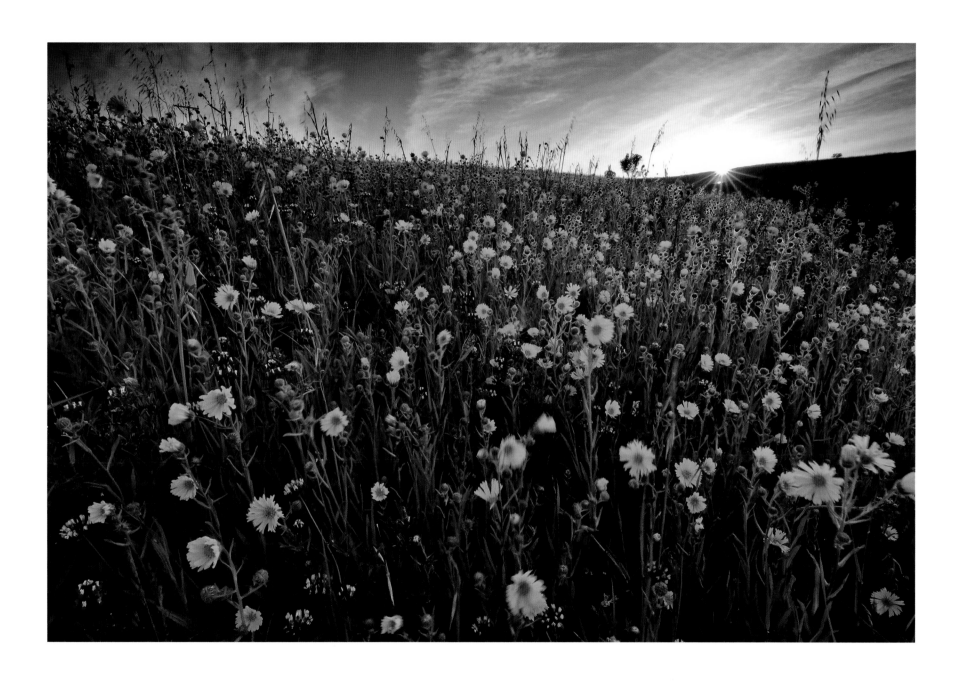

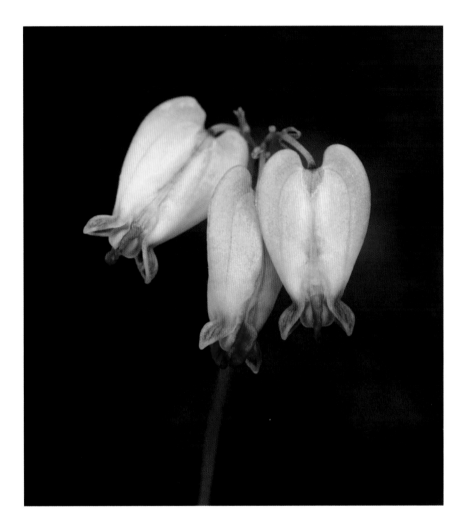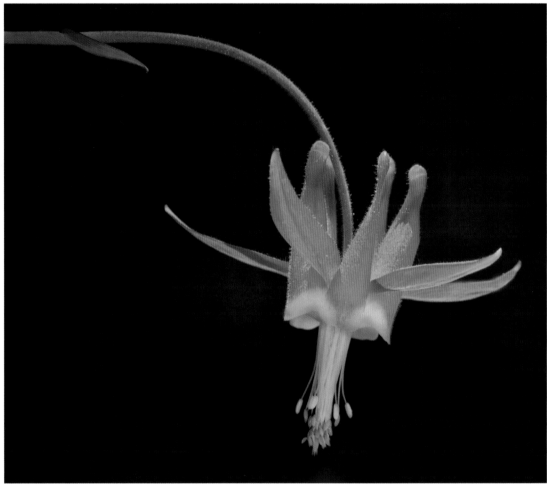

And the day came when the risk to remain tight in a bud was more painful than the risk it took to blossom. —Anaïs Nin

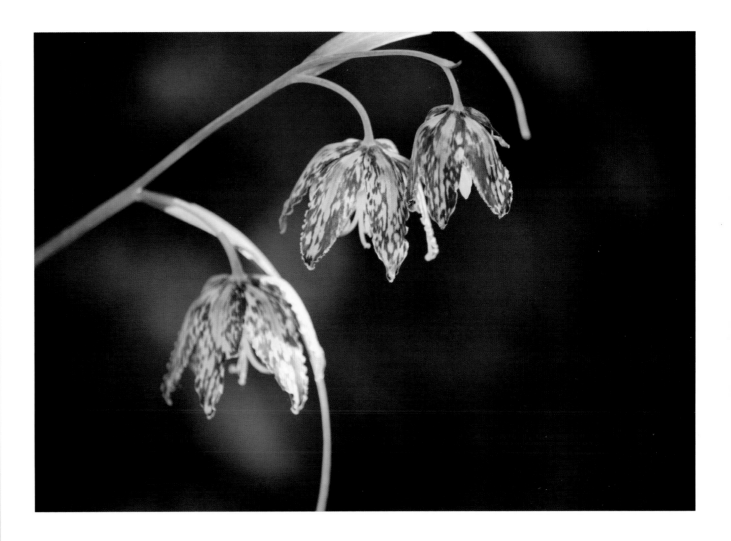

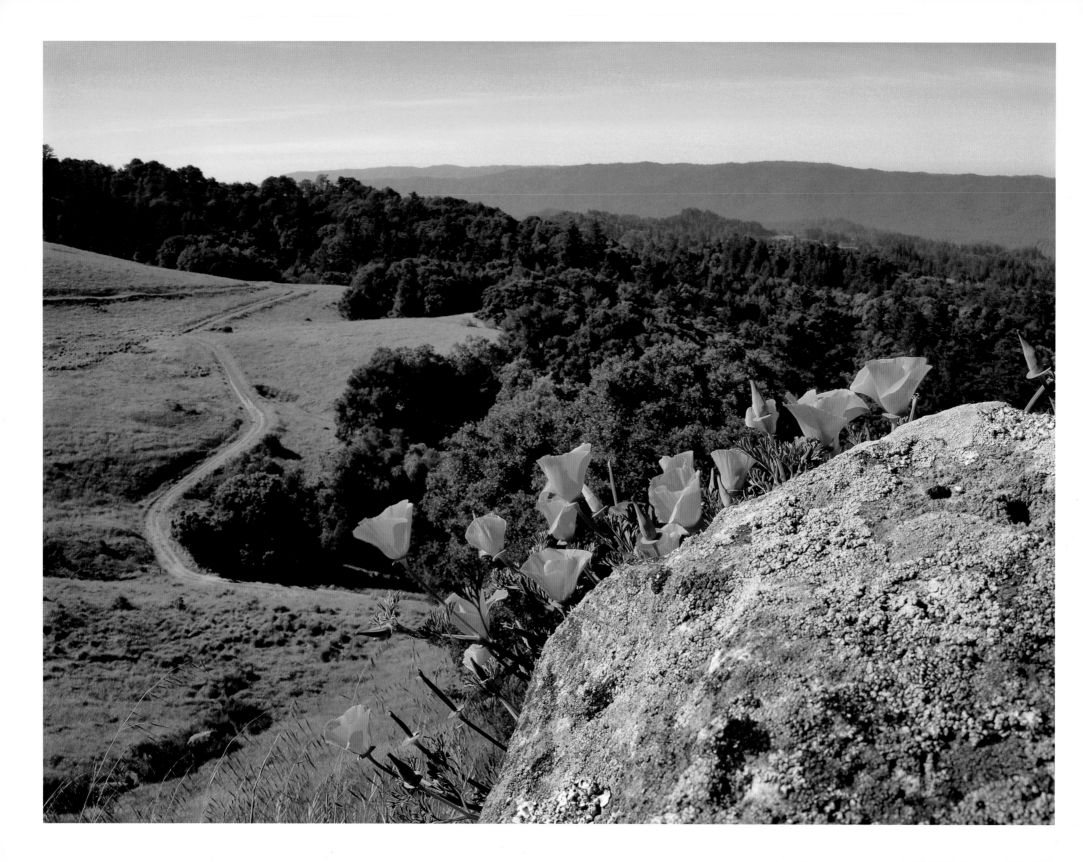

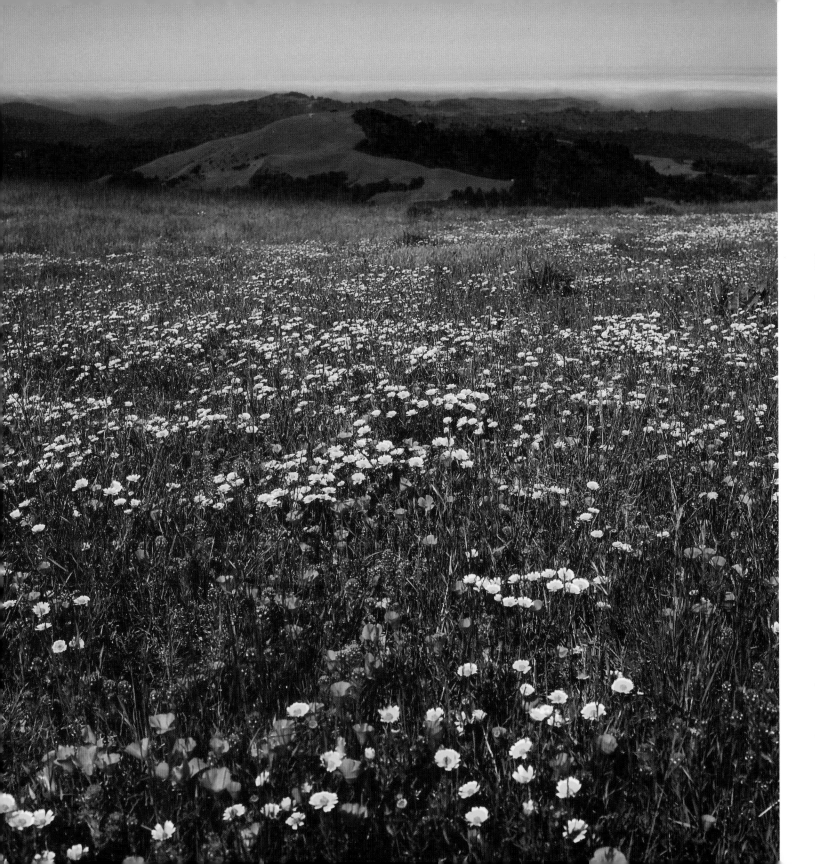

Earth laughs in flowers...
—Ralph Waldo Emerson

LEFT: Darwin Poulos, *Flowers and Mindego Hill,*
Russian Ridge Open Space Preserve, 2000

FAR LEFT: Deane Little, *Rock and Poppies,*
Russian Ridge Open Space Preserve, 2006

25

The pleasures of spring are available to everybody, and cost nothing.—George Orwell

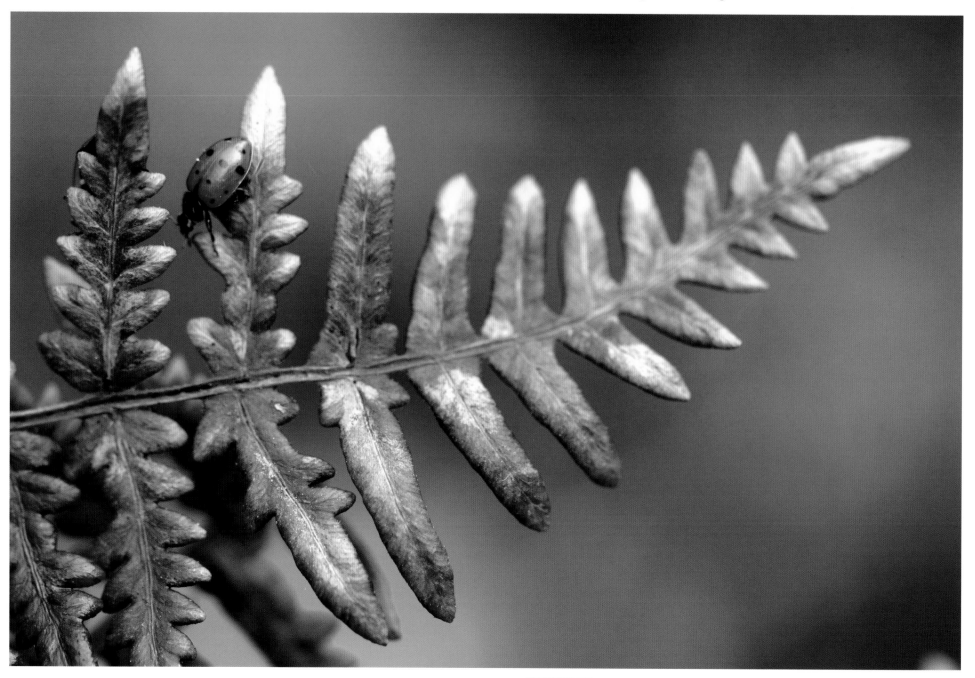

ABOVE: Paul Huang, *Ladybug and Fern*, Purisima Creek Redwoods Open Space Preserve, 2004

RIGHT: Kay Duffy, *Apple Orchard*, Saratoga Gap Open Space Preserve, 2006, watercolor

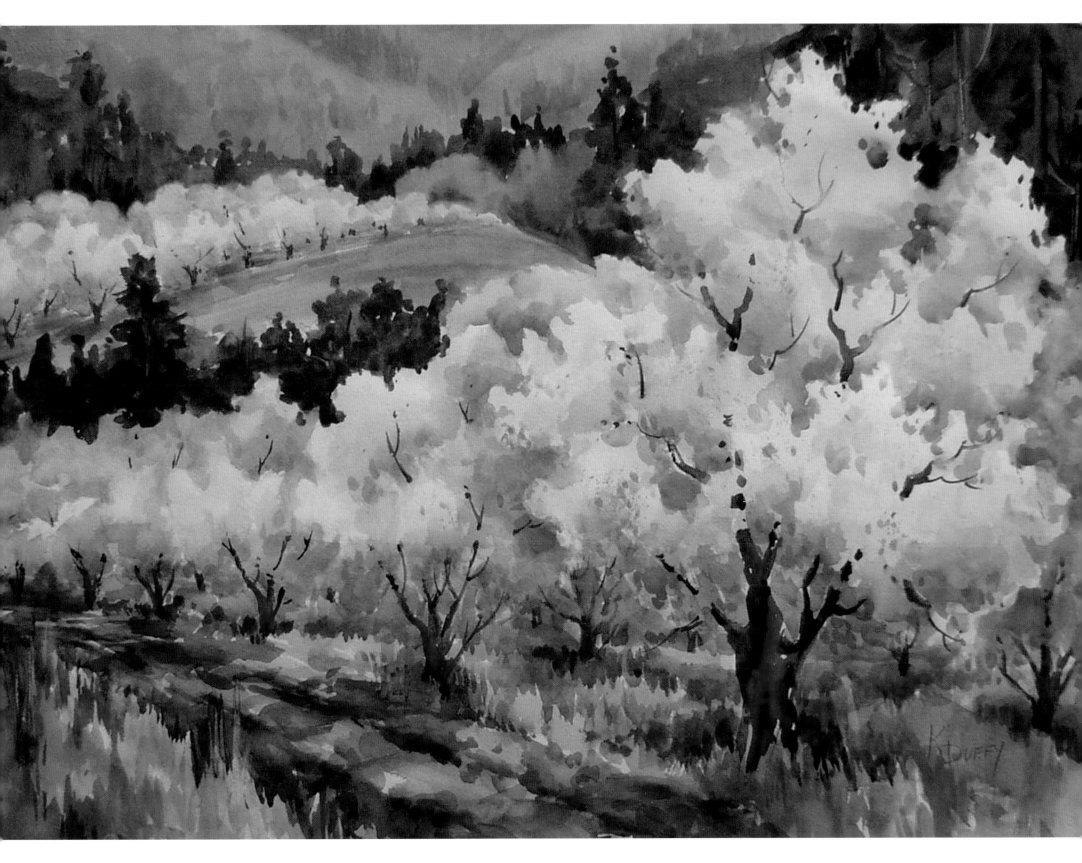

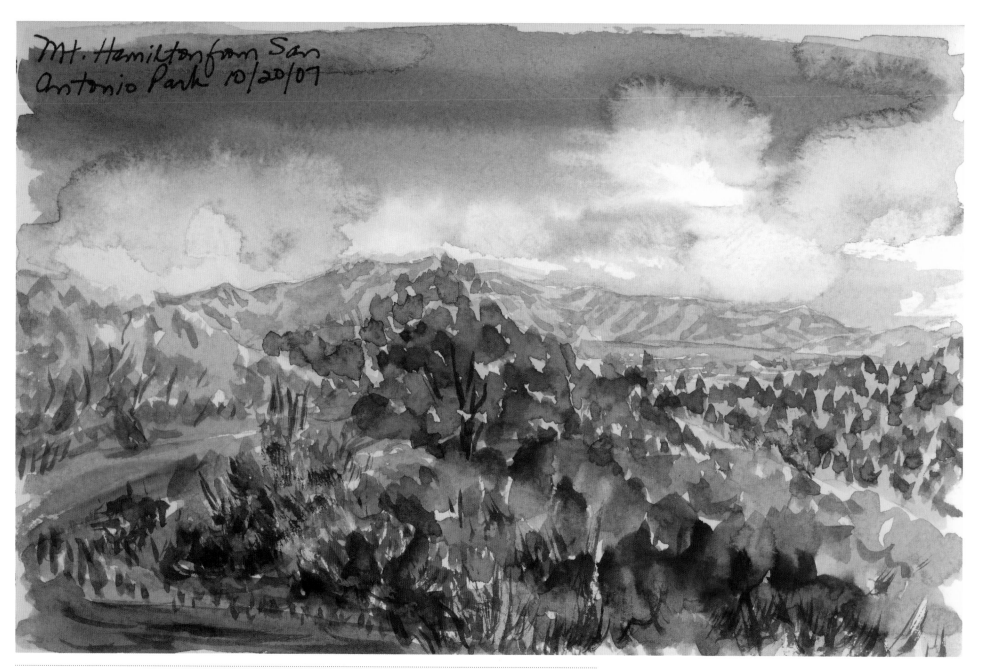

Nancy Hancock Williams, *Mt. Hamilton from Rancho San Antonio,* Rancho San Antonio Open Space Preserve, 2007, watercolor

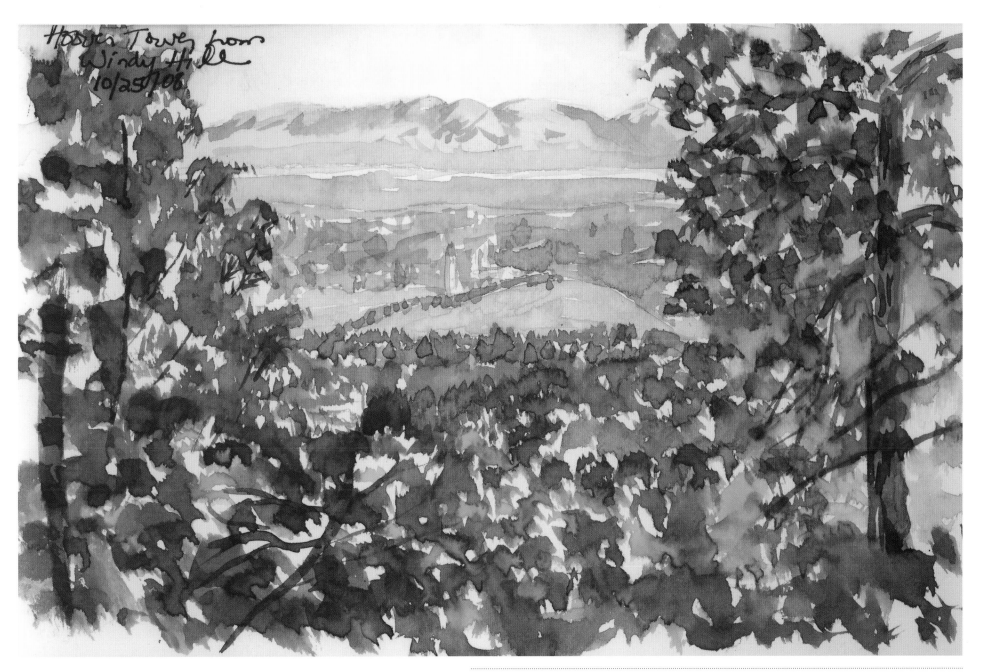

Nancy Hancock Williams, *Hoover Tower from Windy Hill*, Windy Hill Open Space Preserve, 2008, watercolor

from "Foothill Trail, Late February"

Hiking through foothill chaparral
 I pass a thicket of chamise.
 Hidden among russet stems, a wrentit

pipes its haunting trill. As the trail
 narrows, my sleeves rub against brush
 silver-gray like the sky; sage oils spice the air.

A drone of bees draws me
 to manzanita in early bloom,
 tiny pale urns with the Spanish

promise of "little apples." Ahead, spreading
 crowns of live oak, heavy-limbed bay laurel.
 A doe with twin fawns—glimpsed—gone.

I pause before the woodland; clouds
 spill over the Santa Cruz Mountains
 like white spray erasing waves of green ridges.

—Pearl Karrer

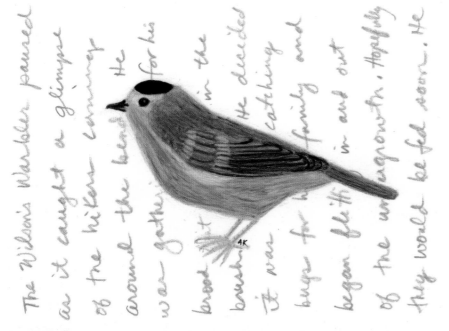

ABOVE LEFT: Hazel Holby, *Wrentit,* Windy Hill
Open Space Preserve, 2009

LEFT: Amanda Krauss, *Wilson's Warbler,* Purisima
Creek Redwoods Open Space Preserve, 2010,
colored pencil drawing on paper

FAR LEFT: Diana Jaye, *Skyline Ridge,* Skyline
Ridge Open Space Preserve, 2008, oil painting

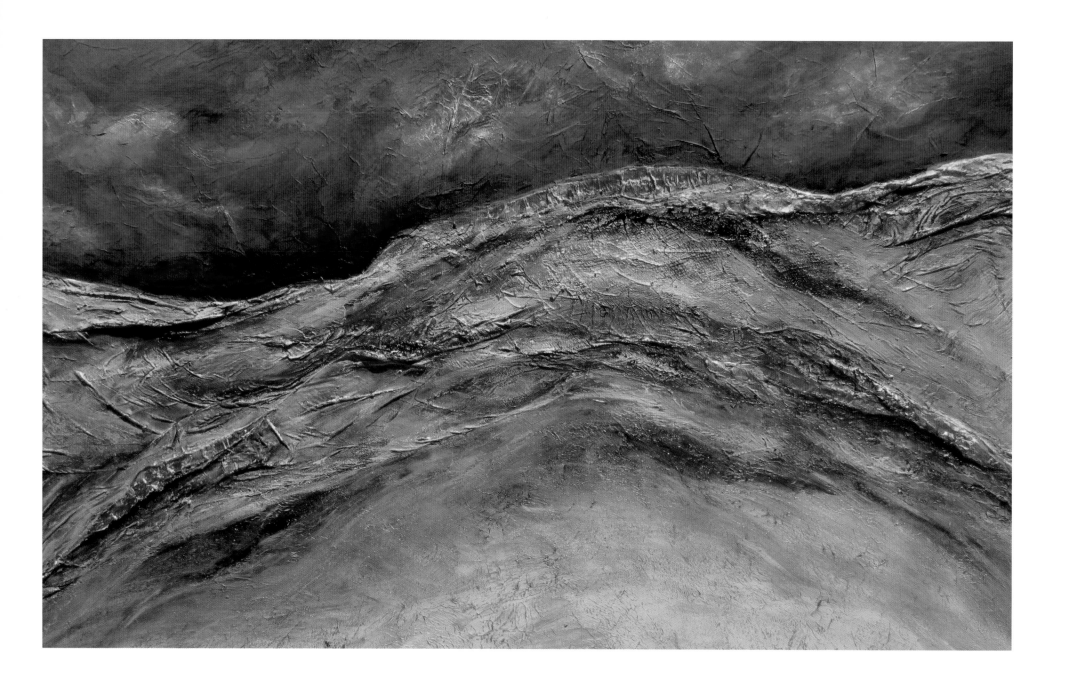

May all your trails be crooked, winding lonesome, dangerous, leading to the most amazing view, where something strange and more beautiful and more full of wonder than your deepest dreams waits for you.—Edward Abbey

LEFT: Oksana Baumert, *Monte Bello, with Its Amazing Rolling Hills and Endless Blue Sky*, Monte Bello Open Space Preserve, 2010, mixed media

RIGHT: Deane Little, *Hawk Trail, Rock*, Russian Ridge Open Space Preserve, 2006

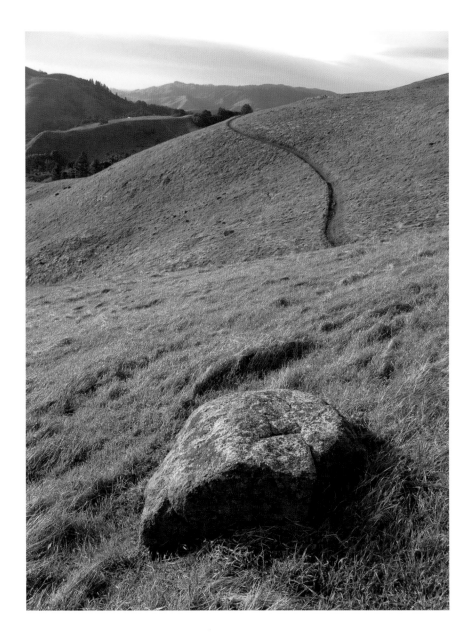

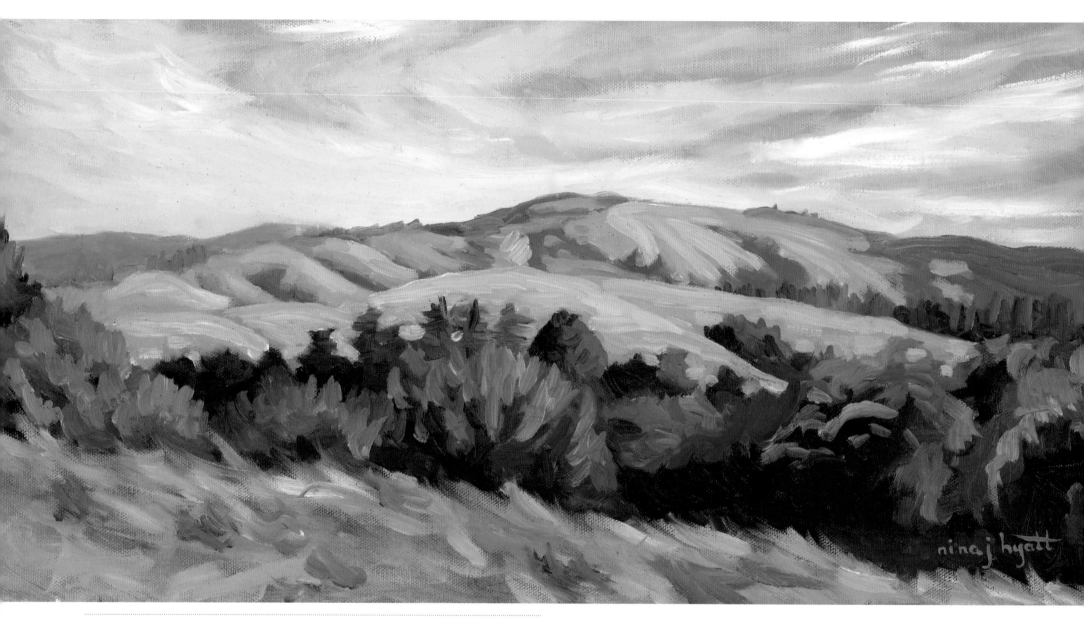

Nina J. Hyatt, *Rolling Hills, Russian Ridge,* Russian Ridge Open Space Preserve, 2011, oil painting

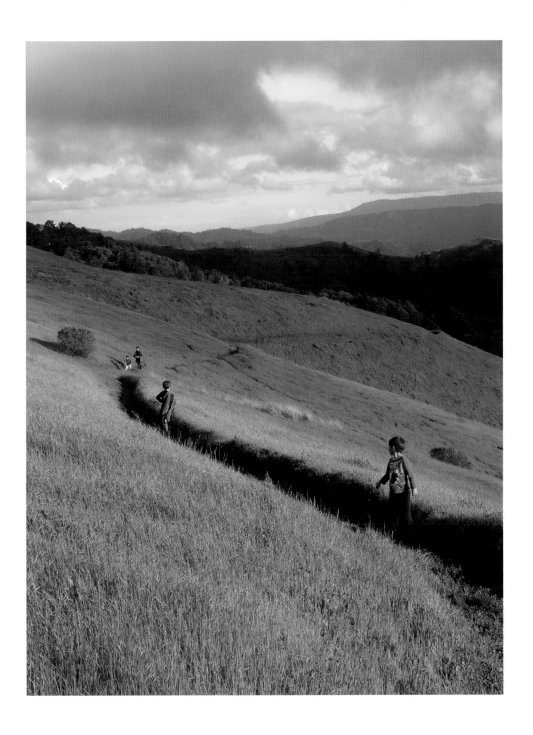

On the Path

Late sun molds the purple hills
where I pass clefts of watercress
and hardy chaparral, coyotes' home.

I find my proper size—a moving point
along a path, as in those Chinese scrolls
of men on mountain roads, bent figures
almost disappearing in white space.

It is enough to be a part of this,
hair like grass, stirring with every breeze,
feet falling in rhythm with my heart.

—Maureen Draper

Deane Little, *Family on Hawk Trail,*
Russian Ridge Open Space Preserve, 2005

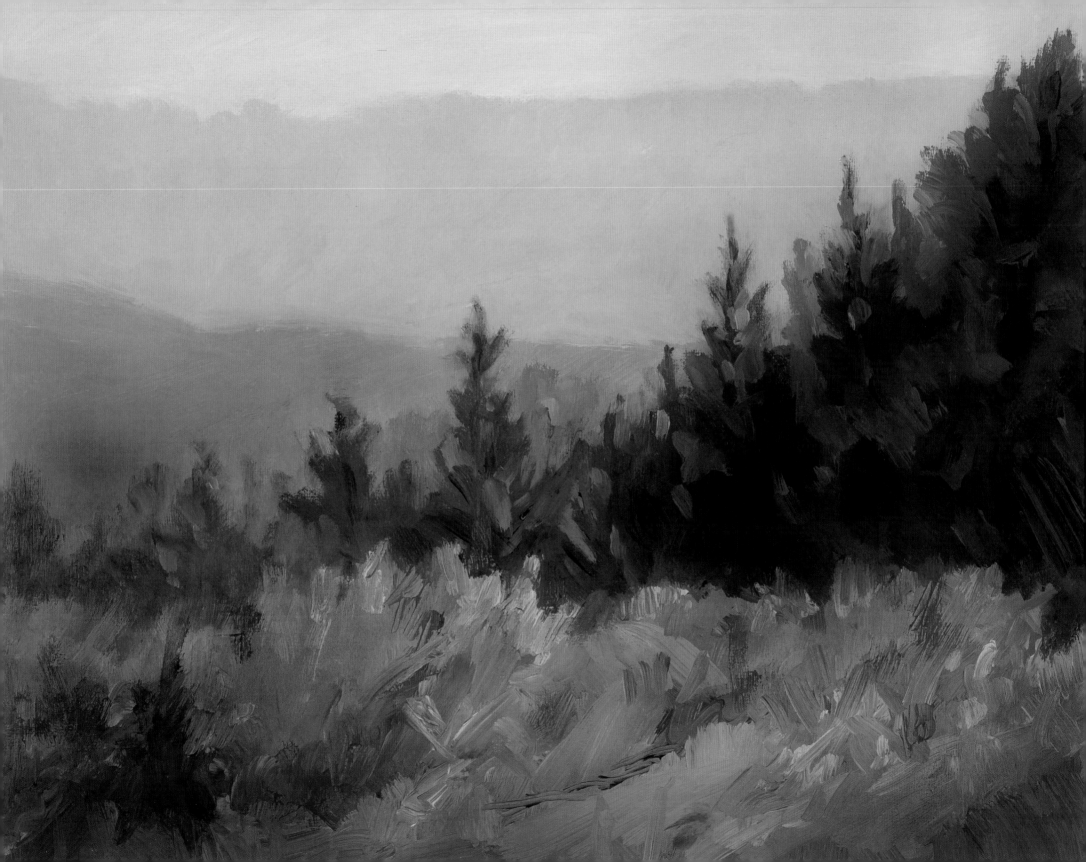

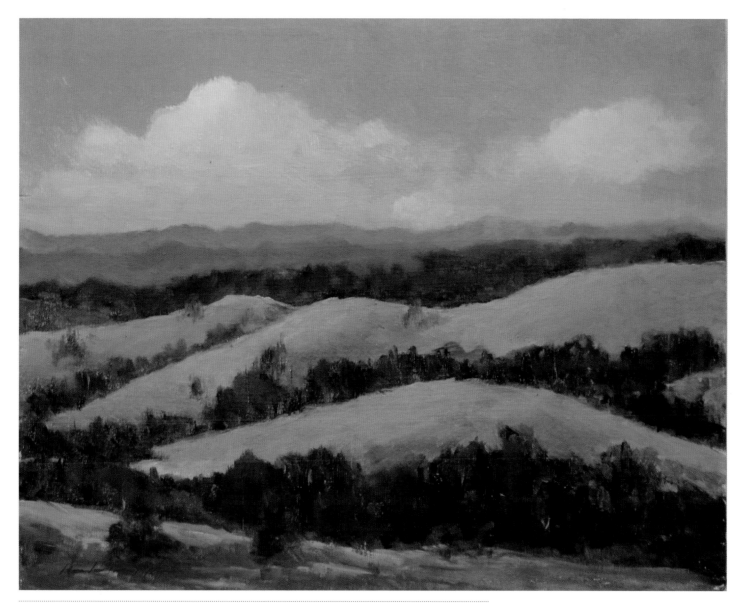

ABOVE: Pam Priest Naeve, *Windy Hill,* Windy Hill Open Space Preserve, 2010, oil painting

LEFT: Susan Migliore, *Sky to Sea,* Purisima Creek Redwoods Open Space Preserve, 2010, oil painting

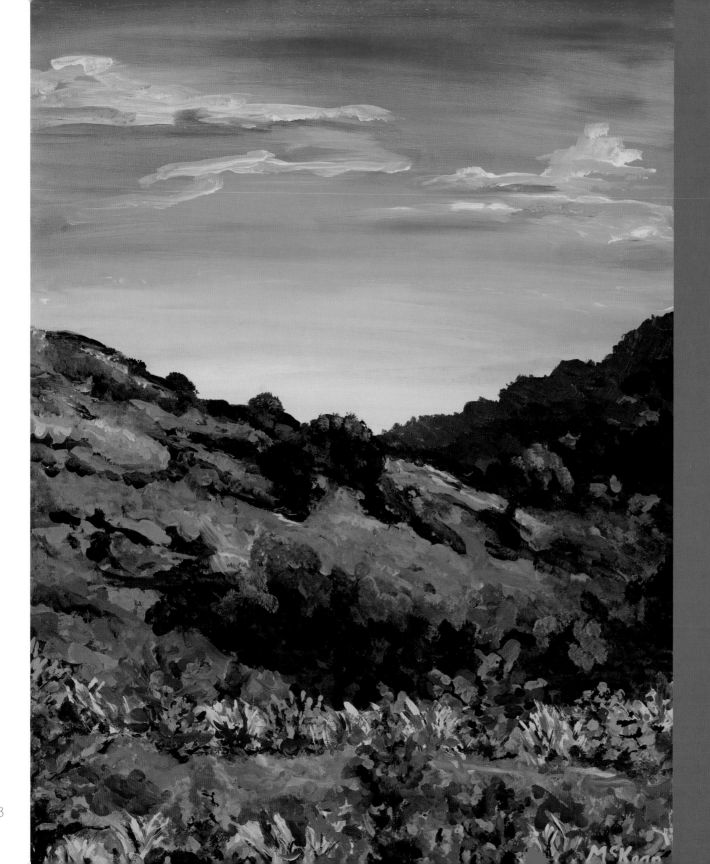

Climb the mountains and get their good tidings. Nature's peace will flow into you as sunshine flows into trees. The winds will blow their own freshness into you, and the storms their energy, while cares will drop off like autumn leaves.

—John Muir

LEFT: Jodi McKean, *Rancho Painting,* Rancho San Antonio Open Space Preserve, 2009, acrylic painting

RIGHT: Oksana Baumert, *Skyline Ridge, Where the Sky Meets the Ocean,* Skyline Ridge Open Space Preserve, 2010, mixed media

FAR RIGHT, TOP: Deane Little, *Afternoon Ride,* Russian Ridge Open Space Preserve, 2006

FAR RIGHT, BOTTOM: Carolyn Shaw, *From Here to the Sea,* Russian Ridge Open Space Preserve, 2010, oil painting

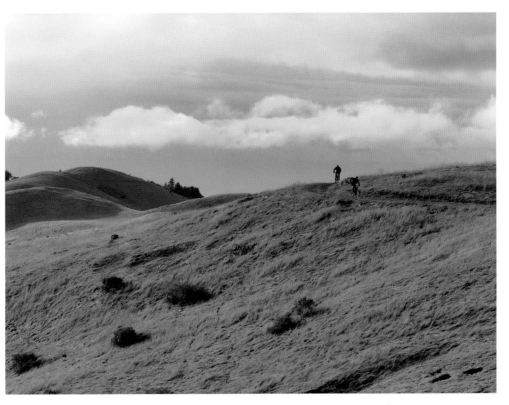

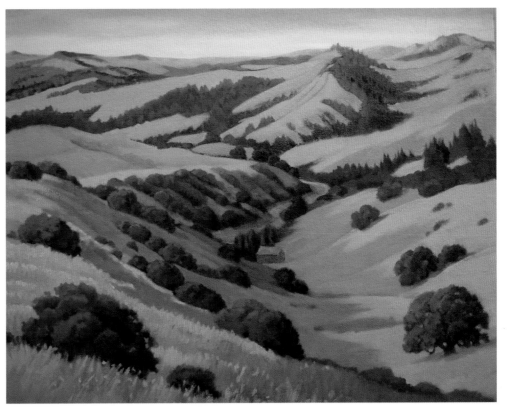

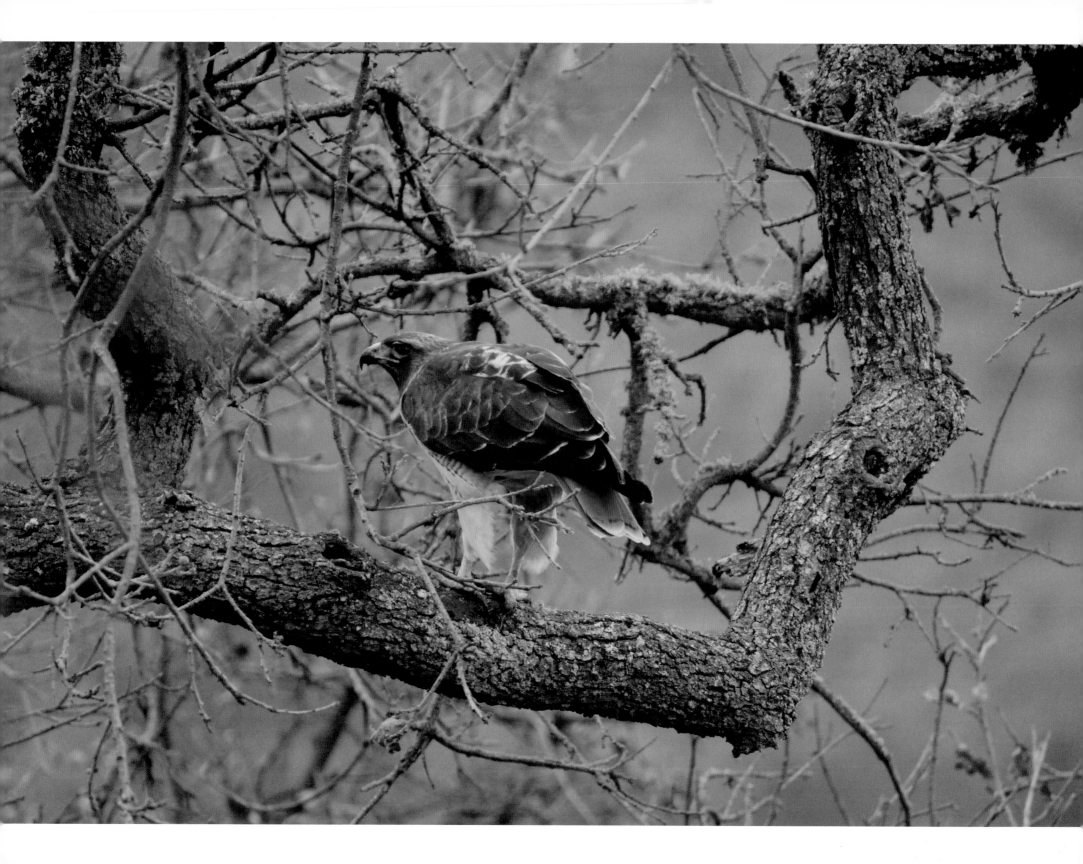

The idea of
wilderness needs
no defense, it only
needs defenders.
—Edward Abbey

LEFT: John Kesselring, *Red-tailed Hawk*, Rancho San Antonio Open Space Preserve, 2009

TOP RIGHT: Randy Weber, *Red-tailed Hawk in Flight*, Purisima Creek Redwoods Open Space Preserve, 2008

NEAR RIGHT: Tim Switick, *Red-tailed Hawk*, Rancho San Antonio Open Space Preserve, 2010

FAR RIGHT: Brian Bucher, *Red-shouldered Hawk*, Rancho San Antonio Open Space Preserve, 2010

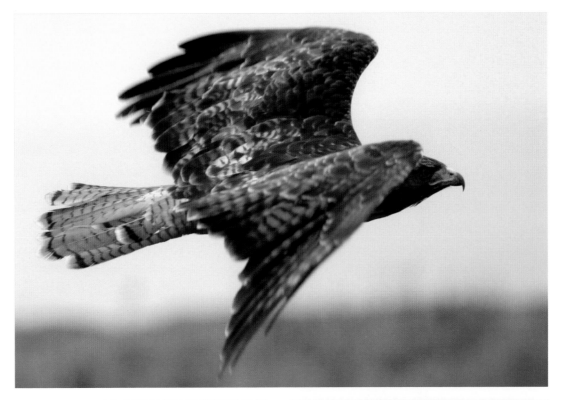

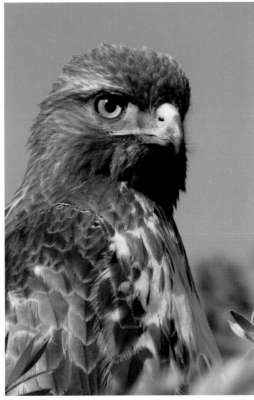

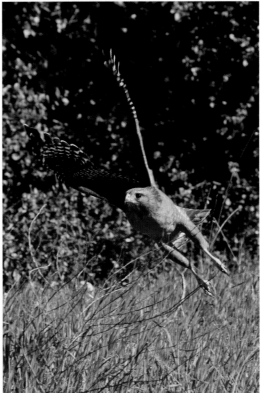

41

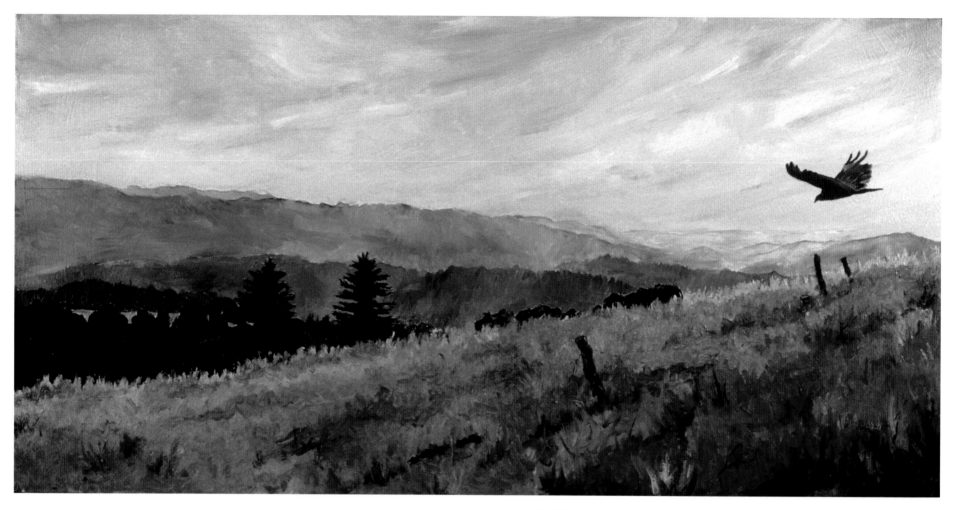

ABOVE: Paul Jossi, *Sailing Free,* Long Ridge
Open Space Preserve, date unknown, oil painting

RIGHT: Karl Gohl, *Juvenile Northern Harrier
Hunting,* Windy Hill Open Space Preserve, 2007

FAR RIGHT: Mike Asao, *Soaring High,*
Windy Hill Open Space Preserve, 2011

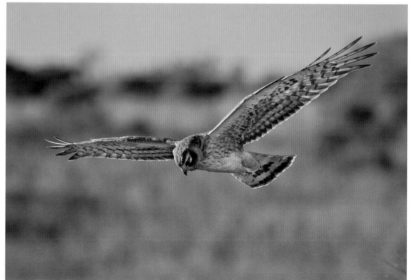

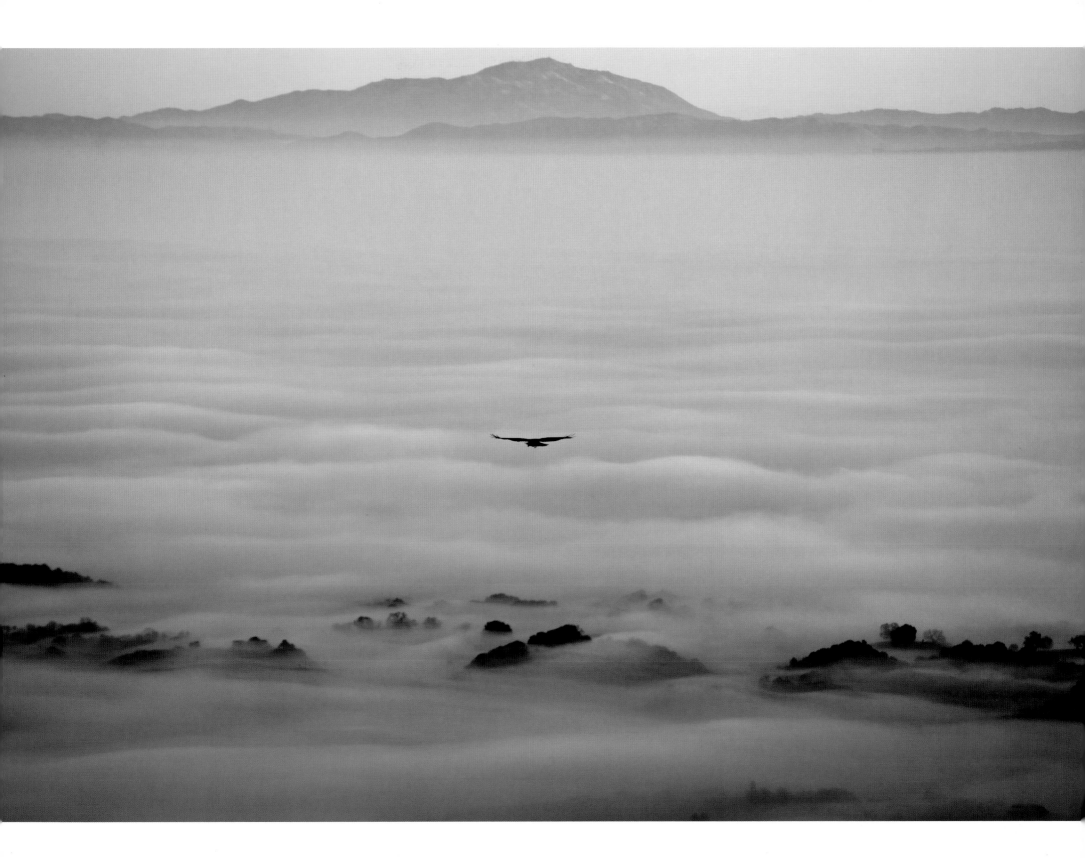

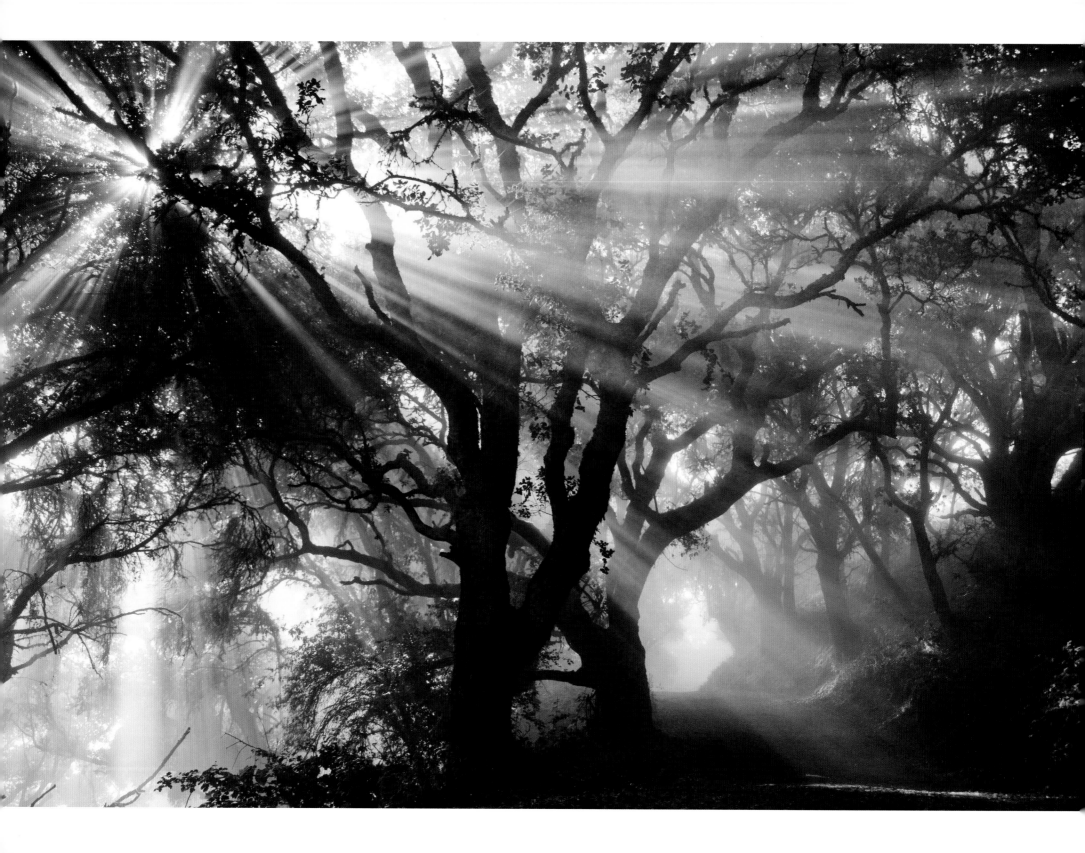

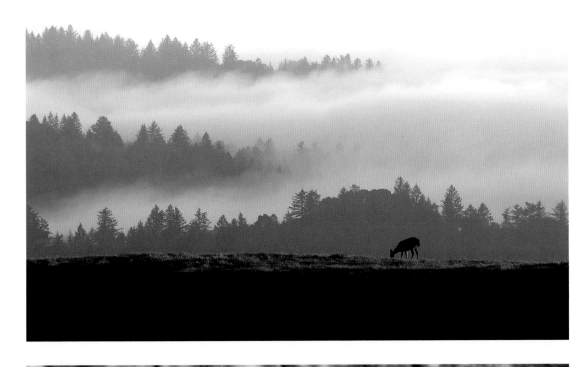

In all things of nature there is something of the marvelous.—Aristotle

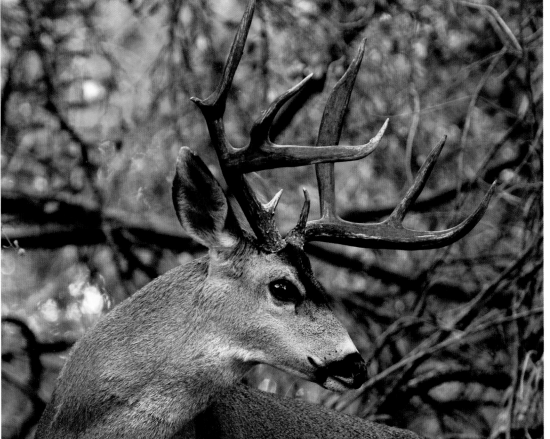

TOP LEFT: Deane Little, *Grazing Deer at Sunset,* Monte Bello Open Space Preserve, 2005

LEFT: John Kesselring, *Male Black-tailed Deer,* Rancho San Antonio Open Space Preserve, 2008

FAR LEFT: Mike Asao, *Scattering Beams,* Windy Hill Open Space Preserve, 2009

from "Alta California"

redwoods from above
like to spin like furry tops
with their arms outstretched

—Charles Nelson

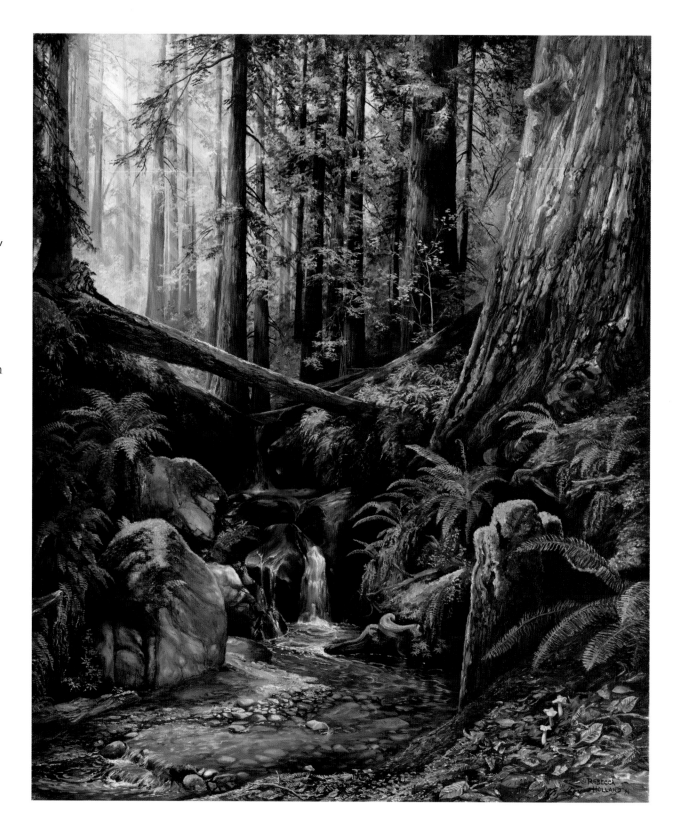

RIGHT: Rebecca Holland, *Virgin Forest,* Purisima Creek
Redwoods Open Space Preserve, 1996, oil on canvas

FAR RIGHT: Karl Gohl, *Redwood Posse,* Purisima
Creek Redwoods Open Space Preserve, 2009

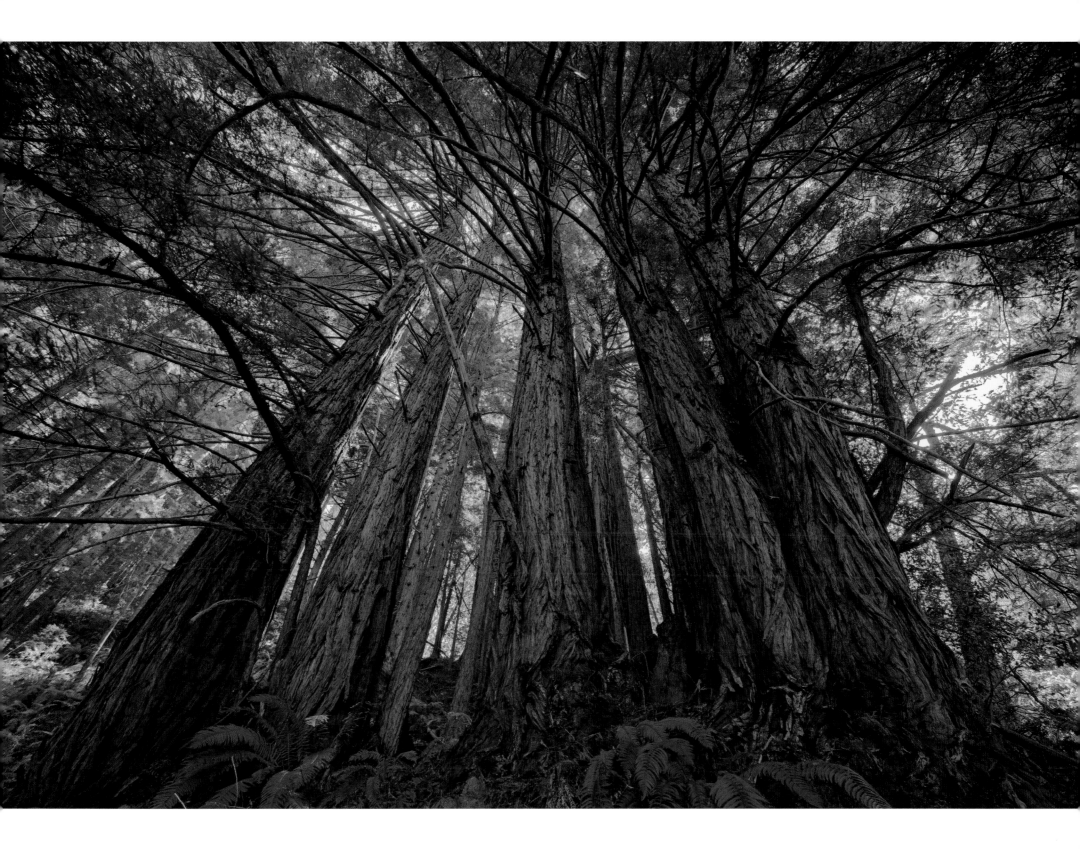

What would the world be, once bereft
Of wet and wildness? Let them be left,
O let them be left, wildness and wet,
Long live the weeds and the wildness yet.
—Gerard Manley Hopkins

LEFT: Ross Finlayson, *Horseshoe Lake*, Skyline
Ridge Open Space Preserve, 2009

RIGHT: Rebecca Holland, *Tunitas Creek*, Tunitas
Creek Open Space Preserve, 2008, oil on canvas

FAR RIGHT: Laurie Barna, *Boris-a*, 2005,
watercolor on wet tissue paper

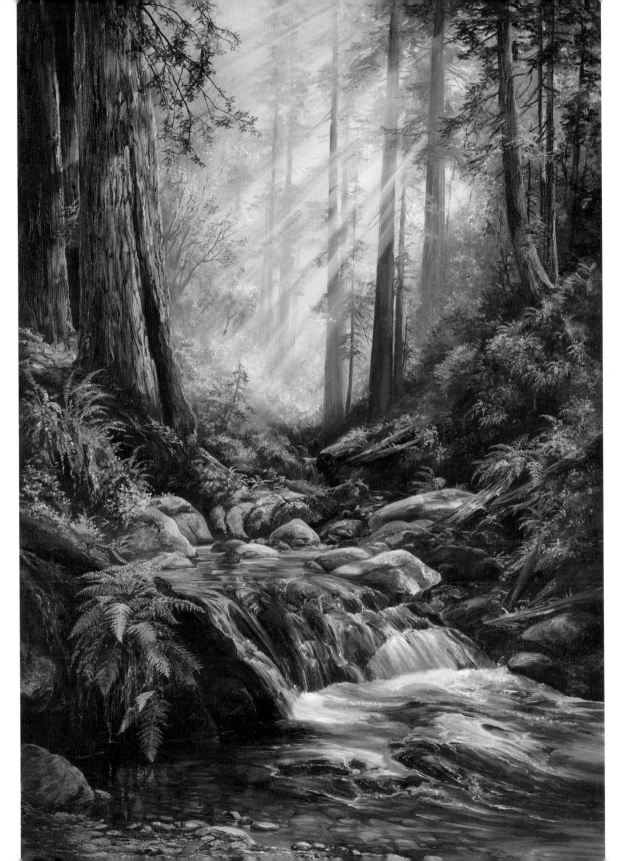

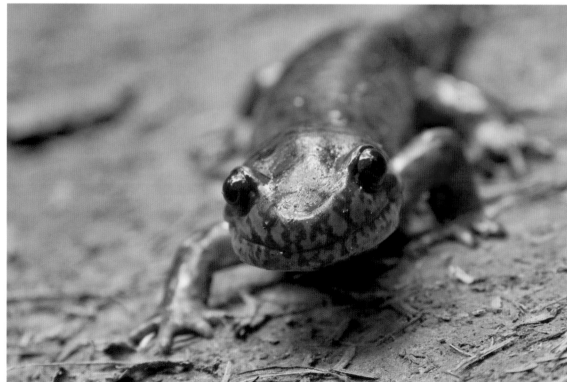

TOP RIGHT: Denise Greaves, *Striped Meadowhawk (Sympetrum pallipes) Near Sausal Pond,* Windy Hill Open Space Preserve, 2009

RIGHT: Karl Gohl, *Salamander Smile,* Purisima Creek Redwoods Open Space Preserve, 2009

FAR RIGHT: Deane Little, *Hidden Waterfall,* Long Ridge Open Space Preserve, 2005

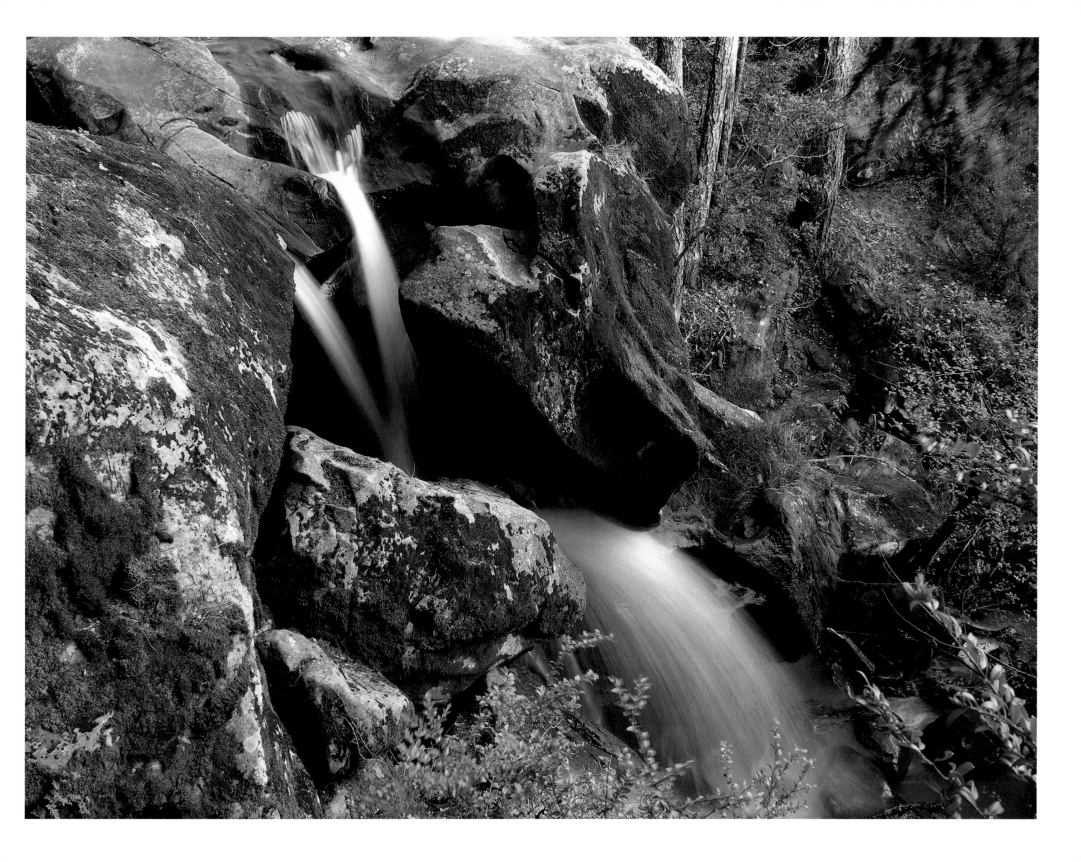

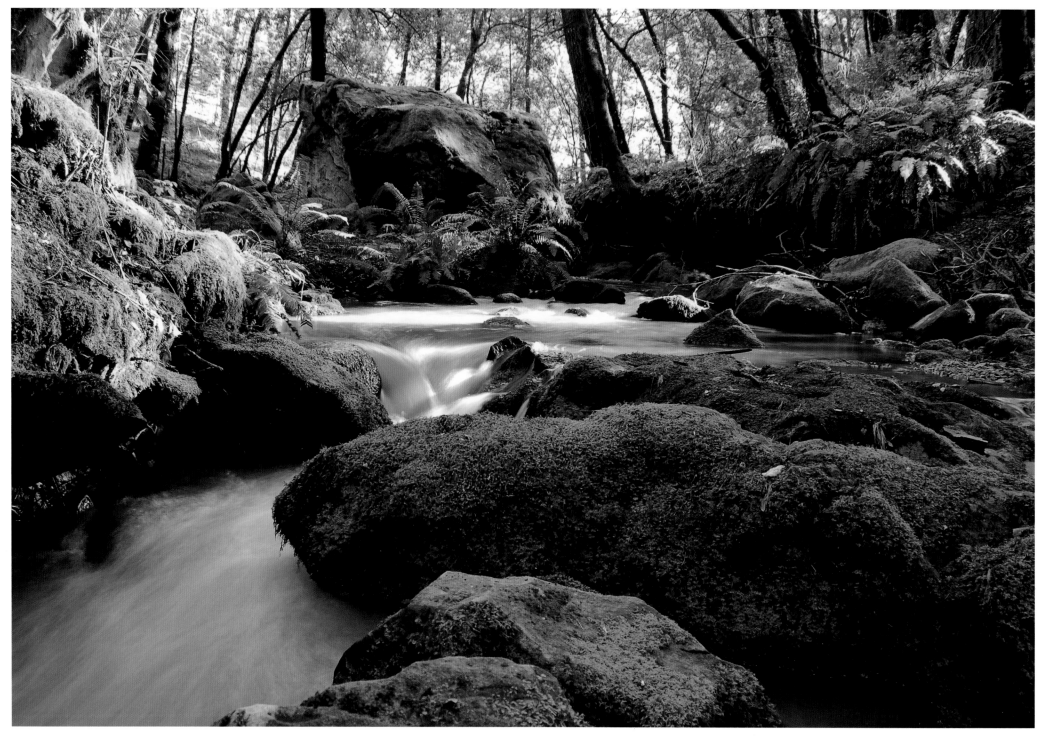

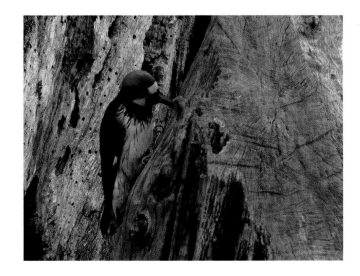

Small Ode to Joy

for Jennifer

—At Long Ridge

Hurry. The redbud won't wait, or the freesia,
or the silver-barked cherry. All the new webs,
shining and floating like unrounded bubbles
won't wait. They'll be gone even faster. Hurry.
Let's lay down heaviness and watch.
If we find ourselves asking whether this is the last spring,
it's not because we want to know.
It's only that asking makes us look.

I know of a walk to a waterfall,
past smaller streams wetting the path,
past butterflies flashing
and banana slugs oozing blindly toward
a heaven of pink-flowered sorrel.
There's the sound of the stream, a distant woodpecker,
and the falls themselves, where water pours down
spreading like hair over the rock.

We don't owe everything to madmen who think
we're only empty shoes in their jig with death.
We don't owe everything to sorrow.

—Charlotte Muse

LEFT, TOP: Jim Liskovec, *Probing Acorn Woodpecker,* Rancho San Antonio
Open Space Preserve, 2005

LEFT, BOTTOM: Amanda Krauss, *Spotted Towhee,* Purisima Creek
Redwoods Open Space Preserve, 2010, colored pencil drawing on paper

FAR LEFT: Deane Little, *Spring Afternoon, Peters Creek,* Long Ridge
Open Space Preserve, 2006

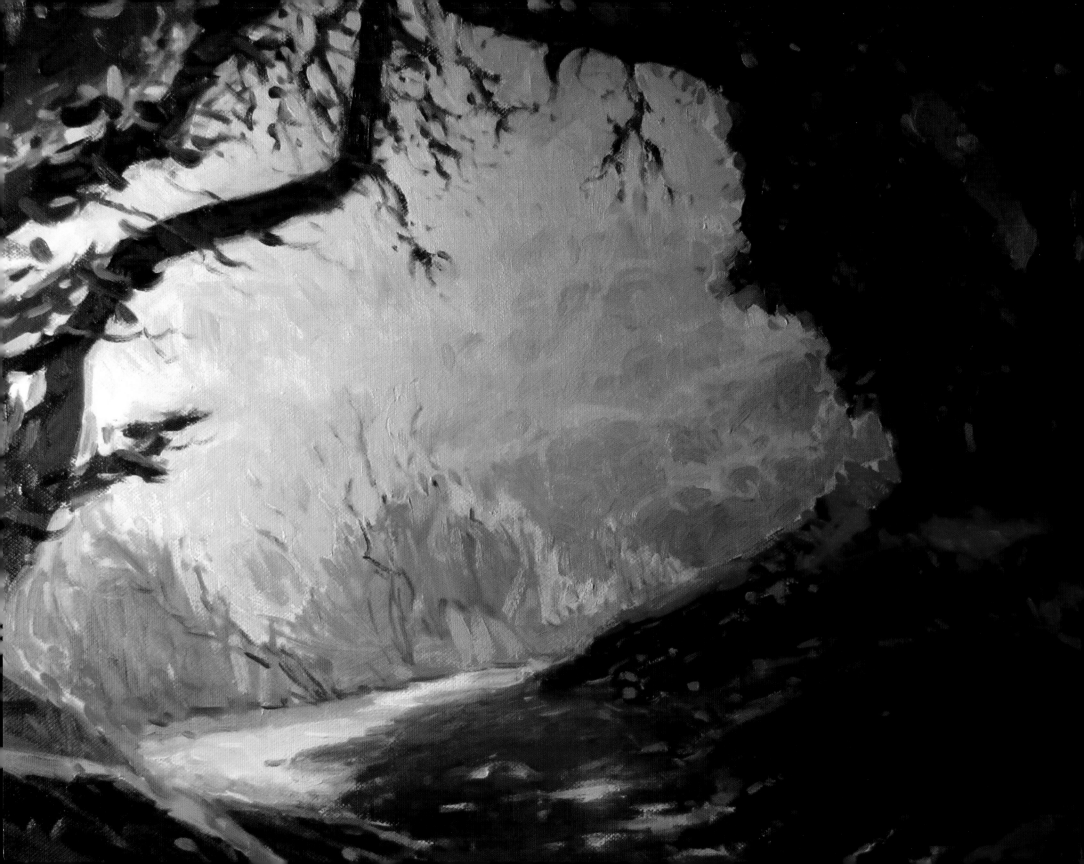

If the simple things of nature have a message that you understand, rejoice, for your soul is alive.
—Eleanora Duse

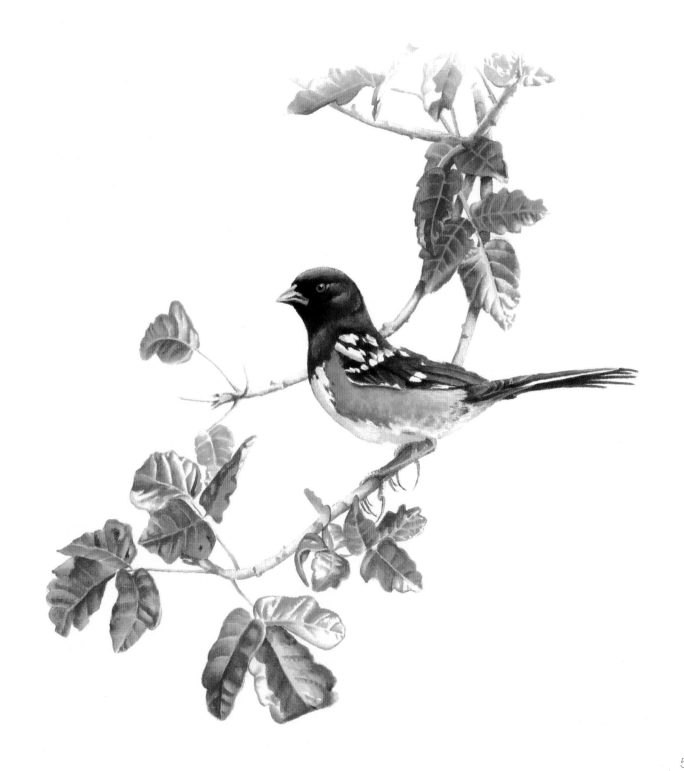

LEFT: Jason Bromfield, *Beyond the Canopy,* Pulgas Ridge Open Space Preserve, 2011, oil on canvas

RIGHT: John Richards, *Spotted Towhee,* 2010, watercolor

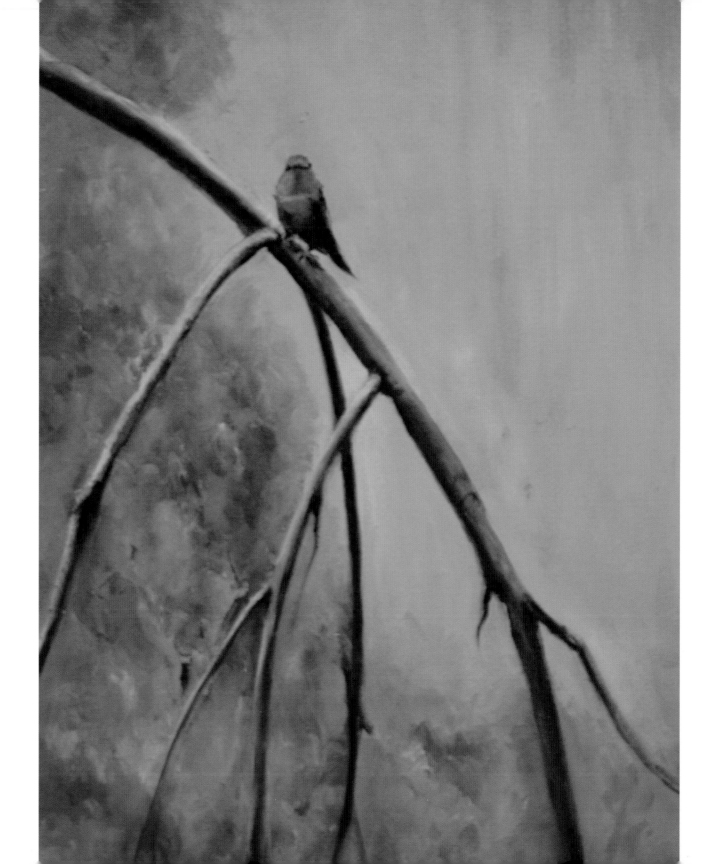

RIGHT: Elyse Dunnahoo, *Colorful Gray Day,* Windy Hill Open Space Preserve, 2010, oil painting

FAR RIGHT: Susan Migliore, *Sunlit Trail,* Sierra Azul Open Space Preserve, 2010, oil painting

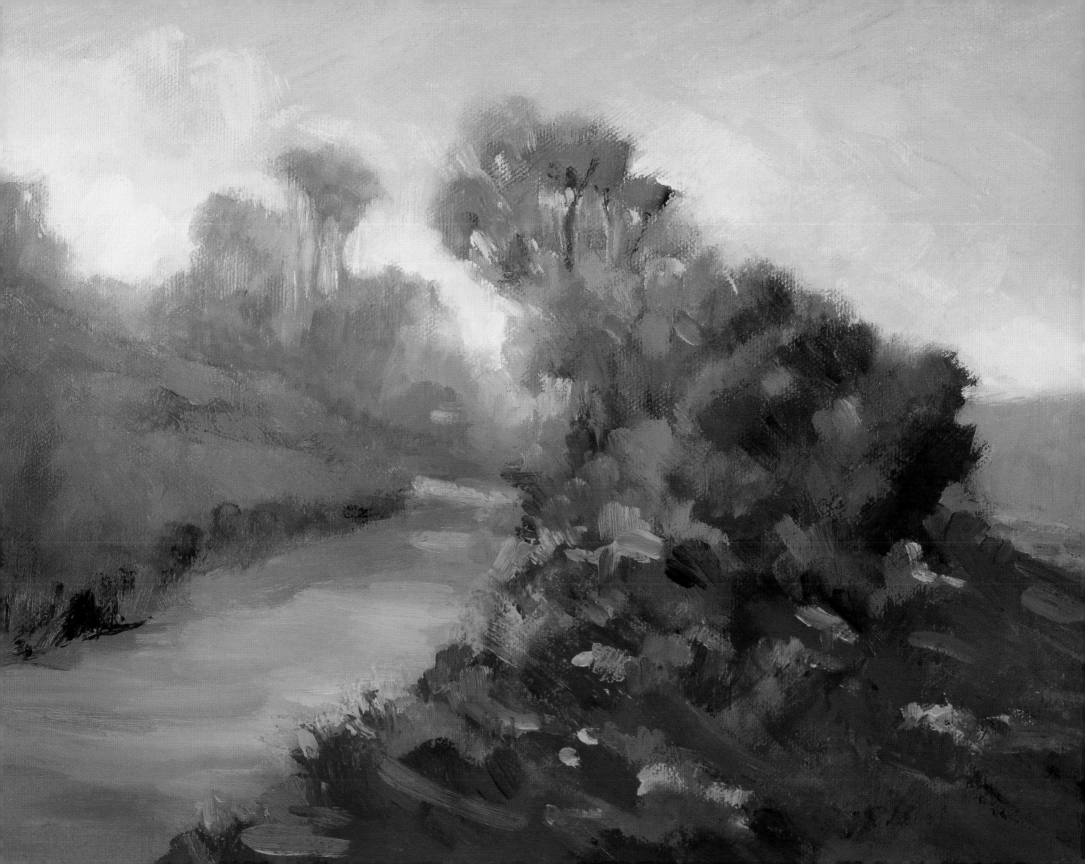

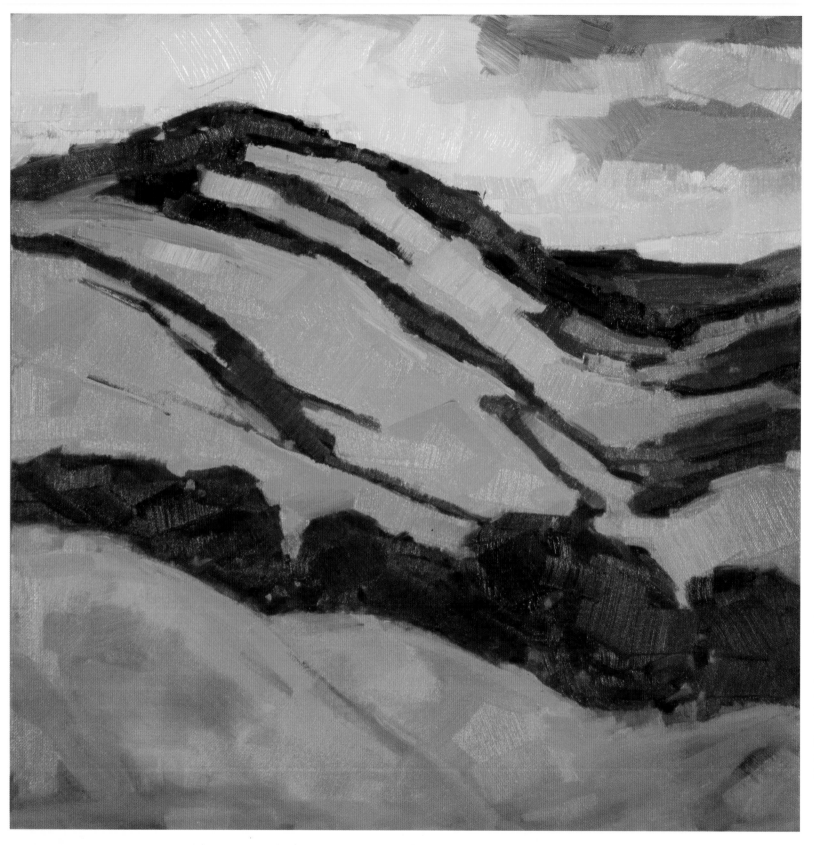

LEFT: Karen White, *Monte Bello Summer,* Monte Bello Open Space Preserve, 2009, oil painting

RIGHT: Karen White, *Valley Oaks,* Rancho San Antonio Open Space Preserve, 2009, oil painting

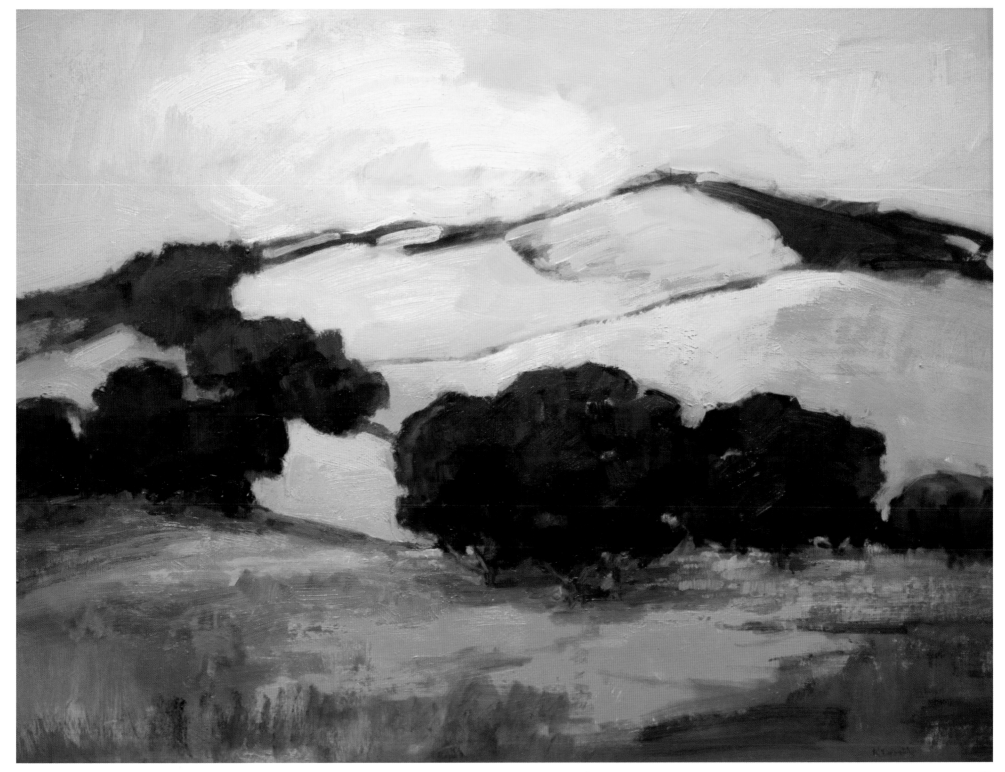

Autumn

Sun sifts through the willow
A sudden wind bends the bough,
The flicker's shrill cry
Pierces a crisp autumn sky.
—Anna Shaff

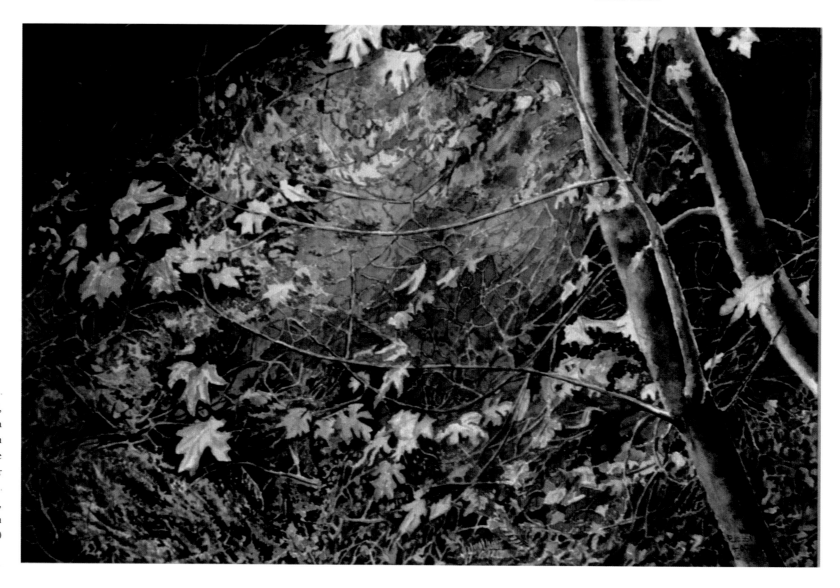

RIGHT: Paul Jossi, *September Song,* Purisima Creek Redwoods Open Space Preserve, date unknown, watercolor

FAR RIGHT: Bob Clark, *Fall Fog,* Windy Hill Open Space Preserve, 2010

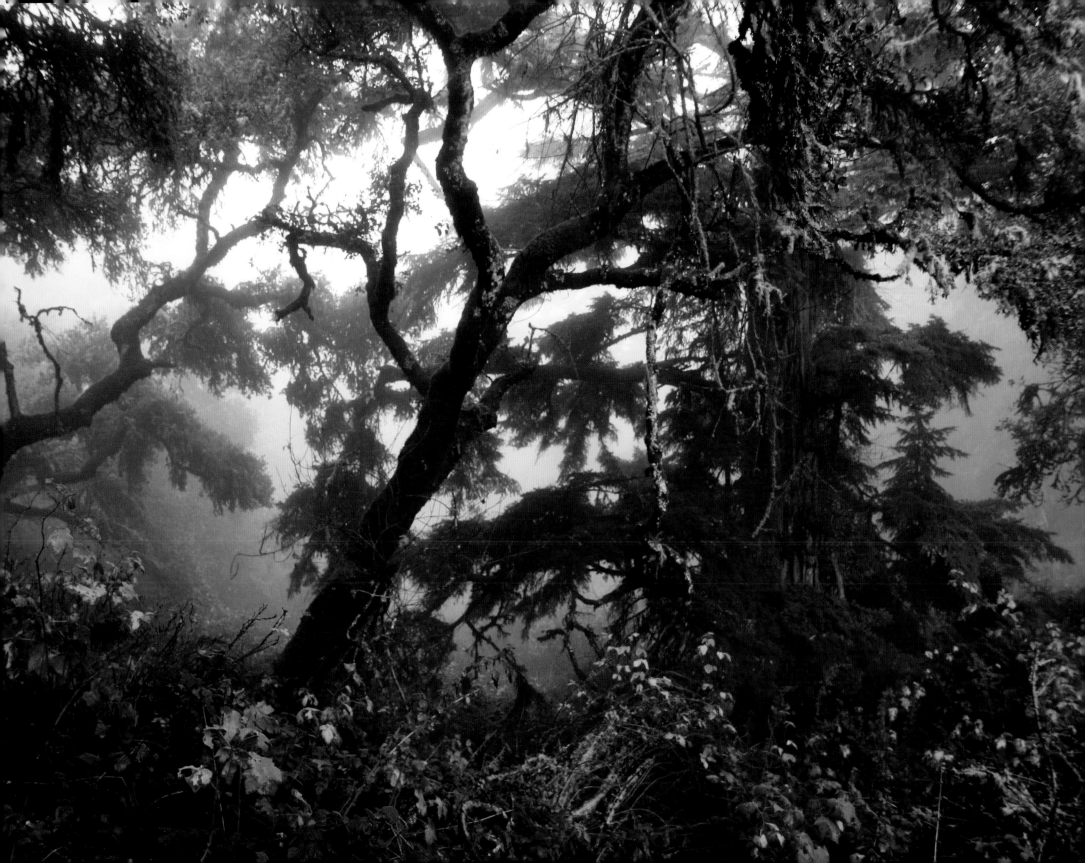

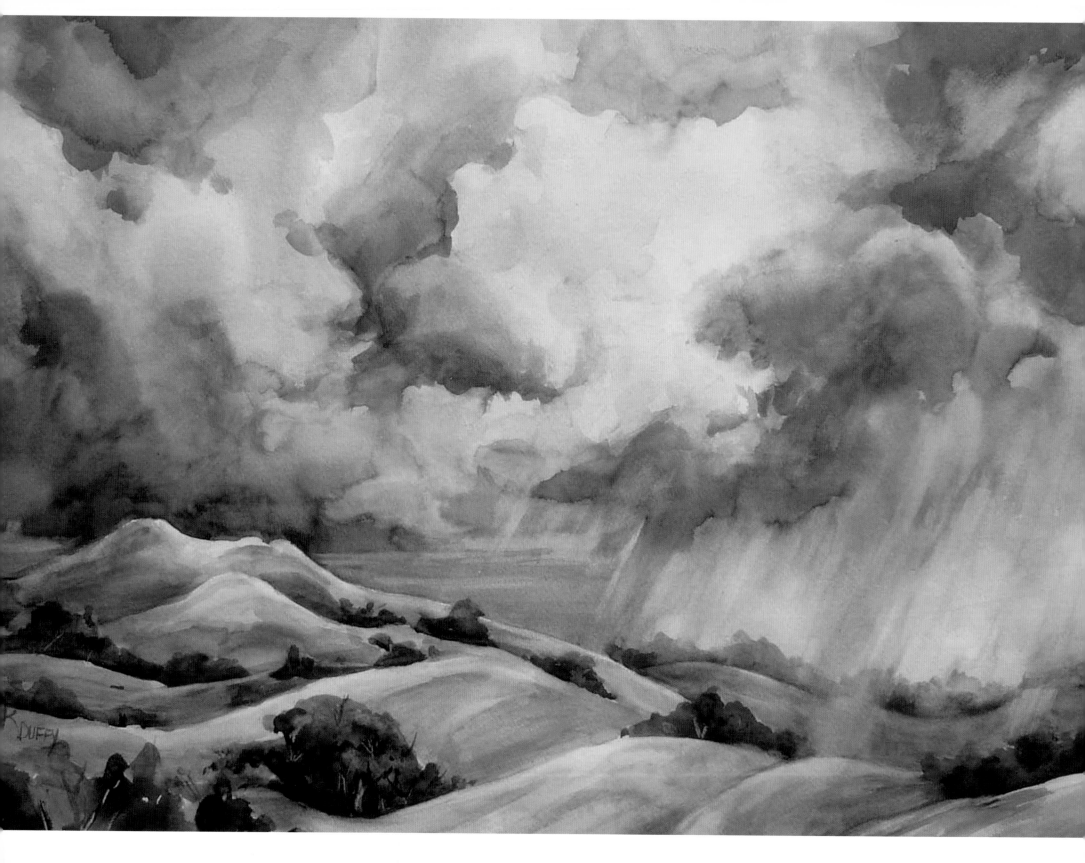

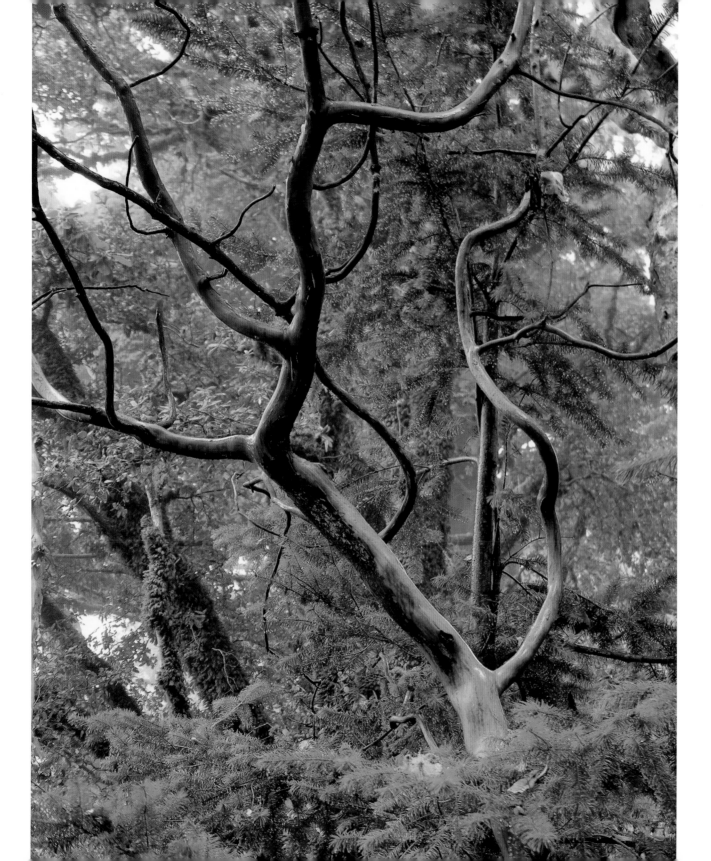

Windy Hill in Winter

Beyond Sausal Pond
Madrone meets majestic oak
Cedar Waxwings sing

—Karen DeMello

LEFT: Deane Little, *Young Madrone in Fog,*
Russian Ridge Open Space Preserve, 2005

FAR LEFT: Kay Duffy, *Windy Hill,* Windy
Hill Open Space Preserve, 1998, watercolor

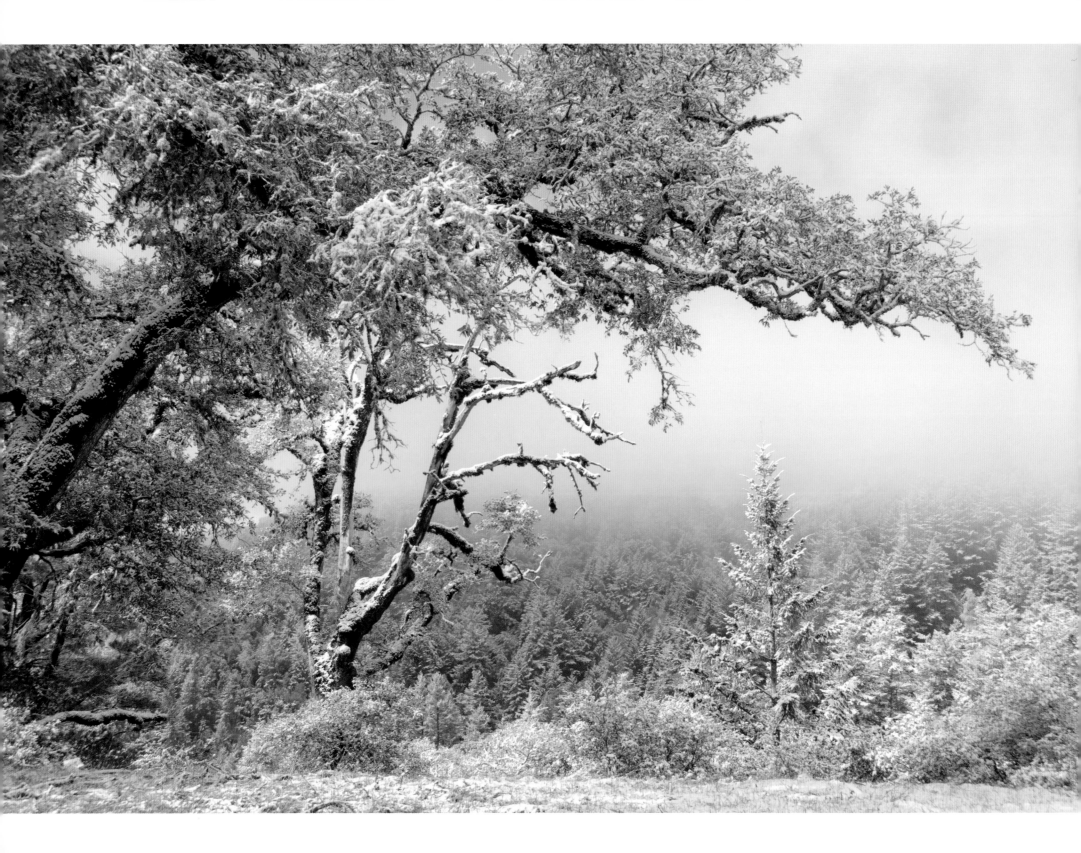

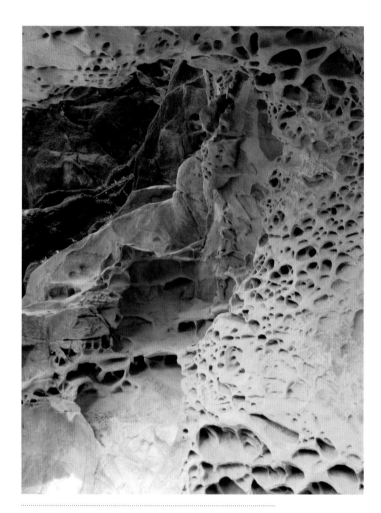

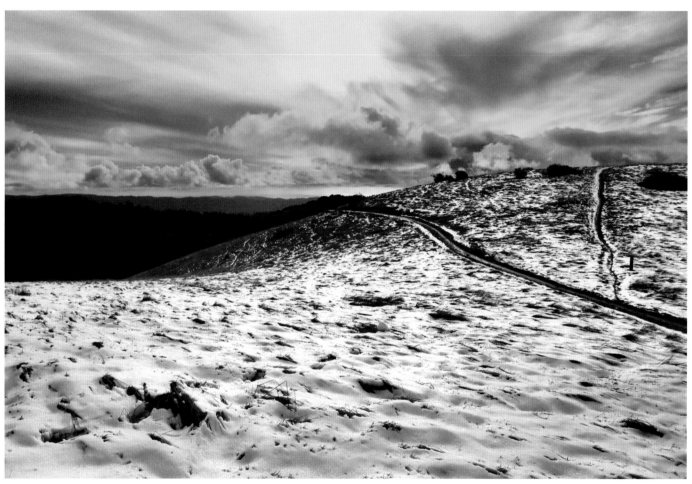

ABOVE: Oksana Baumert, *Tafoni Sandstone Formation,*
El Corte de Madera Creek Open Space Preserve, 2010

ABOVE: Tim Chavez, *Snow on Monte Bello,* Monte Bello Open Space Preserve, 2010

LEFT: Henri Lamiraux, *Snow on Skyline,*
Skyline Ridge Open Space Preserve, 2006

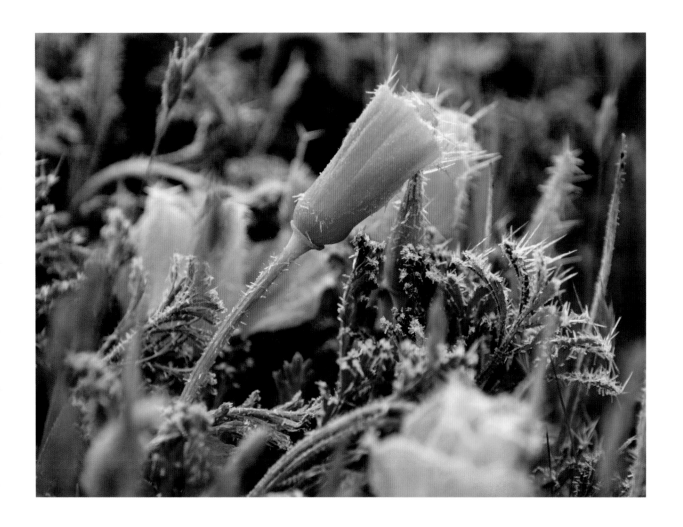

In Wintry February

In wintry February,
the first warmth.
A scent of something erupting...
a bee's fervent response.
The wind, no longer harsh,
splashes soft
against the skin.
A stream of air tumbles downhill
onto a creek thick with winter.
Above
tiny buds
erupt in white and pink,
in the first tremor of spring.

—Anna Shaff

LEFT: Mike Asao, *Early Spring Frost,*
Rancho San Antonio Open Space Preserve, 2008

RIGHT: Sheryl Ehrlich, *Light Dusting,* Long
Ridge Open Space Preserve, 2011

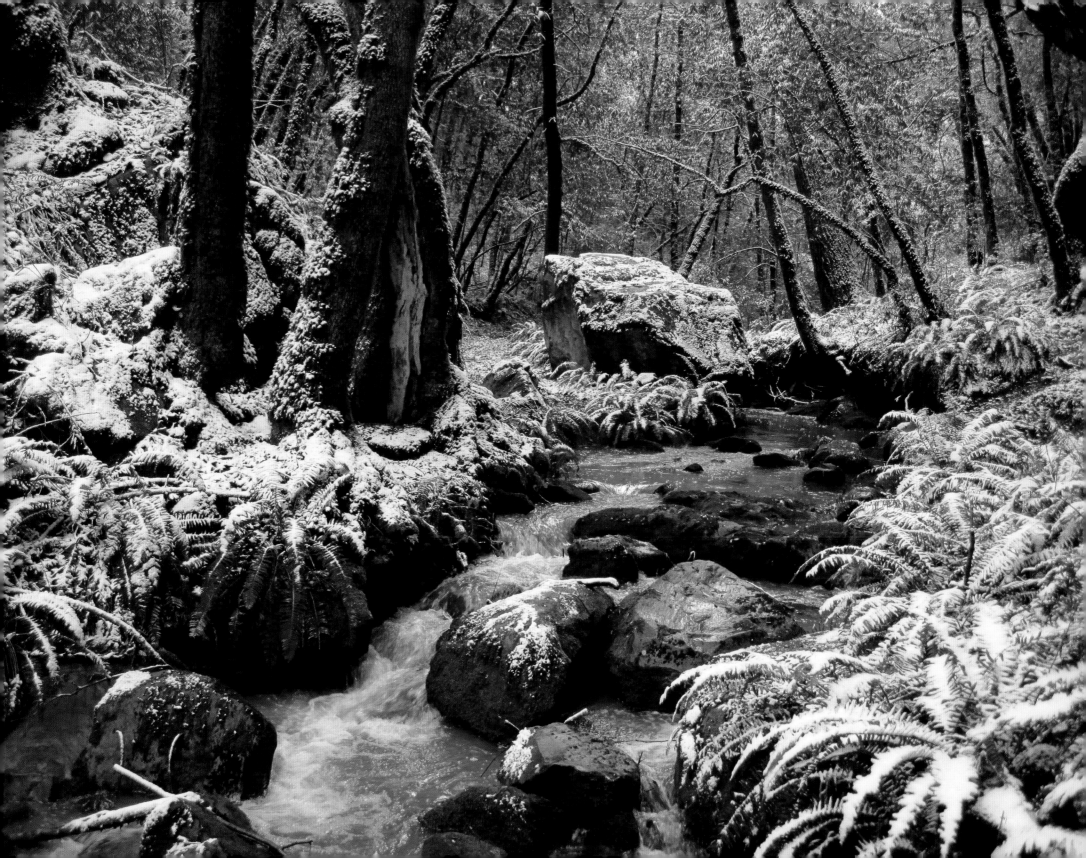

RIGHT: Therese Ely, *Spring Flood,* Purisima Creek Redwoods Open Space Preserve, 2010, oil painting

BELOW: Kit Colman, *Oaks in Fog,* Thornewood Open Space Preserve, 2010, oil on canvas

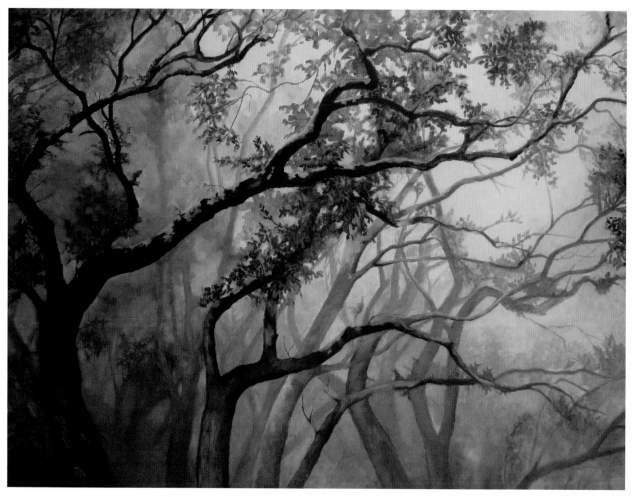

...The future is a misted landscape, no man sees clearly, but at cyclic turns There is a change felt in the rhythm of events...

—Robinson Jeffers

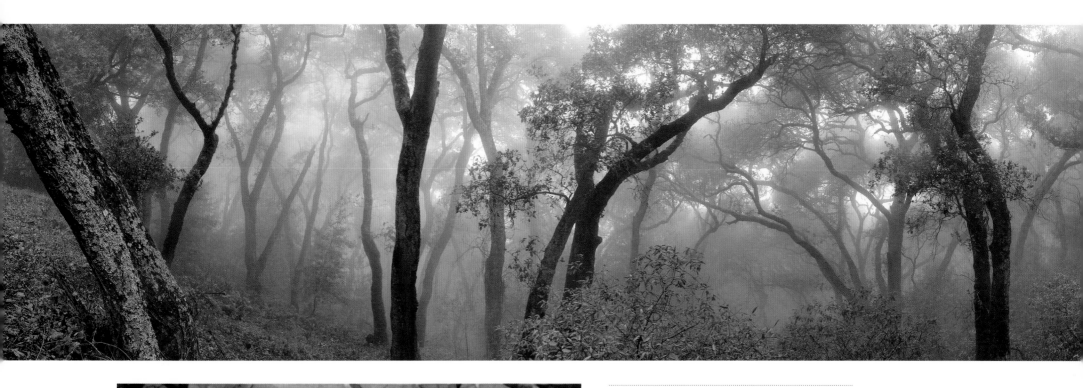

ABOVE: Deane Little, *Foggy Oak Forest,* Foothills
Open Space Preserve, 2006

LEFT: Paul Jossi, *The Fall,* Purisima Creek Redwoods
Open Space Preserve, date unknown, watercolor

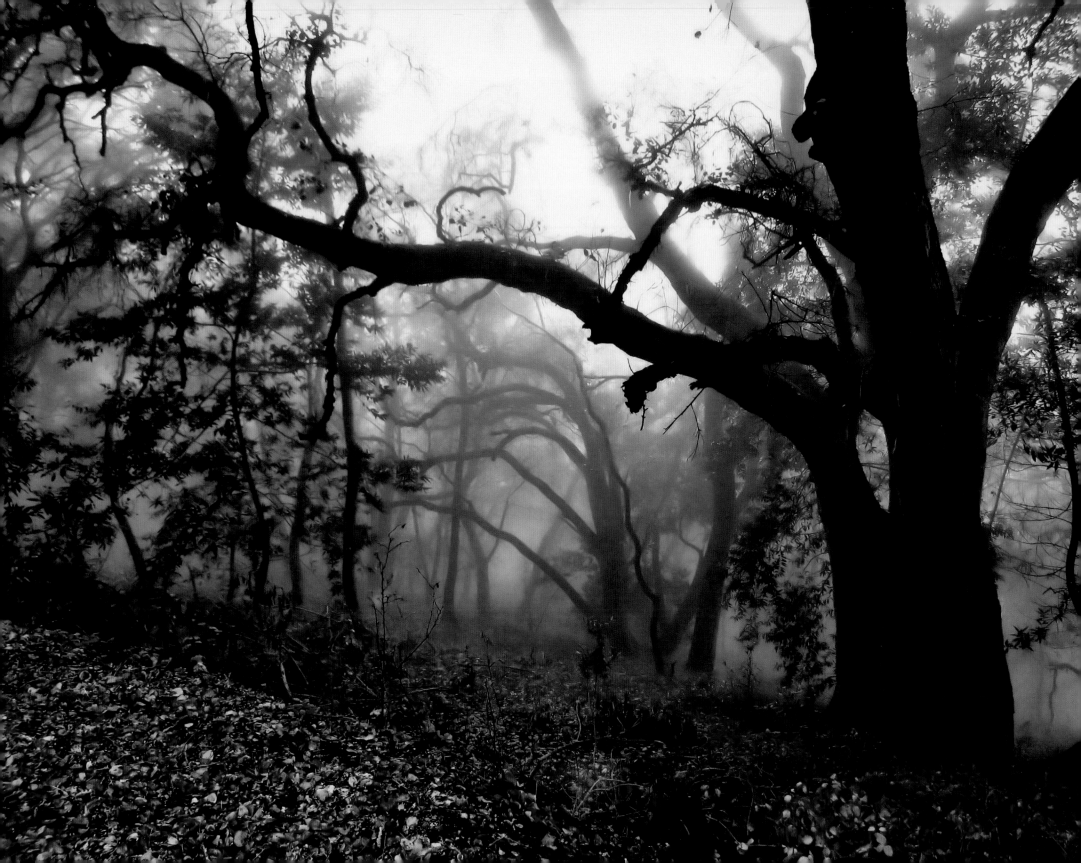

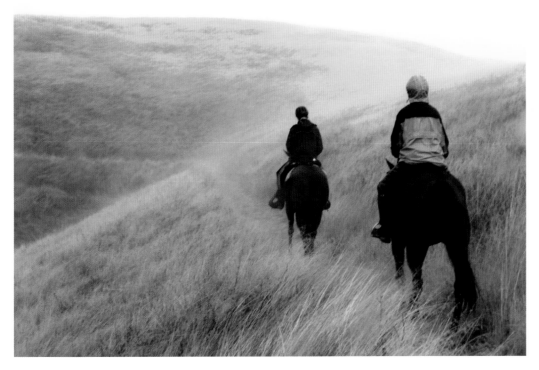

LEFT: Kenneth C. Nitz, *Horseback in Rain and Fog,*
Russian Ridge Open Space Preserve, 2007

BELOW: Edwin Bertolet, *Path to Horseshoe Lake,*
Skyline Ridge Open Space Preserve, 2009, oil painting

FAR LEFT: Andrew Forster, *Endless Fog,*
Sierra Azul Open Space Preserve, 2010

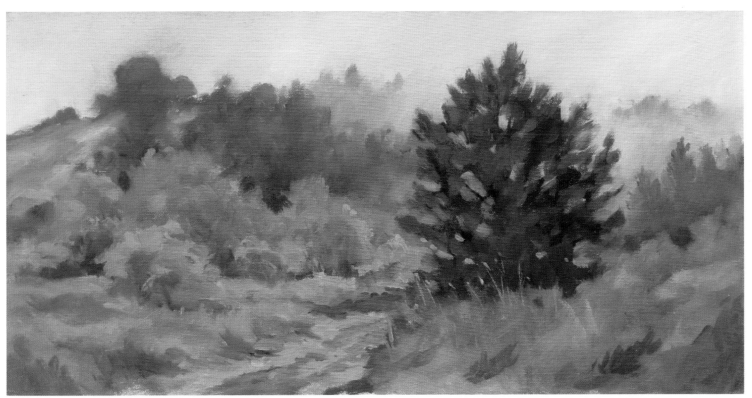

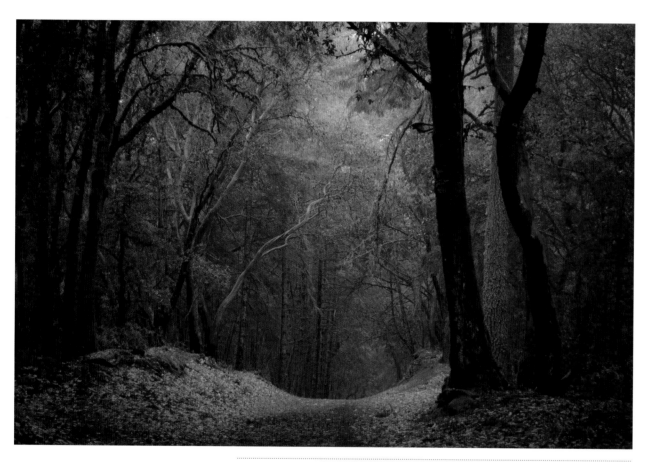

Rob Holcomb, *Down the Trail,* El Corte de Madera Creek Open Space Preserve, 2010

Come to the woods, for here is rest. There is no repose like that of the green deep woods....Sleep in forgetfulness of all ill. Of all the upness accessible to mortals, there is no upness comparable to the mountains.—John Muir

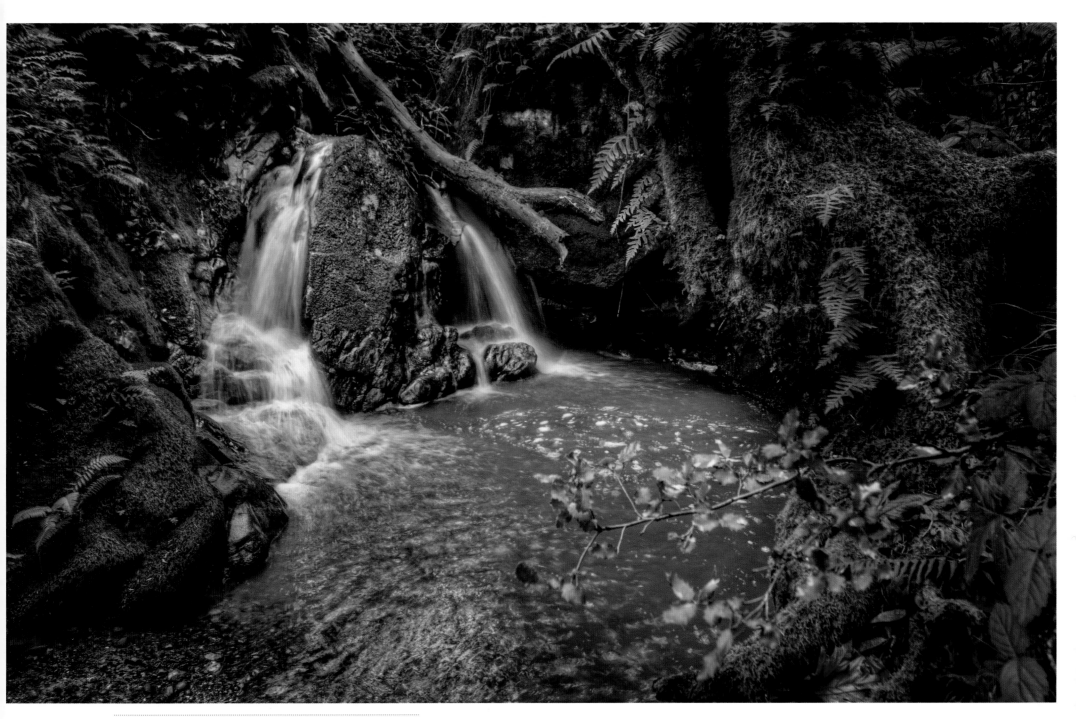

Dean Birinyi, *Forests Deep,* Coal Creek Open Space Preserve, 2010

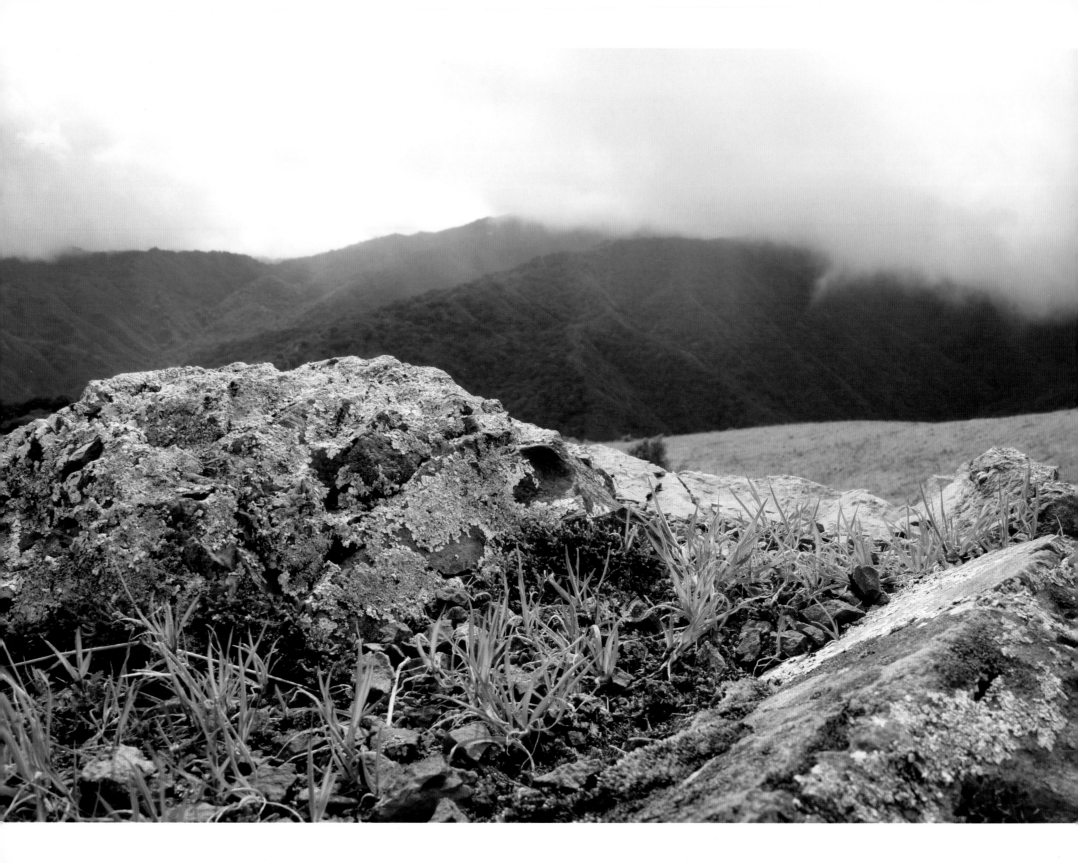

Find your place on the planet. Dig in, and take responsibility from there.—Gary Snyder

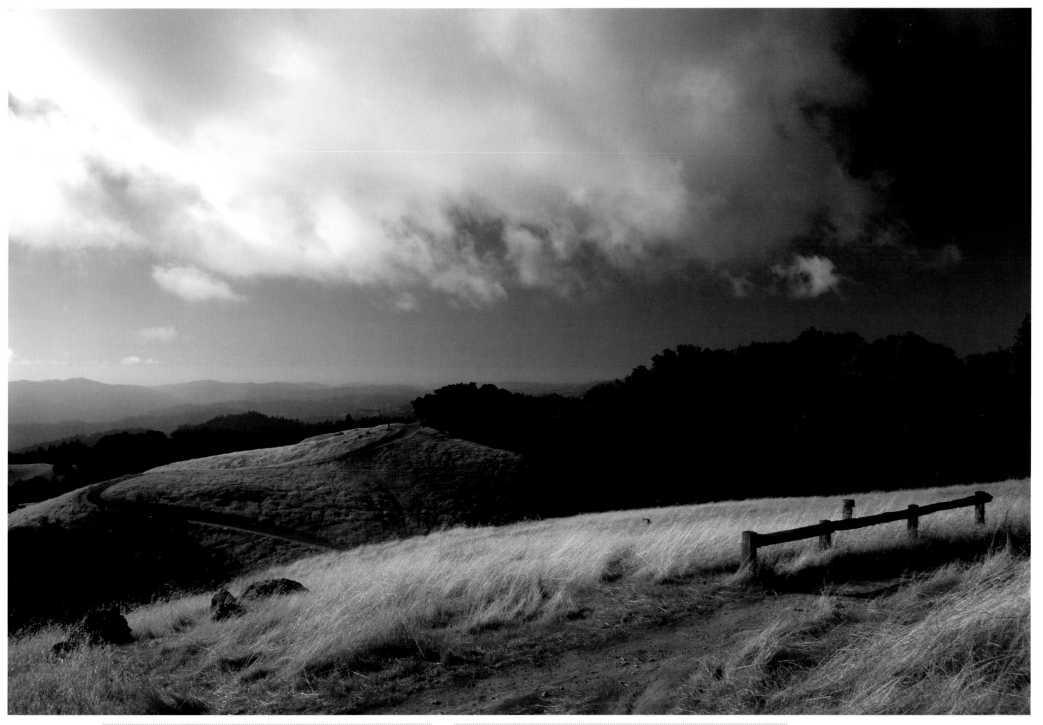

LEFT: Howie Anawalt, *Contrast,* Sierra Azul Open Space Preserve, 2011 ABOVE: Ian Sims, *Above the Fray,* Long Ridge Open Space Preserve, 2007

ABOVE: Deane Little, *Runner, Late Afternoon,* Russian Ridge Open Space Preserve, 2006

RIGHT: Charles Tu, *Sunset,* Rancho San Antonio Open Space Preserve, 2010

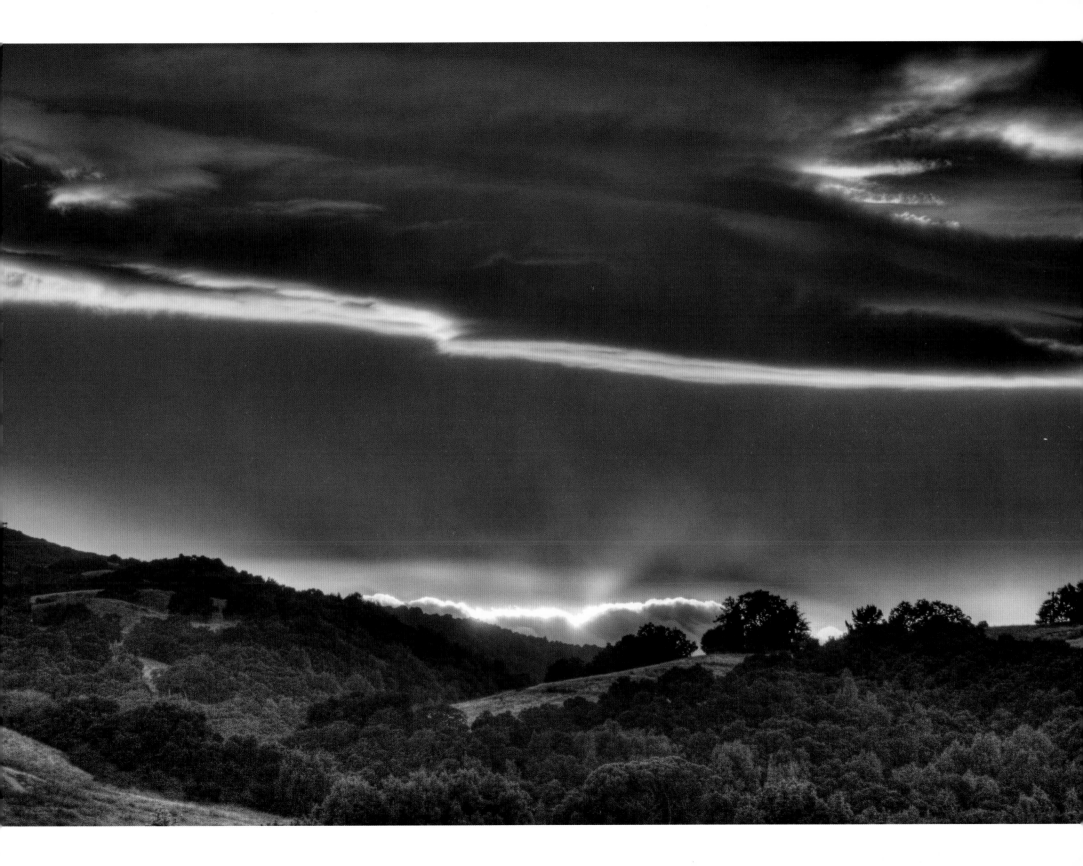

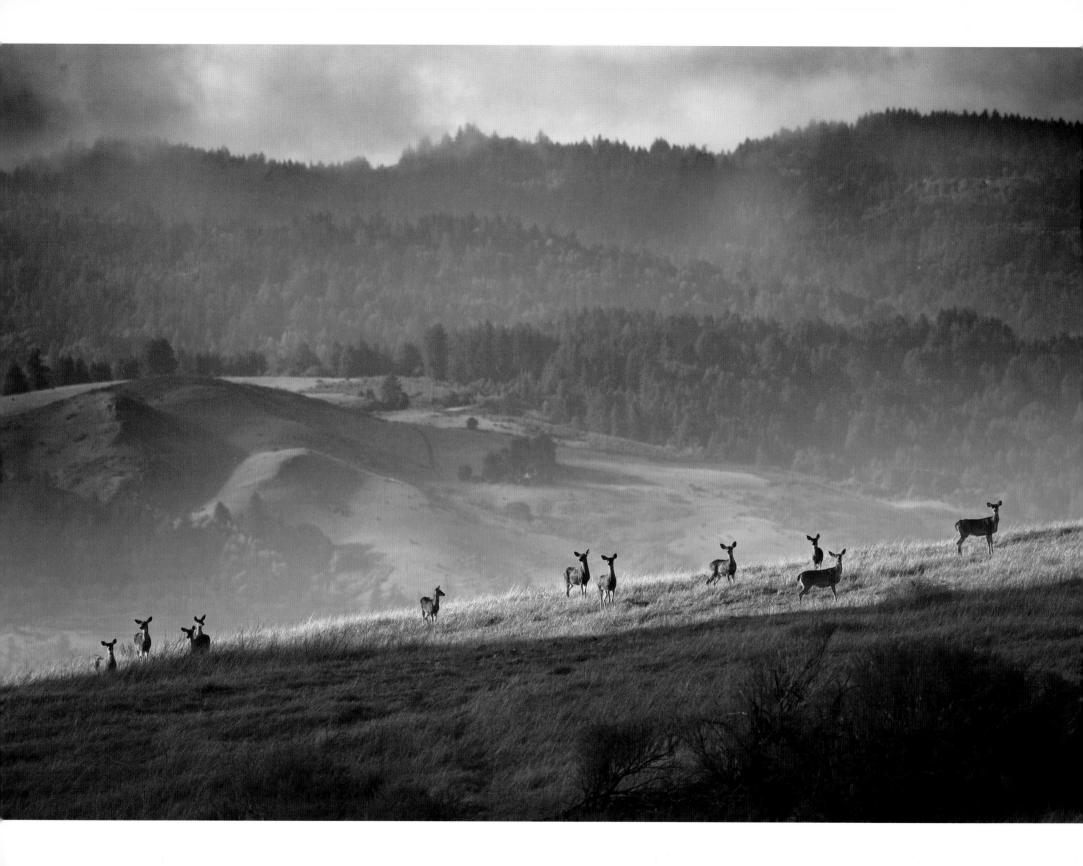

Nature is not a place to visit. It is home.—Gary Snyder

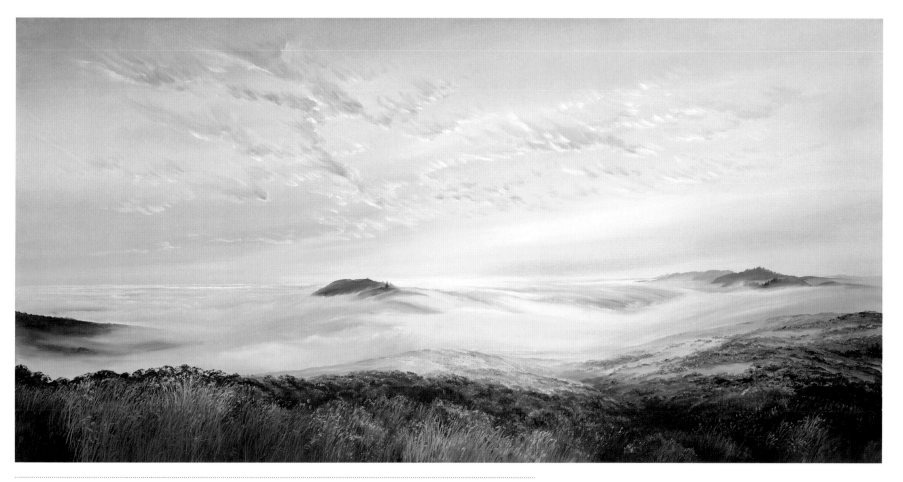

ABOVE: Rebecca Holland, *Kings Mountain Evening,* Miramontes Ridge Open Space Preserve, 2010, oil on canvas

LEFT: Karl Gohl, *Deer on Ridge,* Monte Bello Open Space Preserve, 2008

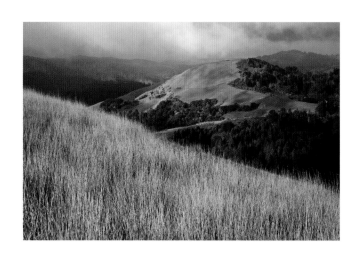

from "Three Views of Mindego Hill"

Evening approaches
An island wrapped in thick fog
Venus bids farewell

—Karen DeMello

ABOVE: Karl Gohl, *Brown Borel, Green Mindego,* Russian Ridge Open Space Preserve, 2007

RIGHT: Daniel Vekhter, *Fog Rolling in at Russian Ridge,* Russian Ridge Open Space Preserve, 2006

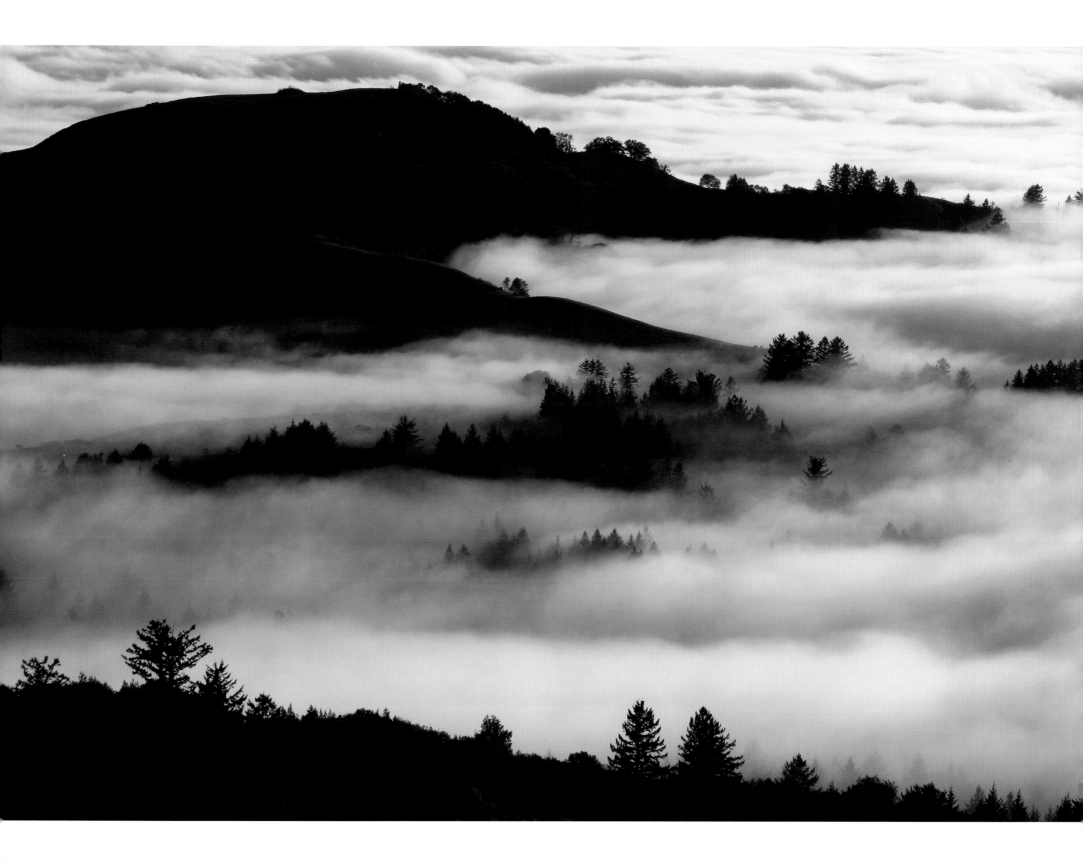

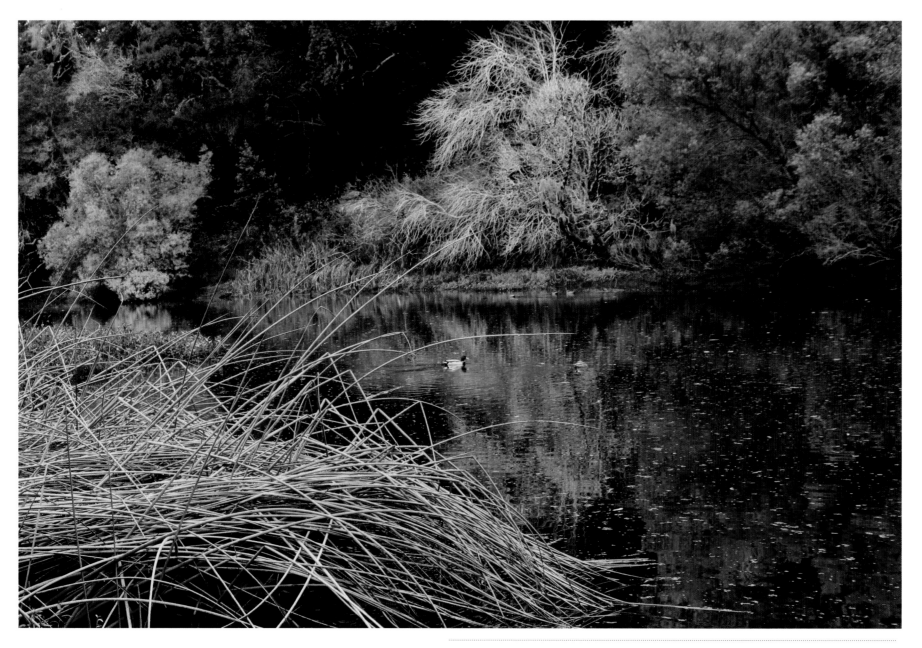

ABOVE: Bob Clark, *Fall Colors and a Duck,* Windy Hill Open Space Preserve, 2010

TOP RIGHT: Vaibhav Tripathi, *Black Mountain Moonrise,* Monte Bello Open Space Preserve, 2011

BOTTOM RIGHT: Eric Lew, *Stevens Creek Nature Trail,* Monte Bello Open Space Preserve, 2008

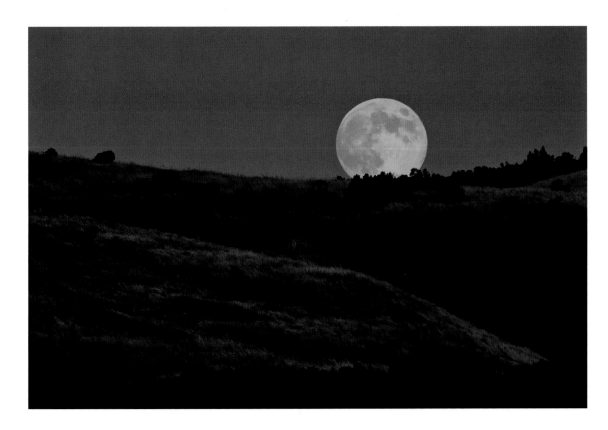

from
"Twilight at the Creek"

Do ducks slide into sleep as we do,
finding it necessary to drain their minds
for rest? Do they meditate?
Standing in the newly cold, pewter light,
I watched them in their monklike stillness.
How completely they give attention
to the oncoming dark.

—Charlotte Muse

Bat Rhapsody

for Eric

O little ships wrinkling the air,
yawned out of caves' mouths
to sail the oncoming dusk,
we greet you! Supremely skilled
navigators of the night,
able to home in on a pin,
we salute you!

Summer evenings, there you are,
out beyond the glare of cars
listening for food.

We praise your intricate ear shapes,
formed by a mushroom-loving God;
the triangle of your face by the One
who understands geometry. Your eyes
not blind, but bright in your face fur.
The glory of your hand wings, Chiroptera—
you fly and scoop and feed all at once,
like a juggler in the air eating peanuts!

I, the land anchored,
become dull-eyed and fat
and drugged by machines,
vow by this poem to change my ways.
I will free my eyes
from the lighted screens,
give up making love to the phone,
set down the cup of despair,
and go look at bats.

—Charlotte Muse

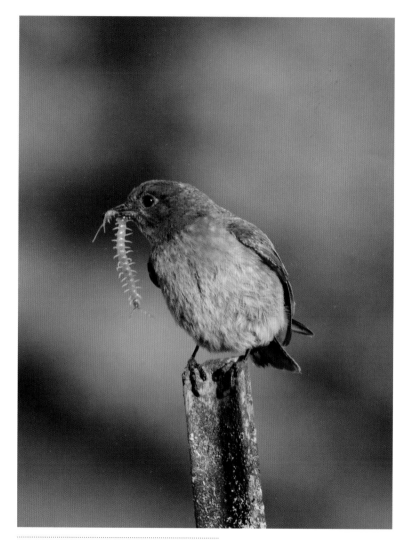

ABOVE: Jacob Osborne, *Bluebird with Prey,*
Long Ridge Open Space Preserve, 2009

RIGHT: Greg Heikkinen, *Winter Clouds,*
Fremont Older Open Space Preserve, 2010

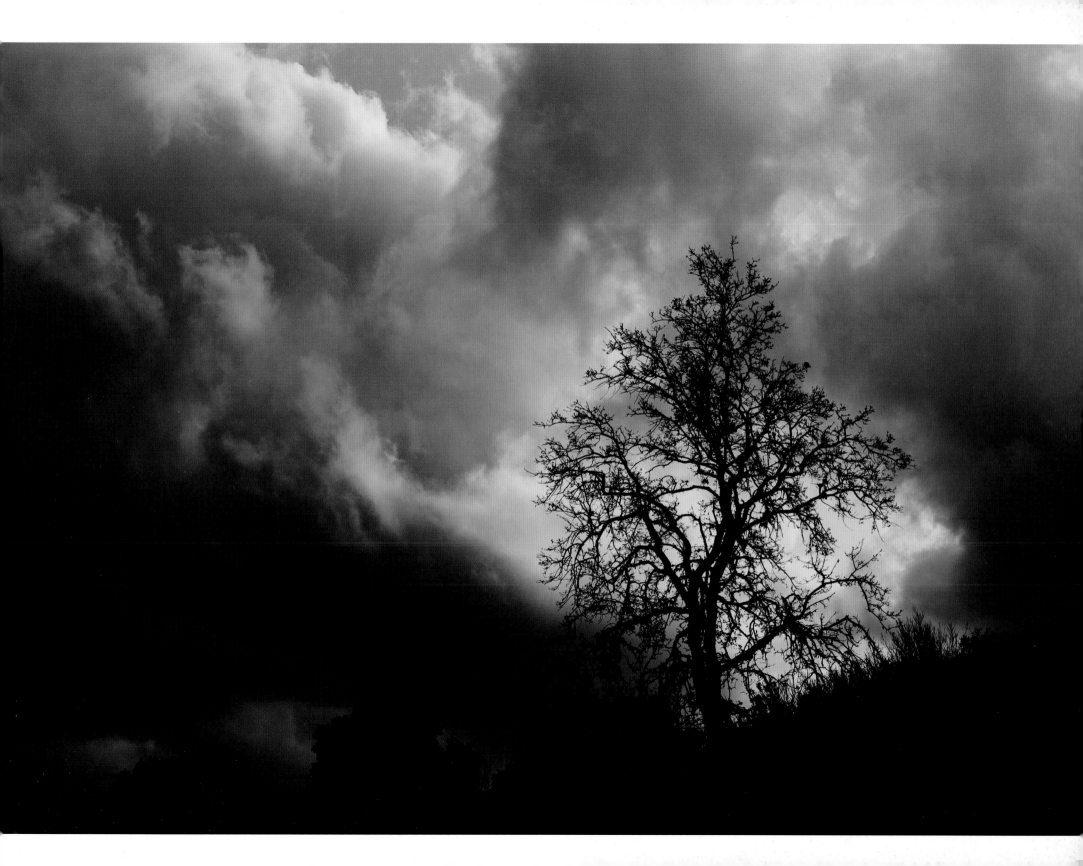

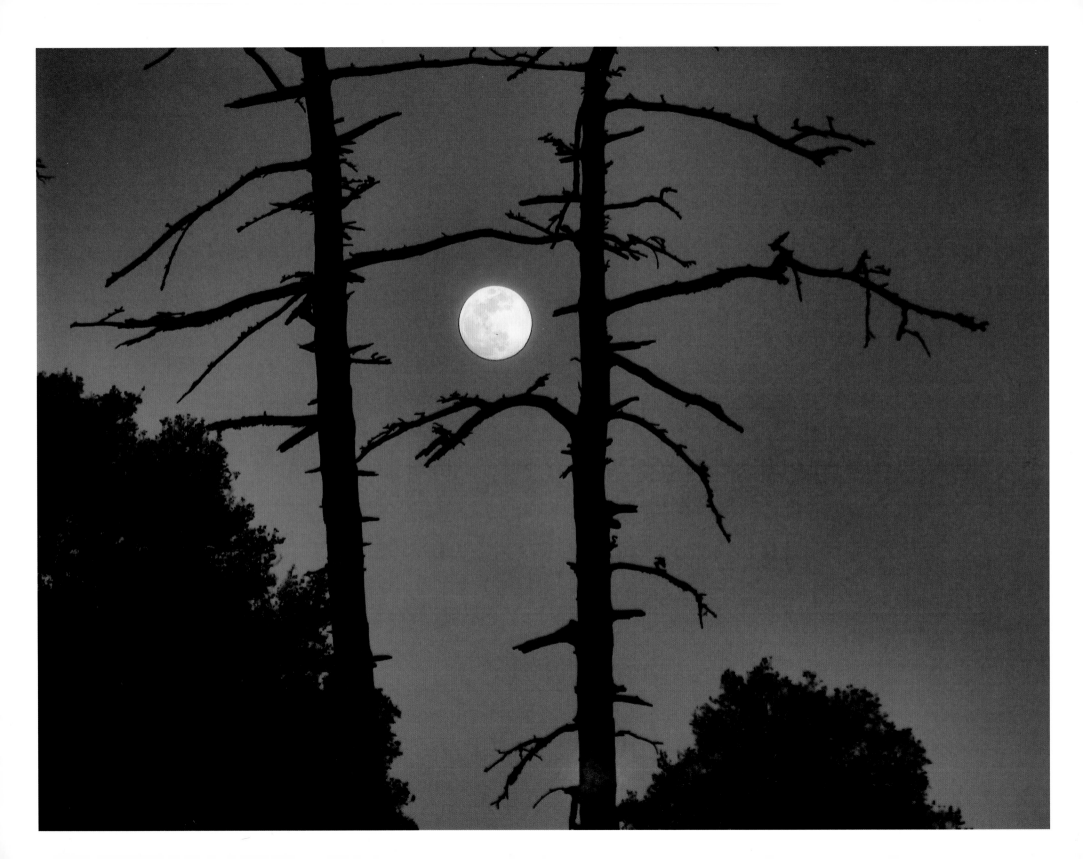

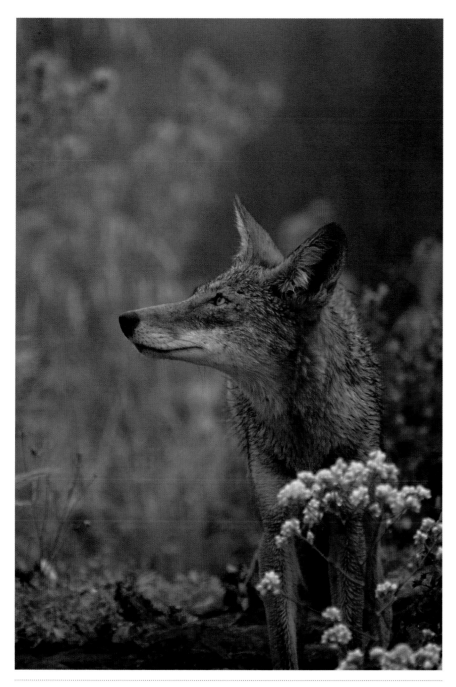

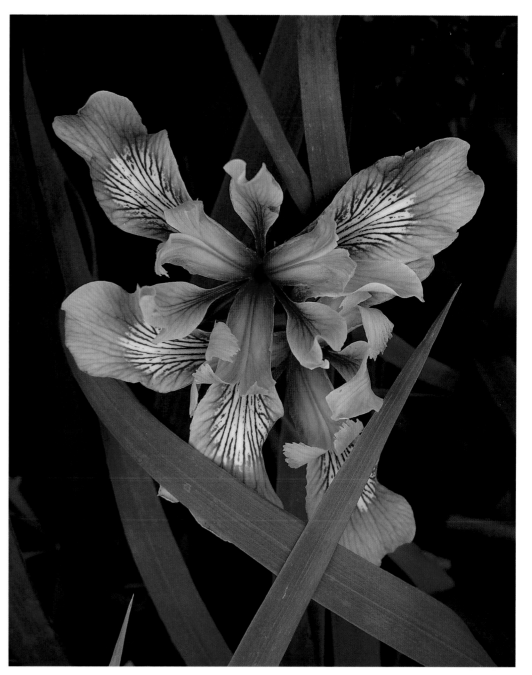

ABOVE: Jacob Osborne, *Voices on the Wind,* Long Ridge Open Space Preserve, 2008

ABOVE: Deane Little, *Wild Irises,* Thornewood Open Space Preserve, 2005

LEFT: Deane Little, *Rising Moon through Snags,* Russian Ridge Open Space Preserve, 2006

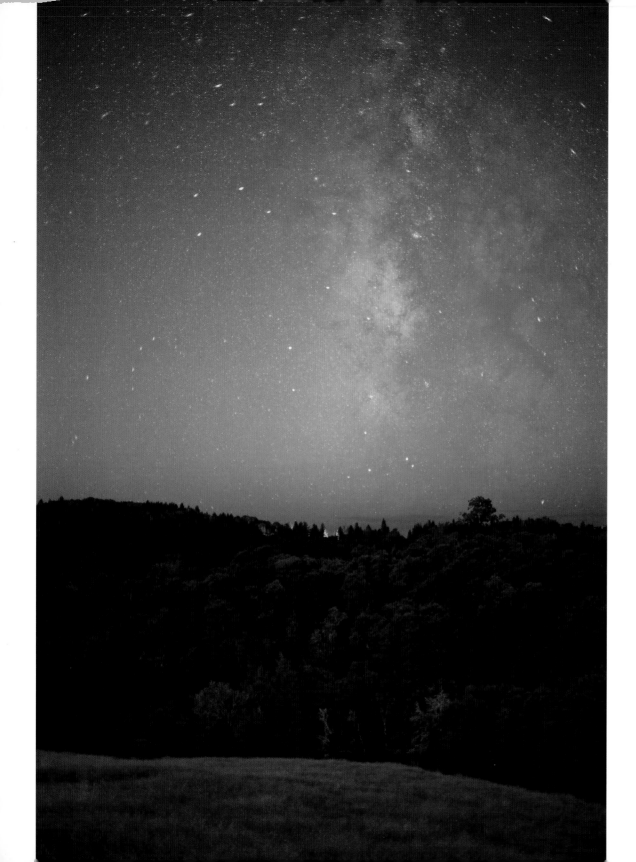

Evening in the Forest

A leaf floated gently down through the trees.
The flowers closed up.
They were done being pollinated
By the last of the bees.

A bird picked up the leaf and carried it away.
Settle down, the night is coming,
The leaves on the trees always say.

Baby birds heard their mother and cried out.
The forest darkened slowly,
Like water dripping from a spout.
Nothing moved, all was still.

The stars poked through the heavy blanket of night.
Shadows were chased away by the faint glow of light.

Goodbye, good night,
Don't wait til first light, the last bird chorused.
Then everything settled in, in harmony,
With the dark forest.

—Lani Southern, written at age eight

LEFT: Vaibhav Tripathi, *Monte Bello Night Sky,*
Monte Bello Open Space Preserve, 2011

RIGHT: Vaibhav Tripathi, *Oak Tree and Moonrise at
Sunset,* Monte Bello Open Space Preserve, 2011

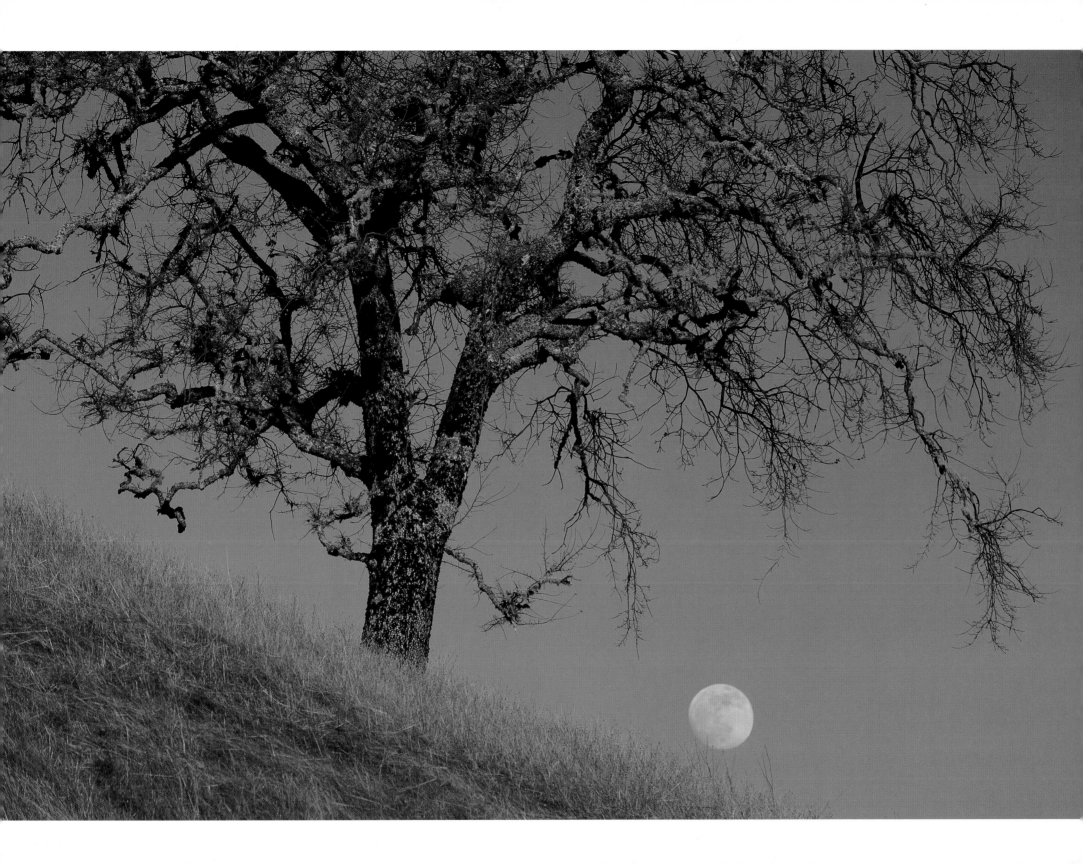

In the end, we will conserve only what we love, we will love only what we understand, and we will understand only what we are taught. —Baba Dioum

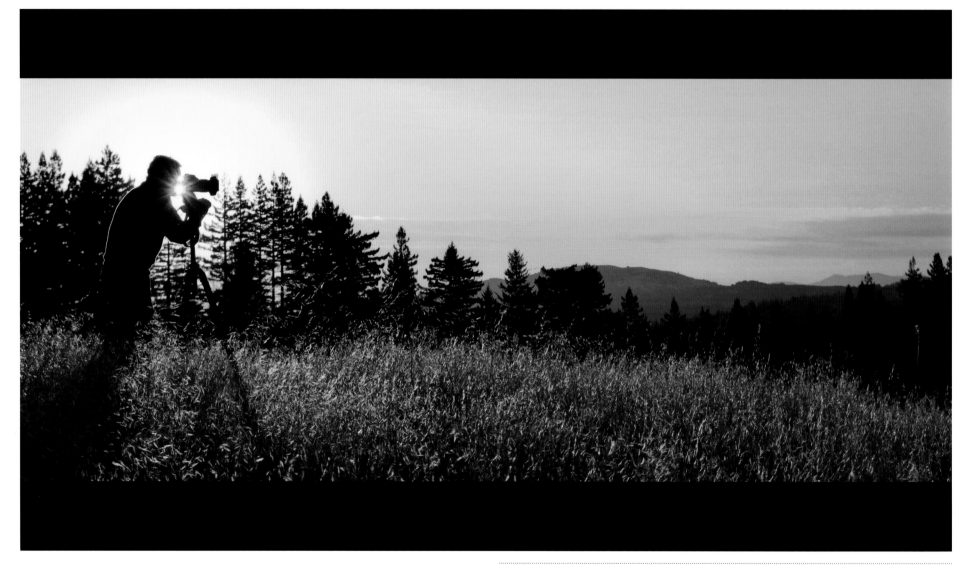

ABOVE: Alex Stoll, *Skylonda,* La Honda Creek Open Space Preserve, 2008

RIGHT: Karl Gohl, *Sunset Ridges through Dancing Snags,* Russian Ridge Open Space Preserve, 2007

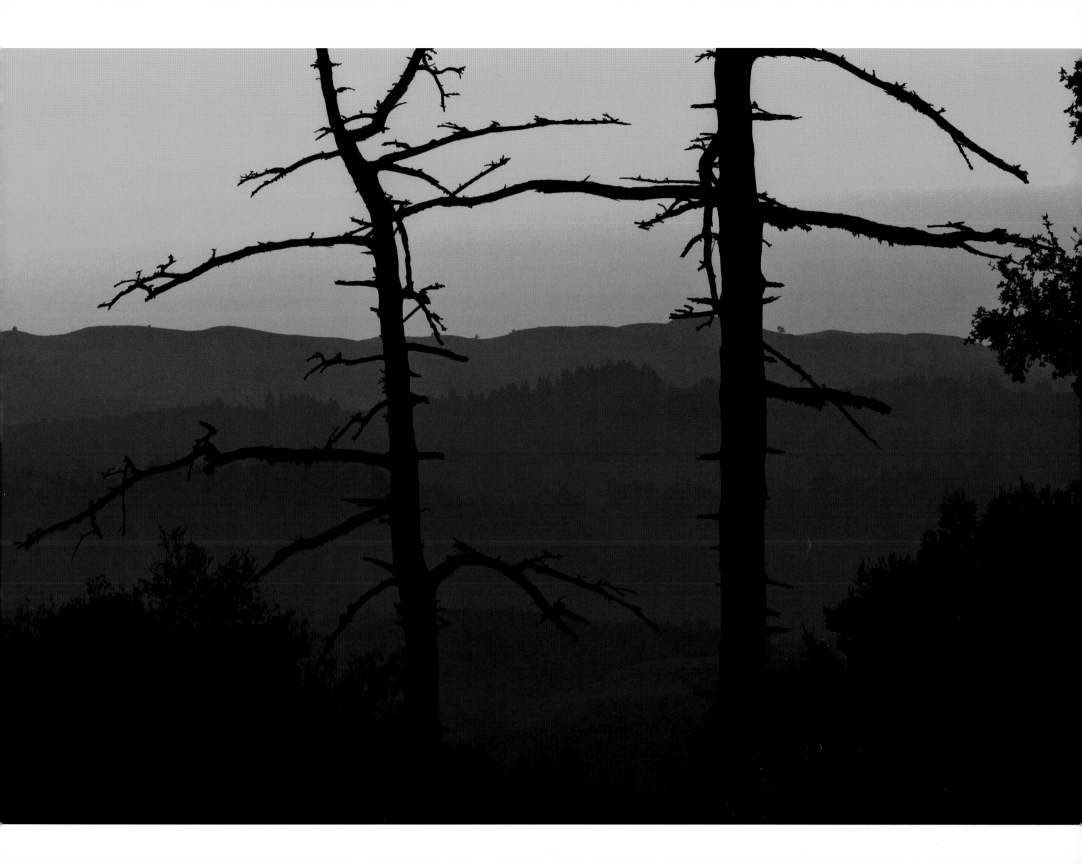

The Inspirations for the Works

The artists, photographers, and poets included in this book were each asked to contribute a statement addressing their work, as well as the value and importance of open space, memorable experiences at preserves in the Midpeninsula Regional Open Space District, or opinions about the best time of day or year at their favorite preserves.

Steve Abbors

page ix

Every visit I make to a District preserve is memorable because each is so unique. I never know which animals I am going to see on a particular day, although I am aware of who should be around in a particular season. It could be the ringneck snakes in the fall, the western newts traveling to and from their summer hibernacula, the first brood of tiger swallowtails in the spring, or the varied thrushes calling in the dead of winter. All are old friends, and yet each time I see them again for the first time in a given season, I feel the same excitement I felt as a young boy wandering the hills of my native East Bay. While their progress is a bit more measured, it's the same for plants. The milkmaids and hound's tongues in late winter are followed by the pink flowering currant and other woodland species; then the wildflowers begin to bloom and the chaparral comes alive with the pinks of the manzanita, the whites and blues of the ceanothus, the yellow of the bush poppy, and later the cream of the chamise.

One of my most favorite places to visit is the PG&E Trail in Rancho San Antonio Open Space Preserve, particularly in the late spring when the wildflowers are at their peak, the butterflies are out in great numbers and variety, and the woodland birds are in full song. It is on this trail that I encounter the Merriam's chipmunk more frequently than any other native mammal. At first I was oblivious to the tiny denizen of the chaparral/woodland edge. Initially I thought I was hearing the call of a female pygmy owl and over the weeks was surprised at how many there seemed to be at Rancho San Antonio Open Space Preserve. They are notoriously hard to locate, and as hard as I searched, I could not see one. However, I began to notice Merriam's chipmunks in the vicinity and was very surprised one day to watch one of these smallest of squirrels making the call I had attributed to the pygmy owl. Suddenly I realized that Merriam's chipmunk was a species that was very common, yet not often seen, all along my favorite trail. Occasionally I am lucky enough to see one eating thistle seeds along the edge of the trail or harvesting blue elderberries high up in the branches. But mostly I hear their chirps every several hundred yards or so and feel all the more one with my surroundings. As I see people pass me with earphones on, I wonder if they will ever be able to fully appreciate the subtle and ever changing chatter and chorus that accompany the sights and smells of the preserves.

Editor's Note: Steve Abbors is the Midpeninsula Regional Open Space District's general manager.

page 74

Howie Anawalt

I walk in our hills as often as I can. Usually I go alone or with my wife, Sue. I go when I'm up, when I'm down, and when I'm in between. I inevitably find quietness and a larger, reassuring space. I hope someday to glimpse a cougar. They live many places I go. If they're nearby, they surely look at me. Probably a lazy glance.

This photo was taken in Sierra Azul Open Space Preserve during mid-morning in early spring 2011. Low white clouds have started to pour over the mountains to the southwest. The dark green constancy of the distant ridge contrasts with a lichen-covered range of exposed boulders. Not too long after, a light rain began. A perfect morning.

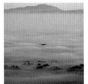

page 43　　　page 44　　　page 66

Mike Asao

To spend a couple of hours in the outdoors is good for my health and relaxation. I started to walk almost every morning with cameras at several open space preserves and county parks five years ago. In June 2009, I had a personal photo exposition at my house and about one hundred people came and viewed the photos I had captured at open space preserves and parks. Many visitors said they felt healing from my photos. From then my main photography subject became healing.

In spring, the best places to see many wildflowers are Rancho San Antonio Open Space Preserve's High Meadow Trail, Upper High Meadow Trail, and the PG&E Trail. I recognized more than sixty species. On Windy Hill Open Space Preserve's Anniversary Trail, in early morning if the fog is around, you can see a gorgeous sunrise just above the sea of clouds. It's quite a healing time. On top of Rancho San Antonio Open Space Preserve's Mora Trail, I feel the contrast between the artificial landscape and the real natural landscape of Silicon Valley. I am very lucky to be here, less than fifty minutes' drive from the busiest business center of Silicon Valley.

Laurie Barna

page 49

After "meeting" a number of rescued birds from the Sulphur Creek Nature Center at an educational event, I created several paintings and donated money to this organization so their work could continue. I was invited by them to attend a donor appreciation night at their center in Hayward, where I had the opportunity to get up close and personal with a rescued great horned owl named Boris. Recently, while undergoing veterinary care, the staff discovered Boris was a female owl! What to rename her after years under their care? Boris-a, of course. Although unable to fly, she was still powerful, elegant, and a credit to her species.

Open spaces are for everyone to enjoy—people as well as wildlife. How blessed we all are to have so many open spaces in our Bay Area. My advice? Get outside, get some sun, fresh air, and exercise, and who knows, you might have a close encounter with something special, like an owl.

Oksana Baumert

page 32 page 39 page 65

I am an expressionist painter, nurtured and inspired by the landscape of my adopted home, California. I consider myself very fortunate to live in an area where miles of open spaces are preserved and carefully maintained for our enjoyment. At Monte Bello Open Space Preserve, where I have been hiking for years, every visit is a new experience. The rolling hills and spectacular colors of light at various times of the day make every hike meditative and rejuvenating. I file away each visit in my memory for future use in my paintings.

One of my most memorable experiences occurred on a clear, warm spring evening at the end of a two-hour hike at Rancho San Antonio Open Space Preserve. I took a moment to sit down on a bench to watch the deer in the meadow as the sun began to set behind the hills. The golden light was picture perfect and it was hard to leave. As I headed back to my car, I heard gentle hoof-steps on the wooden bridge behind me. I turned and saw that a curious young deer was following me. For a moment we looked into each other's eyes, then she turned and darted past me.

page 71

Edwin Bertolet

Being outdoors reestablishes my connection to nature and affirms who I am. The open space allows me to ground myself and strengthen my sense of belonging to the world. I can shed the artificial things of the city and renew my spirit.

The silence and serenity of our open spaces provide a timeless quality that allows me to link with past and future in one unbroken chain. I can imagine what those before me experienced, and hope that new generations will meet me in the same place.

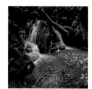

page 73

Dean Birinyi

In my profession as an architectural photographer, I am heavily influenced by the built environment. I like to escape the modern world and explore the many open spaces we are fortunate to have here in the San Francisco Bay Area. I leave behind the works of man and immerse myself in the peace and harmony of nature. I often find myself listening to the wind in the trees, the flow of water in a stream, or the sound of insects singing in the grass and reveling in the freedom. My wife, Erica, and I came across this waterfall in Coal Creek Open Space Preserve during the early autumn, when there was barely a trickle of water from most of the many natural springs that flow year round in the preserve. I came back during the rainy season to capture the magical atmosphere of this storybook forest scene.

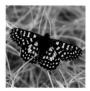

page 20

Frances Freyberg Blackburn

My best childhood friend, Ashley, introduced me to hiking many years ago, and Purisima Creek Redwoods and Windy Hill Open Space Preserves are two of our favorite places to hike together. We've covered most of the trails in every season and in all types of weather, and they have faithfully served as beautiful backdrops for serious conversations on life and love, as well as the companionable silence of old friends. Ashley moved to the East Coast a couple of years ago, but we still get together to hike and share stories when she comes home to visit family in the Bay Area. As our lives continue to change over the years, it's comforting to know that these open spaces are both a tie to our past and will also remain a constant in our future.

In addition to catching up with friends and family over a hike, I also enjoy our open space preserves as special places to contemplate and enjoy

the beauty of God's creation in solitude. One of my favorite aspects of having open space nearby and accessible is the opportunity to see the landscape change with the seasons and the weather. I've hiked and photographed Purisima Creek Redwoods Open Space Preserve in sunshine and in fog; in early morning and late afternoon; when the trail is lined with springtime flowers and, later, autumn leaves; when banana slugs are out in force; and when ladybugs blanket the forest clover.

Through my photography, I hope to educate people about our world, and to interest them in the natural beauty that surrounds us. I believe that photographs have a unique ability to inspire reflection, hope, and action. They hold the power to spark memories and encourage new adventures. They enable viewers to see familiar surroundings from a fresh perspective, or to explore uncharted territories for the very first time.

I was born and raised in the San Francisco Bay Area, where I grew to love the great outdoors. Childhood trips to exotic locations fostered an early appreciation for different places and cultures, as well as a continuing passion for travel. In 2008, I left my job in high-tech communications to travel the world for a year, taking photographs and writing about my experiences. During that time, I built an educational travel weblog with weekly photos as well as historical and cultural information about the countries I visited.

I specialize in portraits of people, wildlife, nature, and architecture from my travels to more than sixty countries. I'm particularly drawn to scenes that express the beauty, excitement, humor, and diversity of our world, whether through a brilliantly colored blossom or a poignant face in the crowd.

Jason Bromfield

page 54

As an outdoor enthusiast, I have always found my inspiration in nature. I love to paint what I notice early in the day and in the early evening, when the light draws out the shadows and seems to exaggerate the colors. Once I find a subject, I quickly try to capture the feeling that first drew me to it. To accomplish this, I'll often try to finish a painting in one sitting.

My work consists of small pieces done on location and larger pieces finished in my studio. I find the small pieces more difficult to produce, as the environment can quickly change. For the same reason, this process can also be far more fulfilling. I

find it also helps keep my work loose and has let me develop my style of brushwork.

Recently my wife and I rescued an extremely shy dog from a shelter. We started visiting the Pulgas Ridge Open Space Preserve to exercise and socialize her. We quickly bonded with the dog and we feel very fortunate to have this space close to us.

A short venture into the El Corte de Madera Creek Open Space Preserve makes you feel like you're nowhere near civilization. In the fall, the treetops gather the fog, which comes raining down as the trees sway back and forth in the wind. It is clearly one of the most beautiful places on the peninsula.

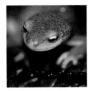
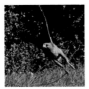

page 14 page 41

Brian Bucher

When I hike through the open space preserves, I am always at peace and all of my worries seem to fade away. Photography in the preserves allows me to appreciate the subtleties of nature and capture its beauty.

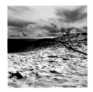

page 65

Tim Chavez

I was a freshman in high school when a mountain biking friend first introduced me to Fremont Older Open Space Preserve. I still vividly remember that day; finding out there was such an amazing place to escape to, so close to home, just thrilled me. That same feeling still comes back to me every time I visit one of the preserves. Now I've been visiting the open space preserves for over half my life. Having those places to go to has been an important part of my development as a complete person, and I hope to be able to share those places with my own children some day.

Monte Bello Open Space Preserve is a magical place to escape from the noise and stress of the valley below. In the summertime, you can close your eyes and hear nothing but the sound of a soft breeze gently blowing through tall, dry grass. Smelling the sweetness of the air, you feel as though you are breathing for the first time. In the winter, with that same spot dusted with ice and snow, I lose myself beneath a dramatic sky that leads the eye all the way to the Pacific Ocean.

page 61 page 82

Bob Clark

I love the tranquility of open space as an escape from the hectic pace of Silicon Valley. Hopefully these pictures capture and can share this with everyone who sees them.

One of my favorite memories of hiking in open space was on a docent-led night hike. We were encouraged to try turning off our flashlights for a short section of trail with heavy tree cover. It was a wonderful, timeless feeling walking through the woods with barely any light. Fortunately there have also been many special times that are easier to show in a photograph.

Kit Colman

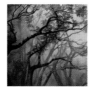

page 68

Having access to the open space preserves since I was a young child probably affected who I am today. Being shy and introverted, I would steal away for hours to sit in the fields overlooking the bay or the redwoods shading the crest of the hills. In my silence, I was able to observe bobcats, foxes, coyotes, turkeys, and hawks, along with the deer and other regular occupants. I grew up valuing this amazing space that was available to me. Today I still go out and explore, but now usually with a small group of friends who also truly appreciate this land surrounding us. It is with my paintings that I celebrate this freedom that still exists for us in the open space preserves.

Sue Copeland

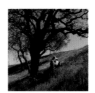

page 3

This photo was taken at Rancho San Antonio Open Space Preserve. We have always admired the beautiful old oak trees, lush grass, and wildflowers in the springtime. This preserve is heavily used, but we had this particular area to ourselves late one afternoon. The photo is of my husband under one of the oak trees, wearing his photographer's vest and Indiana Jones hat. We really enjoy immortalizing the special times and places we've experienced in the Midpeninsula Regional Open Space District preserves.

Karen DeMello

"Windy Hill in Winter," page 63

from "Three Views of Mindego Hill," page 80

On an overnight backpack trip to Black Mountain with friends, I woke early the next morning to blue sky and sunshine above and thick fog below. The fog was like a vast ocean surrounding us, and I felt as if we were on a private island in the sky. A magical experience indeed.

When I am on Midpeninsula Regional Open Space District lands, I feel connected to the past, the present, and the future through the landscape and vistas. I feel whole, I feel hopeful, I feel happy. Open spaces provide respite for today and generations to come.

Editor's Note: Karen DeMello is a Midpeninsula Regional Open Space District docent.

"On the Path," page 35

Maureen Draper

Having lived adjacent to Monte Bello Open Space Preserve for thirty years, I have walked or mountain biked on the trails almost every day. It's not only easy but seductive. I especially love the western bluebirds, year-round residents in Monte Bello Open Space Preserve, who seem to observe the sunrise and sunset, as we do. In the spring, I may see buntings and a raptor at any time. I've had many close encounters of mutual curiosity with deer and coyotes and even occasionally a bobcat, or bob kitten. Once I managed to walk right past a deer at rest under a tree without disturbing it. I've yet to see a puma, but I'm still hoping.

It's become vital to my well-being to feel the earth beneath my feet at least once a day, without intervening concrete. Particularly after rain, the scents of the earth and the California bay laurel are delicious. Being surrounded by the natural world reminds me I'm part of something larger and, as the poem says, "I find my proper size," smaller, but more connected to the whole.

Editor's Note: Maureen Draper is a Midpeninsula Regional Open Space District docent.

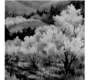 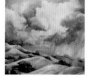

page 27　　　　page 62

Kay Duffy

Windy Hill (page 62) was painted in 1998, after a beautiful spring hike with my hiking group up the face of Windy Hill for a picnic at the top and then back down via Razorback Ridge Trail. On the way, I did a quick sketch and took some photos.

Apple Orchard (page 27) was painted in 2006 on District property off Stevens Canyon Road. My painting group had obtained a permit to paint on site when the blossoms were full. There are some wonderful old buildings and barns on the site, and a rental property.

For me, contact with wild, open spaces and the beauty of nature have healing power that keeps me strong and creative. Fear of losing these wild, beautiful spaces leads me to support numerous conservation organizations, including the Midpeninsula Regional Open Space District. In 1972, I actively campaigned for the formation of the Midpeninsula Regional Open Space District and served twenty years on the board of directors. For forty years I have led monthly American Association of University Women hikes. And I garden and grow great tomatoes!

I bring this passion for nature to my watercolors. Most often I paint plein air, where I feel connected to the natural places I love. There I see light and

shadows, feel temperature, hear the birds, and smell the blossoms. Even dealing with the discomforts of working outdoors keeps my work spontaneous, loose, and impressionistic.

Many years ago my painting group was at Picchetti Ranch Open Space Preserve when a newspaper reporter turned up. We were thrilled to chat with him and complain about having to get permits (at that time) to paint there. We were not so thrilled when we read the article, which quoted the complaints of the "women octogenarians." (Hey, I'm not that old—yet!)

In December 2011 I hiked near Highway 9 along the fairly new Achistaca Trail in Long Ridge Open Space Preserve. It was a little foggy, with damp, earthy smells, and it was very, very quiet except for the dripping trees and the crunchy leaves. The beautiful contorted trunks and branches of the trees in the fog will be a future painting! Too bad I can't capture the smells as well.

Editor's Note: Kay Duffy is a former Midpeninsula Regional Open Space District board director.

Elyse Dunnahoo

page 56

Upon my frequent visits to the Midpeninsula Regional Open District's Windy Hill Open Space Preserve, I ask myself mindfully what I delight more in experiencing: The subtle, warm glow of the sunset? The blue-violet shadows looming large, cast by the oak tree? Or the red-tailed hawk, her quiet silhouetted body observed, her eyes scanning intently? Or the found seed pod, its geometry revealing a logarithmic spiral, or the lovely green hue of the lichen, or the sweet face of the salamander? Or the caws of the ravens communicating to their social unit that I am in their space? Or the feeling of the air's freshness on my skin, the fragrant smell of Earth? Or the exploring buckeye, its intricate wing pattern mesmerizing me? I conclude without a definitive answer but relish how grateful I am to consider the beauty before me.

Sheryl Ehrlich

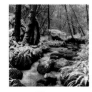

page 67

My favorite time at an open space preserve was during a rare snowfall in a mossy canyon at Long Ridge Open Space Preserve.

Therese Ely

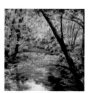

page 68

I truly enjoy walking along Purisima Creek in April. A walker has the sense of being in a wild, untended garden. The creek is running full; spills of water chuckle over rocks and spread out quietly in broad shallows. In April, the coastal fog is likely to recede and the sunlight through the new foliage of the big-leaf maples is blindingly bright. Human noises are muffled by the forest litter underfoot. A surprise drip of water from redwoods overhead; bright yellow banana slugs: both bring a sense of playfulness to the garden. These are the impressions that inspired me to paint *Spring Flood*.

Ross Finlayson

page 48

The open space of the San Francisco Peninsula is a national treasure. How remarkable it is to be able to enjoy such a vast, beautiful, and peaceful expanse of nature less than an hour's drive from a major urban area. Whether on foot, on bicycle, or on horseback, one can soon encounter a scene that shows little sign of human presence. And such was the case when I took this photo of Horseshoe Lake in Skyline Ridge Open Space Preserve. Just yards away, the Bay Area Ridge Trail Council was holding a large group hike and ride. But here I was, experiencing the calm and solitude of a rustic lake.

Andrew Forster

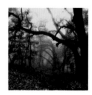

page 70

For as long as I can remember I have loved nature and the outdoors. When I was young, my parents took us camping often and some of my fondest memories are of hikes we took as a family. As I grew older, I eventually lost touch with hiking and the outdoors, choosing to live a sedentary life instead. A few years ago, I met a handful of very special people whose passion and encouragement rekindled my long lost love of nature. It was in many of the Midpeninsula Regional Open Space District's open space preserves where my new-found love of the outdoors and hiking matured. A few years ago I didn't even know these preserves existed, but now thanks to a healthy curiosity I have enjoyed hikes

in nearly every preserve. I have built up my own passion for many of the preserves and cherish every opportunity I get to share them with others. When a new friend or family member asks me to plan a hike, my first choice is usually in one of my favorite preserves. If they want a challenging hike, I know where to take them. If they want an interesting hike, I know where to take them. If they want to simply enjoy beautiful scenery, I know where to take them. This is why I love the District's open space preserves, and it is why I keep coming back.

One day a friend and I decided to go for a hike. Sierra Azul Open Space Preserve was not the destination we had in mind when we started out, but something drew us to change our minds. It was the beginning of December and the weather was cool and overcast. We drove up Hicks Road toward the entrance to the Woods Trail and noticed how thick the fog was almost immediately. When we reached the Jacques Ridge parking lot (near Hicks Road), the fog was so thick we could barely see ten feet in front of us. Since both of us had hiked the trail many times we were confident we'd be okay in the limited visibility and we were certainly rewarded for not turning back. Normally, we hike pretty quickly, but this day was very different, for we couldn't stop taking pictures. We had never seen a scene quite like this. A thick fog blanketed the ground and hugged the trees while thinner fog hovered above, letting a hint of the blue sky sneak through to accent the scene. The result was both beautiful and hypnotic.

Anna George

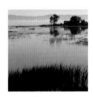

page 9

I enjoy the preserves because they make it possible to put a little adventure in my week. You can end up "accidentally" riding miles farther than intended, and you never know what you might see around the next corner: a crazy explosion of wildflowers, a flock of turkeys gobbling their way up the hillside, a playful coyote trotting along the path ahead until it veers off into the grass to pounce on lunch, or a bobcat lazily sunning itself in the grass. It's also entertaining to encounter other people gaping in sheer wonder at the same.

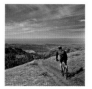
page 1

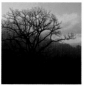
page 8

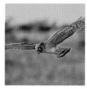
page 42

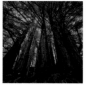
page 47

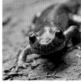
page 50

page 78

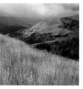
page 80

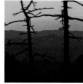
page 91

Karl Gohl

We spend so much of our lives in environments of concrete, steel, sheetrock, and silicon. Some have no need to go beyond the home, office, and mall; no desire to go where the air is not conditioned. I need modern conveniences as much as anyone, but I also need to experience places that have escaped the heavy hand of humans. I'm so glad that so many other people in our area need open space too.

Next to the Alder Spring Trail at Russian Ridge Open Space Preserve, there is a pair of tall dead trees. Each time I pass them, I enjoy how their trunks and branches remind me of a couple doing a ballroom dance. However, I can never decide: waltz or rumba?

Editor's Note: Karl Gohl is a Midpeninsula Regional Open Space District volunteer.

page 50

Denise Greaves

I love visiting Sausal Pond, where the trail leads down to the shore, on a warm summer day to watch for dragonflies and damselflies. That's the place where I saw my first striped meadowhawk, paddle-tailed darner, and desert firetail (a small red damselfly). A couple of times, through the zoom lens of my camera, I've spotted wood ducks on the other side of the pond.

Another favorite place is Horseshoe Lake in Skyline Ridge Open Space Preserve. My husband and I enjoy going there together in the summer. He likes to draw and sketch, so often he'll sit on a bench and sketch while I wander up and down the trail snapping photos. In addition to dragonflies and damselflies, I enjoy capturing shots of butterflies, spiders, lizards, birds, rabbits, flowers, and everything else.

A visit to an open space preserve wakes up something inside me. Suddenly I'm more aware, more tuned in to the world around me. On a warm day on the shore of Horseshoe Lake or Sausal Pond, I can close my eyes and feel and smell the warmth and life. Hearing the occasional bird call or clatter of dragonfly wings adds to the picture.

Greg Heikkinen

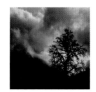

page 85

I first started going to Rancho San Antonio back in high school with my friends Mark and Chris. It was my first experience of the outdoors and coincided with my taking up photography as a hobby. None of us had cars, but Rancho San Antonio Open Space Preserve was close enough that we could ride our bikes or even walk if we couldn't hitch a ride with someone. Its being so accessible meant that we could go after school two or three times a week and usually all day on the weekend. We spent our time exploring the trails and looking for wildlife (it was rarer in those days). Hawks were fairly common, deer less so. I remember being amazed once when we spotted a fox in the distance. All the time I spent at Rancho San Antonio Open Space Preserve back then had an influence that has shaped my entire adult life. To this day, when I get together with my old friends we can't help but reminisce about all the time we spent at Rancho San Antonio Open Space Preserve.

Being outdoors is literally being in a different world. Most of our lives are spent indoors under artificial lights or stuck in traffic wishing we were somewhere else. Then there are all the demands on our time. Headaches at work, errands to run, bills to pay. The value of someplace close by where you can step away from all the stressful things in life is immeasurable. Someplace where there is always something new to explore. Where you are surrounded by peace and beauty. Someplace that can provide balance and fresh perspective in our lives. A lot of people never get to experience these things. We are truly fortunate to have them so close by.

My favorite preserve is the one I happen to be in right now. The thing about photography is that it trains you to always look around for interesting things. Every time I visit a preserve, it's different, new. Even trails I've hiked a hundred times never fail to yield new delights. There are too many hilltop views, shady green trails, pungent manzanita smells. And then there's the light! Pale and shadowless in winter, warm and low in fall, bright and shiny in spring, soft and golden in summer. It's all good!

Hazel Holby

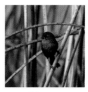

page 31

Heading to Sausal Pond at Windy Hill Open Space Preserve from Highway 280, I always think about the different worlds of Silicon Valley. Go left on Sand Hill Road and you can meet with some of the finest venture capitalists in the world. Go right and you can meet with some of the finest wildlife in the world; you can see coyotes, hawks, and a variety of birds, including the intrepid wrentit, a small songbird found only on the west coast of North America.

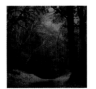

page 72

Rob Holcomb

As Woody Guthrie put it, "This land is your land." It is not about what is mine but what is yours, and collectively that makes it ours. The open spaces make me realize how much beauty and strength there is in our forests, meadows, and wetlands. I get a thrill that lasts days when I'm able to disappear into nature for a few hours once or twice a week.

El Corte de Madera Creek Open Space Preserve is my favorite place to be lost (during daylight hours only) because it takes me back to a simpler time. It gets me thinking about the people who settled this land around our bay and how ancient some of these forests are. On a cool and misty autumn day, I can spend my time watching the way tendrils of vapor wind through the branches of the trees or the way the sandstone formation seems to watch through the haze with thousands of eyes. In springtime, the meadows of Rancho San Antonio Open Space Preserve always have a surprise—sometimes the early blooms of flowers or a fawn staggering through the grass, or a watchful coyote staring at the ground waiting for the vole to move. Wildcat Canyon in Rancho San Antonio Open Space Preserve has many moods also. Sometimes the water is raging and sometimes the forest is so dry you kick up clouds of dust just walking. The bay laurel trees seem to lean away from each other in fits of laughter and the manzanita beckons you deeper into the forest.

And I want to share this.

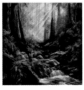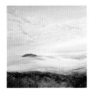

page 46 page 49 page 79

Rebecca Holland

As a teenager living on Kings Mountain, I rode my horse all over the trails on Kings Mountain. My greatest fear was that it would all be gone someday. We used to keep the location of the few remaining virgin redwoods secret; we thought it would keep them safe somehow. Now they are a part of Purisima Creek Redwoods Open Space Preserve, and they belong to us all.

I am still riding and hiking on my favorite trails. I save my photographs, sketches, and memories of all those days, memories of galloping through the woods with my friends on a crisp fall morning, sliding over mossy boulders in a rainstorm, lying in the grass watching the fog turn colors as the sun goes down over the ocean. I find my inspiration in nature. My art is a celebration of the magical beauty I see all around me, and my life as an artist is one of sharing what I see and feel.

Tunitas Creek (page 49) was painted in 2008 for a poster commissioned for the Kings Mountain Art Fair, to celebrate the forty-fifth annual Art Fair. The fair raises money for the Kings Mountain Volunteer

Fire Department, the local school, and other local organizations. I chose fresh running water because it is a precious resource and one worth celebrating. *Kings Mountain Evening* (page 79) was painted in 2010 from photographs taken many years ago. It is a view of the fog over the ocean, and I've seen it countless times, but still it never fails to amaze me. *Virgin Forest* (page 46) was painted in 1996, commissioned by a longtime Kings Mountain resident. We went on a long hike, collecting photographs of our favorite things, and put them into this composite of Soda Gulch.

Paul Huang

page 26

On one chilly January afternoon in 2002, the snow started falling and by early evening several inches had accumulated along Skyline Boulevard and Page Mill Road. I drove up to Russian Ridge Open Space Preserve and the surrounding area and found others had stopped all along the road to play in the snow, including tubing down the gentle hills! I had moved from New England many years before, and this brought back fond memories of playing in the snow. As if the day were meant to be remembered, the twilight sky turned purple-pink with scatterings of thick clouds and a peeking moon and city lights. Never had the feel of New England been so at home in the Bay Area.

Although I love going to any of the preserves on a colorful spring morning, what I especially love is Purisima Creek Redwoods Open Space Preserve in the winter. Not only are the mushrooms, banana slugs, and mini cascades out in full force, this is when the ladybugs come out to play. And I do mean fooling around when I say "play." Be ready to explain to your kids why thousands of the critters gather in tiny patches of vegetation; it ain't just to stay warm!

Nina J. Hyatt

page 6 page 34

Born and raised in the San Francisco Bay Area, I spent most of my youth outdoors, hiking and wandering the hills, valleys, and coastlines of Marin and Mendocino counties, as well as backpacking and skiing in the Sierra. Through the years, I continue to be awed by this region and its particular beauty, geography, and ever-changing moods and light.

My hope for each new painting is that it will convey a sense of the hidden story and character in the land as I experience it. In the time-honored tradition of the early California impressionist pioneers of nineteenth- and early twentieth-century painting, I have recently taken up the exciting

challenge of painting plein air, on location, whenever possible.

My husband and I have been hiking and exploring the Midpeninsula Regional Open Space District lands with our dogs for many years. We feel so grateful to live in an area where our predecessors had the foresight to set aside and preserve undeveloped areas of landscape for wildlife to live in, and for people to visit and enjoy. Our most cherished hike is at Windy Hill Open Space Preserve, where we have completed the Spring Ridge Trail down to Woodside and up the Hamms Gulch Trail in every season and weather condition. We love it for its variety of features and moods—down the vast, open, dry-grass and oak-spotted hillside, through the meandering, cool riparian watershed of Sausal Creek, and back up through the winding, rugged old-growth Douglas fir, madrone, and tanoak forest that make up Hamms Gulch. We always stop and marvel at the truly ancient Douglas fir at the top of Hamms Gulch Trail that have withstood countless raging winter storms and dry spells for millennia. Not much farther along the trail, we once again find ourselves at the top of the ridge, walking along the spine of the Santa Cruz Mountains, with breathtaking vistas of the Pacific to the west, and of the bay to the east. On clear days, it is even possible to see across to the Sierra.

Through all of these zones and habitat changes, Windy Hill is a place of profound natural beauty and stillness for reflection and renewal, and many are the times when I have done my best thinking there, finding surprising outside-the-box solutions to many of life's daily challenges while walking its trails. I have also passed countless others engaged in various conversations or quiet contemplation along the path, and I have often wondered how many of this valley's most important discoveries and innovations were first imagined while walking here. I am so deeply grateful to have all of this, right outside my back door.

Diana Jaye

page 16 page 17 page 30

These paintings on pages 16 and 17 were done about a year apart. The diptych wasn't intentional. When I saw that they nearly connected into a panorama, I was amazed and made it work. We learn to pick subjects that have a unique meaning. I didn't realize how special!

A group of Peninsula Outdoor Painters met here to paint Horseshoe Lake, which is just beyond the parking lot. When I saw this magnificent hill, I knew I had found my spot! There is so much beauty in these coastal hills that we never run out of special spots!

Paul Jossi

page 5 page 19 page 42

page 60 page 69

I have been painting in the Santa Cruz Mountains for over thirty years. For over ten of those, I have been painting mostly in the preserves of the Midpeninsula Regional Open Space District, and some of our local state and county parks, in oil, watercolor, ink, and acrylic. My paintings have been shown in places of business, libraries, and art shows. Over one hundred and twenty-five of my paintings are shared by people in their homes in the area.

I always have my camera with me when I hike, and, at times, a sketch pad. One of the big attitudes I had to overcome as I looked for things to paint was that urge to capture The Epic Painting. When it finally hit me that one need not hike for ten or twelve miles to find something to paint, I started to paint groups of leaves and limbs, and trees, creating something pleasing out of the everyday forest. There are those days, however, when one comes upon a scene that is, in itself, just right.

Most of my paintings are small, and I suppose that is because I have a short attention span. A small painting (by art show standards) may take me forty hours to paint. *Legacy* (page 19) is painted from photos and sketches in the spring at Russian Ridge Open Space Preserve. Once ranch land, these fields have changed back into meadows, and the forest of oak, chestnut, madrone, and undergrowth are once again returning to a more natural environment. The area still has remnants of days past. Fences happen here and there, old dividing lines between here and there; property lines long forgotten; livestock barriers. Split redwood posts that have survived rain and sun are slowly covered by undergrowth, and they eventually nourish the spring wildflowers.

Sailing Free (page 42) illustrates the feeling of freedom. The blue hills in the distance offer no visual wall, nor does the horizon of the Pacific Ocean as it reflects the sun in the distance. One's thoughts are free to go on forever.

Purisima Creek Trail is as much like Raggedy Ann's Deep Deep Woods as anything I could imagine. In the fall, the maple leaves are as big as the brim of a straw hat, and they glow a soft butter yellow in the dimness. My idea for *September Song* (page 60) was to do a close-up landscape. Off the trail, one can't see very far anyway, and the leaves put on quite the show.

Editor's Note: Paul Jossi (1933–2004) is a former Midpeninsula Regional Open Space District volunteer.

from "Foothill Trail, Late February," page 31

Pearl Karrer

A life-long love of the outdoors has given me the opportunity to introduce my grandchildren to the Midpeninsula Regional Open Space District preserves. Their trails have allowed us to name wildflowers like canyon delphinium and fairy lanterns, to recognize the cries of a red-tailed hawk, the trill of a wrentit. We love to touch the smooth trunk of madrone, to rub bay and sage to release fragrant oils. Early mornings sometimes bring young bucks or a doe with spotted fawns. Once in Los Trancos Open Space Preserve we even surprised a bobcat!

 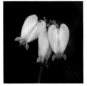

page 4 page 40 page 45

John Kesselring

I love walking at Rancho San Antonio Open Space Preserve in the early morning when the wildlife is active. I was on the Mora Trail near its high point when I saw six crows raising a ruckus over the oak trees. I immediately began searching the trees, and there was a red-tailed hawk with a ground squirrel it had just captured.

I frequently walk alone in the open space areas. My grandson Ian asked me if I feel lonely on these walks, and I replied that I feel very comfortable with the wildlife that I see, and they give me a real sense of companionship.

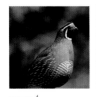 (page 22)

page 20 page 22 page 22

Judy Kramer

My favorite preserve is Russian Ridge Open Space Preserve because on a short hike there, you can experience the grassy fields and woodlands and thus a variety of wildflowers and trees. As a bonus, you also get sweeping views from San Francisco Bay to the Pacific Ocean. When I hike there, I feel peaceful and connected not just to daily life but to the processes of the ages.

A favorite moment came when I was hiking down the hill toward the Page Mill parking lot and caught sight of something furry at the edge of the trail. Pulling up, I saw it was the head of a gopher, with those characteristic chopper teeth, popping in and out of its burrow and nipping at nearby grass. You just never know what you might encounter if you slow down and keep looking.

Amanda Krauss

page 31 page 53

My artwork reflects the everyday actions of the beauty of the birds I observe in our open spaces. My artwork included in this book is of birds spotted at Purisima Creek Redwoods Open Space Preserve, one of my favorite spaces for birding. Purisima Creek Redwoods Open Space Preserve offers a wonderful opportunity to observe many different species of birds and many special chances to peek inside the everyday lives of the birds around us. I am thankful to be able to go to these open spaces to capture these moments in time.

Henri Lamiraux

page 2 page 64

I grew up in France in the Alps region and moved to the United States and the Bay Area in the late 1980s. I rediscovered photography in the late nineties, when digital photography became more mainstream and affordable. Having a computer engineering background, my initial approach to digital photography was very much geared toward its technical aspect. But I quickly got interested in landscape photography and started to drive up and down the Peninsula looking for subjects. Aside from a couple of hikes here and there, I hadn't paid much attention to the natural aspect of the Bay Area during my first ten years living here. But photography opened my eyes to the beauty, history, and diversity of the Bay Area parks and open space preserves.

From very early on, my "hunting" ground of predilection has been along Skyline Boulevard. One spot in particular has been attracting me over and over. It is the corner of Page Mill Road and Skyline Boulevard. Five of the best open space preserves are easily accessible from this spot: Russian Ridge, Skyline Ridge, Monte Bello (one of my early photography territories), Los Trancos, and Coal Creek. If I had to choose, Skyline Ridge Open Space Preserve would probably be my preferred one. It has it all: open vistas, meadows, oaks, and ponds (Alpine Pond and Horseshoe Lake). Walking the preserve's extensive trail network on a foggy early fall or spring morning is an experience I'll never get tired of.

In at least one of the open space preserves, there are visible vestiges of the people who inhabited the Bay Area well before Europeans; these artifacts are in the form of grinding rocks. I always make sure to stop and admire them when I visit the preserve on a quiet day, and I like to picture people gathering around these rocks to grind acorns. What were they talking about? Were there children running around? What was the view from these rocks at the time? How much did the landscape change? Being able to travel back in time and experience what these people were experiencing is one of my dreams.

page 83

Eric Lew

For me the outdoors is all about serendipity. No matter how carefully I plan my route, check the weather, or pack my gear, I never really know what will be around the next bend in the trail. How will the light filter through the trees? What sort of wildlife will I encounter? Which type of wildflower will be blooming? I'll never know until I get outside, and that's what makes it so exciting!

My first time in the Midpeninsula Regional Open Space District was through a photography outing I organized for the Stanford Photography Club. We woke up before sunrise, crossing paths with a few late-night partygoers as we left, and then almost got lost on the roads winding up to La Honda Creek Open Space Preserve. Once there, we navigated along a short trail to a viewpoint. As the sky continued to brighten, we realized that we were just above the fog line, and all around us the hilltops formed tiny islands surrounded by a vast sea of fog. When the sun broke the horizon, it cast spectacular orange and red shafts of light across the eerie landscape. It was a stunning introduction to La Honda Creek Open Space Preserve that I'll never forget.

page 53

Jim Liskovec

The woodpecker in my photo was probing the 15-foot-tall stump of the dead oak tree along the Lower Meadow Trail near the entrance to Rancho San Antonio Open Space Preserve. I had walked past the tree many times before, and never was a woodpecker in the right spot.

Nature has been my playground since I was a child. Growing up I just observed and enjoyed. I've since augmented my observation and enjoyment with photography; my images of wildlife and wild places allow me to share my experiences with others for their enjoyment and education.

My wife, Sue, and I have lived near Rancho San Antonio Open Space Preserve for over thirty years. The preserve has been an integral part of our lives. It is our place of refuge, where we hike regularly and bird. I almost always carry a camera, and I've captured images of acorn woodpeckers, bobcats, California quail, lazuli buntings, and other creatures for which Rancho San Antonio Open Space Preserve is home. Of all the bobcat encounters I have had at Rancho San Antonio Open Space Preserve over the years, one stands out. Early one morning I was walking from the restroom parking lot to the horse trailer parking lot along the edge of the meadow. There was a bobcat in the meadow, walking toward the restroom. With camera in hand I followed him at a distance. He walked through the parking lot and then to one side of the building. How do I know it was a male? The cat lifted its leg to mark its territory,

and then proceeded to a small grassy area to wait for an unsuspecting rodent. I captured a few very nice images.

I come truly alive in the outdoors, and Rancho San Antonio Open Space Preserve does that for me. It is wonderful to know that creatures like bobcats will always have a place to live and thrive in the preserve and places like it.

Besides photography my other favorite activity at Rancho San Antonio Open Space Preserve is listening to birdsong, and sharing that experience with other birders. For many years I have gone birding in the spring, when birdsong is at its peak. Birds sing everywhere—in the parking lot, in the trees, and in the low vegetation. And I listen to it all.

Deane Little

What strikes me most as a photographer on the Midpeninsula Regional Open Space District's lands is the huge number of magical experiences that happen there. Stunning light and fog, wildlife sightings, dramatic clouds and landscapes—it's an amazing place to shoot pictures. But one of my favorite experiences happened without my camera, while descending Rhus Ridge Trail in Rancho San Antonio Open Space Preserve. The trail is steep and I was watching my step when for some reason I looked up and there, not ten feet away and level with my chest, was a gorgeous adult bobcat perched on the limb of a tree at the trail's edge. He was certainly aware of me long before I saw him, and could easily have jumped down and disappeared before I approached him. But instead he stayed, and we stood and stared at each other for what seemed like several slow minutes. I could almost have reached out and touched him, and he seemed utterly aware

but unafraid of our closeness. I wish I'd had my camera, but it might have spoiled the moment, and the memory is so vivid that I almost didn't need it.

The summit of Black Mountain in Monte Bello Open Space Preserve is one of my favorite places on the planet. It seems ancient and yet ever changing, a wild place that makes and is made by the weather. Rough, weathered rocks protrude from the ground, and smooth grassy hills emerge from the forests below. Late in the day, fog often creeps up the coastal valleys, gradually shrouding the ridges in mist while the grassy slopes near the summit remain lit with warm sunlight. It's a dramatic scene and this image (page 45), of a grazing deer at sunset, was one of those magical moments that photographers and hikers live for.

Editor's Note: Deane Little is a former Midpeninsula Regional Open Space District board director.

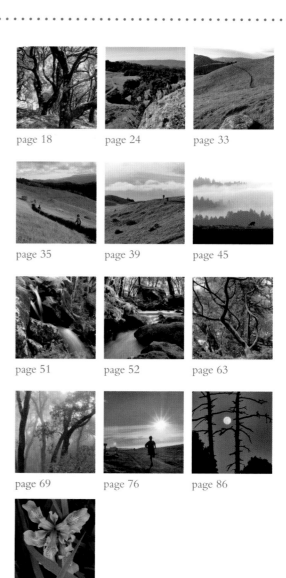

page 18 page 24 page 33

page 35 page 39 page 45

page 51 page 52 page 63

page 69 page 76 page 86

page 87

Stephanie Maclean

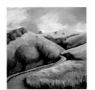

page 7

When I discuss the scenes in my paintings, I am often surprised that so many people do not realize how close by and accessible these preserves are. It's remarkable that this expanse of nature is just a few miles from Silicon Valley, and it's a great privilege to have such broad access to it. Winter is my favorite season in the hills. Fewer people venture out to the preserves, but the shallow angle of the sunlight brings out the texture of the landscape, and the rains start to bring the green to the meadows. Of course for a painter, the colors are key. My work is characterized by vivid blues, greens, and yellows, possibly a reaction to my upbringing in a much cloudier country. Getting sunburnt on a New Year's Day hike was a surprising welcome to California.

My favorite open space preserves are Monte Bello and Windy Hill. Ascending from the Portola Valley parking lot, the view of the twin summits of Windy Hill changes constantly, passing through such a rich variety of terrain—just count the number of types of wildflowers on the way. And in Monte Bello, the painting here shows the Bella Vista Trail looking toward the top of Black Mountain, where you can see the Bay, the Pacific, the city, and Silicon Valley.

Jodi McKean

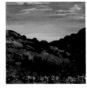

page 38

I grew up in a home full of art. Largely self-taught, I had parents who encouraged me to follow my dreams. As a teenager, I was transfixed by Picasso, Monet, Kandinsky, Norman Rockwell. Every artist intrigued me. I wanted to get into their world, to understand their technique, their use of texture, color, and movement. I love the thought process that evolves into creating a painting. Soon that passion in me exploded into vivid paintings with rich, bold colors.

I am an avid hiker and grew up on a farm in Oregon, so nature has never been far from my thoughts. The open space preserves, for me, are a priceless refuge from the noisy city. Hiking the open spaces around the Bay Area fills me with an inner peace and sparks my creative mindset. My entire mood changes, calms, expands, when I pass through a trailhead gate.

I can hike the same trail at different times of day and feel like I have never hiked that trail before. The late afternoon sun casting an orange glow over the grasses or drawing long shadows out from stately oak trees, even the early morning scent of eucalyptus leaves and wet dirt or the sounds of quail and Steller's jays, give me a whole new outlook for my next painting. And the vistas are incredible! Whether I'm standing at the top of Priest Rock Trail where it meets Kennedy Trail in Sierra Azul

Open Space Preserve, sitting on the bench at the top of Rancho San Antonio Open Space Preserve's PG&E Trail, or walking next to redwoods on Windy Hill Open Space Preserve, the inspiration for painting is infinite.

Susan Migliore

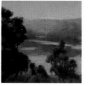 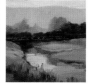 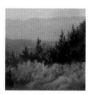

page 11 page 15 page 36

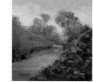

page 57

When I was painting at the baylands at Ravenswood Open Space Preserve, a man and a woman on their hike stopped to see what I was doing. For a few minutes, they looked at my painting and then they looked at the scene around them. After some time the women said, "I had never looked at it that way. I had never really seen it." One of the things about painting outside is you really have to stop and look. Sometimes others take the time to stop and see your view.

I do most of my painting outdoors. I can be painting in wooded areas, wetlands, fields, ponds, mountain ranges, and sweeping vistas within a short drive. I usually have only a few hours to paint. It is during that period of time I forget about everything and enjoy. I am just grateful that these open spaces are left.

My true passion has always been painting, feeding my lifelong fascination with the interplay of light, color, and texture. The majority of my work is done outside, where the intensities and subtleties of light, color, and texture are most on display. I usually complete each piece in one sitting. For me it is the only way to capture the sense and feeling of time and place. I love the immediacy and energy of painting *alla prima*. My paintings are studies of the interaction between light and color in the tradition of California Impressionism. The varied Northern California landscape is rich in possibilities for interesting and evocative paintings.

Micki Miller

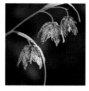

page 23

The seasons and the wildlife are the reasons I go out in the open spaces. You never know if you are going to round a corner and see a pair of deer or a stag with an amazing set of antlers. Or you may look up and see turkey vultures circling around a field and then watch a mad vertical dive as they spot their prey. On a spring morning hiking the trails at Rancho San Antonio Open Space Preserve, you can pass bunnies hopping around and feeding, almost out of a Disney movie. And then a little farther on are families of quail trotting in front of you. In the winter, a glance up a barren hill will reveal a coyote watching you. Each season has its own show. And as winter days pass and the animals aren't obvious, you

start to see the green shoots you know will give you the perfect wildflower that will be even lovelier than the one you photographed the previous spring. I was on a hike coming out from Horseshoe Lake (at Skyline Ridge Open Space Preserve), when up ahead we saw three young coyotes tumbling across the trail in play in the deep fog. It was unbelievably thrilling. The day I finally managed to climb to Black Mountain (at Monte Bello Open Space Preserve) and found rare wildflowers to capture on "film" was another hike to remember.

My late husband was an avid hiker and, as he became ill with early onset Alzheimer's disease, one of the few things left to him was hiking. I found trails we hadn't done, searched out vistas for us both to marvel at, and learned the names of wildflowers we saw so I could repeat them back to him when he asked what they were. On a hike to Long Ridge Open Space Preserve, we made it as far as the Wallace Stegner bench and relaxed together, enjoying the beauty and the silence.

Breeze Momar

Outside, I am sunbathed, spent (and glad of it), unwound, refilled, and flush with the contours.

Charlotte Muse

When I was hiking alone at Rancho San Antonio Open Space Preserve one December afternoon, a mountain lion rose from the grasses, not twenty feet away. I froze. He ignored me, crossed the path, and following a game trail, stuck his paw into likely holes looking for food, with quick gestures like a hunter checking traps. Then he disappeared among the hills' wheaten hues, while I stood watching, the still uneaten Muse.

Pam Priest Naeve

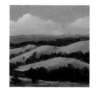

page 37

I started painting as a young child, receiving my first oil painting set when I was ten, and I've been painting in oil ever since. I prefer to paint outdoors and on location, using my studio for the larger paintings. My favorite spots are the greater Bay Area (Pacific Coast, Hollister/Gilroy, Napa) and Wyoming. One art class at Northwestern University that I took as an undergraduate is my only formal art training, with a few workshops at the Pacific Art League of Palo Alto, in Colorado, and in Wyoming, refining my skills. My greatest teacher is being in nature, experiencing the color and light, and recording it on canvas. My work is featured in various collections throughout the United States and Europe.

Charles Nelson

from "Alta California," page 46

Windy Hill footsteps, on many a winter morning, can be as crunchy as breakfast cereal. Heaved up a few inches, the trail mud balances on myriads of tiny ice needles, and the Anniversary Trail edge crumbles. A man with a rolled-up glider on his shoulder approaches the summit, lips closed tightly, nostrils flaring against the acrid chill. Frost smoke is drifting uphill, obscuring his boot.

In order to be reborn, one might decide to learn hang gliding, achieve an adequate skill level through diligent practice, obtain a permit with the District, then resolutely and single-mindedly stand at the Windy Hill summit, expecting to fly.

A few intrepid souls, members of our group called the Windy Hill Skyriders, have launched and soared (yes, legally) on their hang gliders, peering down at the burrowing owls and lost cars of Skyline Boulevard. Some flew alongside numerous white-tailed kites on Spring Ridge.

Hang glider pilots at Windy Hill enjoy the olfactory pleasures of the troposphere. Essence of redberry and madrone can be funneled upward and concentrated like flotsam, bobbing on the sky's surface.

These Windy Hillbillies wish to thank the park and open space agencies for their assistance in achieving unpowered, silent flight above the preserve.

Kenneth C. Nitz

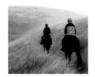

page 71

This photograph was taken while I was horseback riding with my friends from Bear Creek Stables on a rainy, foggy day at Russian Ridge Open Space Preserve. Riding trails on horseback gives a unique perspective on the preserves—the longer distances you can go; the nice, slow pace compared to mountain biking; the plod, plod, plod of each horse footfall. The quiet, even though friends are just a few yards away, but too far to talk, creates an opening to hear the birds flitting around and the horse huffing its way uphill. It's a unique experience and something I don't do very often at all. I normally hike the Midpeninsula Regional Open Space District trails, usually with my greyhound Nell.e and my girlfriend (we met at Pulgas Ridge Open Space Preserve) and her dog. Sometimes it's just for the dogs, and sometimes it's just to get away from the work week, clear our heads, and get ready for the next. It is so great to have these lands so close by for everyone to enjoy!

Editor's Note: Kenneth C. Nitz is a former Midpeninsula Regional Open Space District board director.

Jacob Osborne

 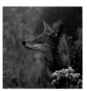

page 84 page 87

Open spaces close to city centers and suburban areas, such as Rancho San Antonio Open Space Preserve and the preserves and parks running along Highway 35 (Skyline Boulevard), provide several invaluable services for Bay Area residents. First, they preserve sites that serve as a record of human as well as natural history. They also offer local, healthy, and inexpensive opportunities for recreation for people of all ages and physical abilities. Lastly, and perhaps most importantly, Midpeninsula Regional Open Space District preserves offer some of the few remaining opportunities for children raised in the digital age to witness and be inspired by simple wonders of wild nature, such as a spider spinning a web, or a flock of wild turkeys perched on the limbs of an aging oak tree, or a coyote slinking through tall grass. These are services that most of us are too busy to think about but that we would sorely miss if they disappeared under streets and housing developments.

One of my favorite spots to visit is the old apple orchard on Long Ridge Open Space Preserve. It's especially fun to visit in mid-autumn, when deer and birds are still fairly active and the trees are laden with apples. It's amazing that the trees are still so productive given how old they are, and the fruit is as flavorful and organic as you can get (sometimes including the odd caterpillar). Sites like that preserve some of the rich history of the region and are a welcome reminder that even developed areas can return to a natural yet still useful state if given the chance.

Darwin Poulos

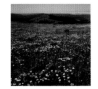

Yearly I visit Monte Bello Open Space Preserve as the "resident astronomer" at Deer Hollow Farm to show the night sky (with telescope) to the summer campers. It is so satisfying when these youth see something they have never seen before. They begin to ask questions and become more curious about the world around them.

To be outdoors is energizing; to be in open space is fulfilling to the spirit. It is because nature is so rejuvenating to the spirit that there must be some open space to escape to so all can benefit from nature.

My favorite time to walk or hike is in the morning. The earlier the better, especially during the summer. The light is magical, and you get a chance to see some wildlife waking up and others bedding down. In addition, there are fewer people to disturb you. I have a preference for Rancho San Antonio Open Space Preserve because it is walking distance from my home.

The Cathedral Tree in Rancho San Antonio Open Space Preserve is a place of peace, solitude, and comfort. It is a place that I have gone to center my spirit when life "gives me lemons." The sounds of water in the creek, birds, and the occasional deer are renewing to me, but the silence is the most rewarding.

Editor's Note: Darwin Poulos is a Midpeninsula Regional Open Space District volunteer.

John Richards

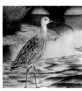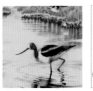

My art focuses on plant, bird, and reptile painting. I am inspired by the detailed beauty and paradoxical complexity contained in the simplest of my subjects.

My work has been featured in textbooks, public buildings, maps, and private collections.

Anna Shaff

I don't impose a preconceived form on my work but capture a poem as it emerges, refining each within the context of its own needs. The term "free verse" is the least constraining (but would be misleading, since it's perceived by most as a non-rhyming form).

Certain emotional depths can only be accessed through nature—such as the feeling of being afloat yet thoroughly merged with the universe, which I have encountered in the vastness and solitude of Russian Ridge Open Space Preserve. These are the moments that insist on being captured in words, or images, or sound. It is the process by which nature, filtered through human perception, creates art.

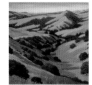

Carolyn Shaw

Of course, the outdoors is especially important to me because I am a landscape painter but, beyond this, I believe everyone benefits from being at one with the greatness of the natural world, which is preserved especially for us by the Midpeninsula Regional Open Space District, as well as others. From the panoramic views of the ocean to the intimacy of a rivulet trickling down beside a tree-studded trail, the primitive state of nature captures our imagination and provides us with welcome breathing room for the spirit.

I'll never forget the time when we walked up Windy Hill Open Space Preserve on, yes, a windy day, and I had on my brother's oversized shell-type windbreaker, zipped up to my throat, when suddenly a big gust of air went right up inside, inflating it and almost lifting me off the ground! We spent the next few minutes on our hands and knees crawling up the rather precipitous trail to safety. It was one of those moments when I realized the power of Mother Nature and also how Windy Hill got its name!

Ian Sims

Our open space preserves offer an incredible diversity of experiences. In the past year, I've hollered with pure joy while riding through the redwoods at El Corte de Madera Creek Open Space Preserve, watched deer casually munch on grass as the sun set behind the hills of Rancho San Antonio Open Space Preserve, made a tiny snowman at the top of Monte Bello Open Space Preserve after a rare winter dusting, and shown friends from out of town how to properly hug a redwood at Purisima Creek Redwoods Open Space Preserve. A sincere thank you to all of the donors, volunteers, and staff who maintain these spaces and make these moments possible!

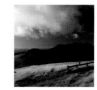

page 75

Timon Sloane

It was years before I understood what drew me so intensely to painting the landscape.

Soon after I began to venture outside to paint plein air and for reasons I didn't fully understand at the time, painting landscapes on location became an obsession. I became engrossed in the pursuit of capturing more than the mere look of a location, seeking to also capture what it felt like—the full experience of being there.

Years later came my "ah ha" moment: I read that a walk in nature can elevate one's mood as powerfully as antidepressants. I realized that I had been drawn to plein air painting as a means of exploring the powerful experiences one can have spending time away from civilization.

There is a harmony in nature. The wilderness offers far more than just beauty and tranquility. Nature provides us with an inexplicable form of rejuvenation. This is why so many of us use weekend hikes and vacations to remote locations to counteract the effects of our modern lives. This is why it is so vital for us to protect our open spaces.

I painted *Orange Wetlands* after hiking into some protected wetlands just a stone's throw away from the hustle and bustle of Silicon Valley. Access to these beautiful locations will benefit us all for generations to come. Through my artwork, I strive to interpret and capture just a bit the revitalizing power I feel when visiting our open spaces. With each new painting, I hope to preserve and pass on a small taste of nature's energy, and I am honored when others connect with my interpretation and are moved by my work.

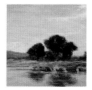

page 10

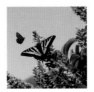

page 20

Strether Smith

Getting a good picture of a swallowtail is easy. Get out in the spring, find a buckeye tree in flower, and wait. If you are lucky, there will be an accident and you will get a picture like this.

My favorite spot in the Midpeninsula Regional Open Space District is the trail junction at the bottom of the Seven Springs Loop in Fremont Older Open Space Preserve. I take advantage of the fact that I am quieter on my bike than hikers and, if there is no one else around, it takes very little time for the critters to come into view. Acorn woodpeckers and flickers hunt for insects in two snags, quail scurry in the bushes, and squirrels and jays make it plain that it is time for me to move on. After five minutes or so, I oblige them and climb back up to the hayfield.

Editor's Note: Strether Smith is a Midpeninsula Regional Open Space District volunteer and docent.

"Evening in the Forest," page 88

Lani Southern

When I first went to Skyline Ridge Open Space Preserve, it was on a field trip in the third grade. My experience was enhanced by a wonderful guide and my enthusiastic teacher. We got to taste miner's lettuce and see an Indian grinding stone. It was wonderful!

I respect the outdoors and the people who have lived there for so many years, living with a happy simplicity yet battling the elements every day of their lives. I have wanted to live in the 1800s for a long time. Being in a totally secluded outdoor place is one of the ways I can get as close as I'll ever get to living there. I hope everyone has a chance to feel nature's magic.

Editor's Note: Lani Southern is ten years old.

Susan Stienstra

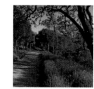

page 18

I love to walk at Windy Hill Open Space Preserve. I step lightly and look around myself. I look for the small brown rabbits at the trail's edge. I speak softly to a doe and her fawn. The gift of nature's beauty and her creatures brings me peace.

I took my sister and my best friend to the Indian grinding stone at Russian Ridge Open Space Preserve. We stood there quietly. My eyes filled with tears. We sensed the spirits of the Ohlone women from so long ago. The forest encircles and holds us together.

Alex Stoll

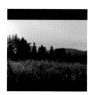

page 90

On this morning, about a dozen of us from the Stanford Photography Club met up before dawn and carpooled up to La Honda Creek Open Space Preserve to catch the sunrise from this especially scenic location. It was great to see how every photographer approached the landscape differently, and also to have human subjects to make our shots that much more interesting!

Besides La Honda Creek Open Space Preserve during an autumn sunrise, I love sunsets from Russian Ridge Open Space Preserve, particularly on the rare summer afternoons when every hill is an amazing shade of green and both the Pacific Ocean and the entire Bay are visible with startling clarity.

Tim Switick

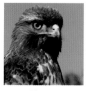

page 41

I never tire of taking photos and hiking at Rancho San Antonio Open Space Preserve. It's a beautiful place with a great diversity of wildlife and scenery. I especially enjoy going in the spring to observe the nesting hawks.

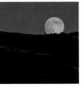

page 21 page 83 page 88

page 89

Vaibhav Tripathi

Being outdoors to me is always a novel, enchanting experience. In each visit, there is something different in the air with Mother Nature conjuring up a new trick of her own. At a time when the human population has grown beyond seven billion and the pressure on natural places is increasing every instant, places like this need to be preserved to remind us of the beautiful world we live in and to make sure that it remains the same for generations to follow.

Borel Hill (at Russian Ridge Open Space Preserve) on a summer evening with fog rolling in from the west is a special place to be. It is 90°F in the valley but here it is a cool 70°. The sun is playing hide and seek: one moment you see all the way down to San Francisco and then suddenly the view is blocked and even the trees on the trail are hazy. Song sparrows sing merrily with the refreshing mountain air carrying their song all over the region. On a lucky evening, one might spot a curious coyote as well.

Green grass with deer grazing in the meadows, wildflowers dotting the landscape, and the beautiful golden morning light with wide vistas make a spring morning my favorite time to visit Monte Bello Open Space Preserve.

page 77

Charles Tu

As a resident of Silicon Valley for almost thirty years, I've been a frequent visitor of almost all the open space preserves of the Midpeninsula Regional Open Space District. Rancho San Antonio Open Space Preserve is one of the few that I visit most often. The preserve provides diverse natural environments for exploration, interesting cultural history for historical studies, and the setting for formal and informal recreational opportunities. I like to visit the preserve in either early morning or late afternoon before a winter storm or after a summer rain.

Daniel Vekhter

page 81

Once, I set off for a short afternoon hike at Russian Ridge Open Space Preserve with a friend. At sunset, heavy fog (much like the fog in the photo) settled over the preserve like a heavy down comforter. We marveled at the otherworldly stillness but soon became uneasy as we realized that we could barely make out the path ahead of us. As darkness encroached, we quickly lost the path entirely. Using the light of our cell phones as makeshift flashlights, we wandered for what felt like hours, as silent trees shrouded in fog watched us. When we finally made it back to the parking lot, we both commented on how strange it was that the preserve, which we both had considered practically our back yard, revealed to us a new side—a remote and foreboding wilderness. Ever since, I have regarded it with respect—and always bring a flashlight.

Randy Weber

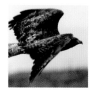

page 41

At Purisima Creek Redwoods Open Space Preserve, from the Half Moon Bay entrance, one of my favorite mountain bike rides is ascending Whittemore Gulch Trail and returning by descending the Harkins Ridge Trail. Not only is it a great workout, but it also includes some of the most beautiful scenery in the San Francisco Bay Area. When I reach the top near Skyline Boulevard, the views of the Half Moon Bay coastside are just spectacular!

Within only a short drive, a visit to my favorite preserve allows me to escape the fast pace of everyday living. I take a deep breath, relax, and leave my troubles behind.

My favorite time of year to visit Purisima Creek Redwoods Open Space Preserve is in the fall. The colors of the big-leaf maple trees along the creek and trails make for amazing photo opportunities!

Nikki Weidner

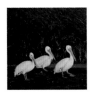

page 14

As a photographer with a disability, I am so grateful for the nearness and accessibility of much of the Midpeninsula Regional Open Space District's open space preserves. The Stevens Creek Shoreline Nature Study Area, in particular, is just a short drive from home. The half-mile trail is flat and gentle—a perfect morning stroll—and the wildlife and waterfowl are in such splendid abundance that my love for nature photography can easily be fulfilled, in spite of my physical limitations. Peter Lik, eat your heart out.

Bonnie Welling

page 12

Walking along the Stevens Creek Shoreline Nature Study Area makes me feel alternately tranquil and excited. Tranquil from the peaceful quiet, and excited by the changing scenery of flowers, birds, water, and sky. Each visit provides a new experience with the changing seasons and weather. Different birds and animals surprise and delight. In my painting, I have focused on the dawn when the water reflects the color of the sky and frames the birds. I hope my painting inspires others to enjoy the beauty of the Stevens Creek Shoreline Nature Study Area and support the preservation of open spaces.

Karen White

page 58 page 59

I often paint plein air in our open space preserves. One afternoon after heading home from a day of painting at Windy Hill Open Space Preserve, I learned that a mountain lion had appeared to stalk a member of our painting group just a day earlier! Word has it that the lion became uninterested and wandered off, apparently not wishing to be the subject of an original oil painting.

Spending time outdoors is exhilarating! Hiking in our open spaces takes me back to the way California used to be, the way our ancestors found the land—wild and unspoiled. Our open space preserves are our legacy to future generations and, for me, remain a special source of artistic inspiration.

Using heightened color, simplified design, and a stylized approach, I hope to share the exhilaration I feel when encountering each unique scene.

The trails at Monte Bello, Windy Hill, and La Honda Creek Open Space Preserves, among other open space preserves, reveal scenes of tranquility and lush beauty. Morning sun in summer bathes the hills in gold and highlights greens of native oak stands and distant ridgelines. Along the ground, squirrels and lizards dart among green and golden grasses. I have often painted at these preserves or from along Skyline Boulevard, where the painter can capture amazing vistas of open space, reaching from the ocean to Mount Hamilton.

Nancy Hancock Williams

page 28 page 29

Windy Hill is my favorite open space preserve, especially in the spring, because the terrain is so varied and vivid. Hiking up from the Portola Valley parking lot, there's that daunting, steep trail embraced by grasslands and chaparral—the twin peaks of the hill looming gracefully to the west—where I've been thrilled to occasionally see the resident coyote darting about the green meadow to catch a mole or a vole for his lunch. Near the top, the ghostly wind rustles the branches of the stately sentinel cypress trees, at the base of which I recently encountered a large rattlesnake warily sounding his rattle under some gnarled roots. (I backed away slowly and

respectfully!) At the top is that glistening view of the ocean, and along the trail toward Skyline Boulevard, dainty pink checkerblooms, orange California poppies, and purple lupine alongside the trail compete for attention with that glorious panorama of the entire Bay. At "Bob's Bench," my husband (his name is Bob) and I have a rule that we have to sit for one minute and observe the view of Mount Diablo. Then it's down, down through the lush redwood and oak forest, to the gentle creek, and back to the car, where, if it's been a good day, I'll have brought a bit of the outdoors home with me in the form of a little watercolor painting.

Epilogue
The Next Forty Years

Kristi Britt

Despite the fact that the purpose of an epilogue is to provide a conclusion, often revealing the fates of characters at the end of a story, this story, the one of protecting open space on the Peninsula, is still being written. Although the details aren't certain, we know a few things: we know that the District will continue its successful buying of open space lands to protect our natural environment for clean air and water, sustainable agriculture, and critical wildlife habitat. The District will also increase its focus on protecting natural resources by strengthening its stewardship capabilities while providing more low-impact recreational opportunities and access for public enjoyment and education.

But more funding is needed to support the District's ability to continue to buy land and deliver the services that create healthy communities and quality of life. In the chapters of the District's future, continued public and community support is needed to complete the original vision: creating a thriving greenbelt on the San Francisco Peninsula; providing public access to green mountains and golden hills; planning for the next generation; and ensuring continued success over the next forty years.

The photographers, artists, and poets featured in this book did their part to share their interpretation of nature's importance with you. For our part, we can begin by remembering open space is "room to breathe."

About the Authors

Kristi Britt was the Midpeninsula Regional Open Space District's public affairs specialist for nearly ten years and worked for the District for over fifteen years. She served as editor of the quarterly newsletter, *Open Space Views,* and oversaw production of the District's trail guide book, *Peninsula Tales and Trails.* Profiled in Jim Cassio and Alice Rush's 2009 *Green Careers: Choosing Work for a Sustainable Future,* she has a bachelor's degree from San Jose State University in business administration.

Kristi has an affinity for nature and credits her parents and her grandfather, the "refined outdoorsman," for her love of the natural world and exploring the outdoors. Kristi lives in the South Bay, along with her husband, Bill, their daughter, Sadie, and their two dogs and two cats; she has recently begun a new life chapter spending more time at home with her family and hopefully instilling in Sadie some of her joy for the open spaces and its wild inhabitants.

Ken Fisher is the founder, chairman, and CEO of Fisher Investments, a $44 billion money management firm. He is best known for his over twenty-eight years as *Forbes' Portfolio Strategy* columnist and is the subject of *The Making of a Market Guru: Forbes Presents 25 Years of Ken Fisher* by Aaron Anderson (Wiley, 2011).

He has written eight books, most recently national bestsellers including *Markets Never Forget* (2011), *Debunkery* (2010), *How to Smell a Rat* (2009), *The Ten Roads to Riches* (2008), and *The Only Three Questions that Count* (2006), all published by John Wiley and Sons.

Ken's hobbies include the history of Kings Mountain, California, nineteenth-century redwood lumbering history, and all aspects of redwood science. He has located, excavated, and cataloged more than thirty-five pre-1920 steam era redwood lumber mills and is generally recognized as the leading expert on redwood lumbering history south of San Francisco. Most of his adult life has been spent somehow, someway in the redwoods. He lives in Woodside, California, with his wife, Sherrilyn. They have three adult sons.

Steve Abbors left the golden hills of the East Bay in 2008 for the forested slopes of the Santa Cruz Mountains when he took the helm as general manager for the Midpeninsula Regional Open Space District. He earned a master's degree in biological sciences from California State University, East Bay, and began his professional career as a naturalist with the East Bay Regional Park District. In 1984, he joined the East Bay Municipal Utility District, where he managed

twenty-eight thousand acres of watershed land for water quality protection and recreation.

Outside of work, Steve is an amateur nature photographer, classical guitar player, and gardener with a particular affinity for growing dahlias and grapes. A viticulture enthusiast, he enjoys making his own wine. Steve and his wife live in both the South Bay and the East Bay and have two grown daughters. Whether in the East Bay Hills or Santa Cruz Mountains, Steve is an avid hiker, logging over twelve hundred miles annually, usually carrying a camera and always with a curious and appreciative eye toward the natural world.

About the Midpeninsula Regional Open Space District

The Midpeninsula Regional Open Space District's mission is to acquire and preserve a regional greenbelt of open space land in perpetuity; protect and restore the natural environment; and provide opportunities for ecologically sensitive public enjoyment and education.

Midpeninsula Regional Open Space District
330 Distel Circle
Los Altos, CA 94022-1404
Phone: (650) 691-1200
Fax: (650) 691-0485
Email: info@openspace.org
Website: www.openspace.org
Twitter: @mrosd
Find us on Facebook
Watch us on YouTube

About Heyday

Heyday is an independent, nonprofit publisher and unique cultural institution. We promote widespread awareness and celebration of California's many cultures, landscapes, and boundary-breaking ideas. Through our well-crafted books, public events, and innovative outreach programs we are building a vibrant community of readers, writers, and thinkers.

Thank You

It takes the collective effort of many to create a thriving literary culture. We are thankful to all the thoughtful people we have the privilege to engage with. Cheers to our writers, artists, editors, storytellers, designers, printers, bookstores, critics, cultural organizations, readers, and book lovers everywhere!

We are especially grateful for the generous funding we've received for our publications and programs during the past year from foundations and hundreds of individual donors. Major supporters include:

Anonymous (3); Acorn Naturalists; Alliance for California Traditional Arts; Arkay Foundation; Judy Avery; James J. Baechle; Paul Bancroft III; BayTree Fund; S. D. Bechtel, Jr. Foundation; Barbara Jean and Fred Berensmeier; Berkeley Civic Arts Program and Civic Arts Commission; Joan Berman; Buena Vista Rancheria/Jesse Flyingcloud Pope Foundation; Lewis and Sheana Butler; California Civil Liberties Public Education Program; Cal Humanities; California Indian Heritage Center Foundation; California State Library; California State Parks Foundation; Keith Campbell Foundation; Candelaria Fund; John and Nancy Cassidy Family Foundation, through Silicon Valley Community Foundation; The Center for California Studies; Graham Chisholm; The Christensen Fund; Jon Christensen; Community Futures Collective; Compton Foundation; Creative Work Fund; Lawrence Crooks; Nik Dehejia; Frances Dinkelspiel and Gary Wayne; The Durfee Foundation; Troy Duster; Earth Island Institute; Eaton Kenyon Fund of the Sacramento Region Community Foundation; Euclid Fund at the East Bay Community Foundation; Foothill Resources, Ltd.; Furthur Foundation; The Fred Gellert Family Foundation; Fulfillco; The Wallace Alexander Gerbode Foundation; Nicola W. Gordon; Wanda Lee

Graves and Stephen Duscha; David Guy; The Walter and Elise Haas Fund; Coke and James Hallowell; Historic Resources Group; Sandra and Charles Hobson; G. Scott Hong Charitable Trust; Donna Ewald Huggins; Humboldt Area Foundation; James Irvine Foundation; Claudia Jurmain; Kendeda Fund; Marty and Pamela Krasney; Guy Lampard and Suzanne Badenhoop; Christine Leefeldt, in celebration of Ernest Callenbach and Malcolm Margolin's friendship; LEF Foundation; Thomas Lockard; Thomas J. Long Foundation; Judith and Brad Lowry-Croul; Kermit Lynch Wine Merchant; Michael McCone; Nion McEvoy and Leslie Berriman; Michael Mitrani; Moore Family Foundation; Michael J. Moratto, in memory of Ernest L. Cassel; Richard Nagler; National Endowment for the Arts; National Wildlife Federation; Native Cultures Fund; The Nature Conservancy; Nightingale Family Foundation; Northern California Water Association; Pacific Legacy, Inc.; The David and Lucile Packard Foundation; Patagonia, Inc.; PhotoWings; Robin Ridder; Alan Rosenus; The San Francisco Foundation; San Manuel Band of Mission Indians; Greg Sarris; Savory Thymes; Sonoma Land Trust; Stone Soup Fresno; Roselyne Chroman Swig; Swinerton Family Fund; Thendara Foundation; Sedge Thomson and Sylvia Brownrigg; TomKat Charitable Trust; Lisa Van Cleef and Mark Gunson; Patricia Wakida; Whole Systems Foundation; Wild by Nature, Inc.; John Wiley & Sons, Inc.; Peter Booth Wiley and Valerie Barth; Bobby Winston; Dean Witter Foundation; The Work-in-Progress Fund of Tides Foundation; and Yocha Dehe Community Fund.

Board of Directors

Getting Involved

To learn more about our publications, events, membership club, and other ways you can participate, please visit www.heydaybooks.com.